a guide to modern + contemporary

ART

in the city *london*

TIDDY ROWAN

Consultant: Chris Stephens
Curator (Modern British Art) & Head of Displays, Tate Britain

QUADRILLE

Contents

Introducing Art in the City 4

How to use this guide 5

London: Capital of Art?
by Chris Stephens 8

A-Z of Artists 16

Directory 113

 Public galleries, art venues and organizations 114
 Private galleries 121
 Photography 150
 Gallery tours and walks 151
 Public art 151
 Art colleges 157
 Art fairs 158

Maps 163

Picture credits 188
Index of artists 189
Author's acknowledgments 192

Introducing Art in the City

A while ago, an art collector called me from New York. He was coming to London on a short business trip and asked whether I would give him a tour around the places I thought most likely to appeal to his contemporary art taste-buds. I was going to Paris that week, so, knowing I couldn't accompany him, I sent him some ideas. I devised a two-day tour of private galleries and another day visiting particular pieces of art in public galleries and spaces, to give him a snapshot of what was going on.

He got plugged in, bought some limited-edition prints and was very appreciative of the guidance. He'd been able to get immersed so quickly, he told me later, that he reckoned I should write a book. I canvassed the opinion of others interested in modern and contemporary art – visitors, locals and people who work in the art business – and they all agreed that with the ever-increasing interest in contemporary art, a guide would be very helpful.

The artists showcased here have been chosen from the broad selection of art to be seen at any one time in London. Its art – like that of any city – is made up not only of the work of its home-grown artists but that of others whose work can also be seen here. 'Great artists have no country' yet they form part of the collective culture of many of the world's greatest cities.

London's art scene consists of a rich mix of artists and their art as well as the galleries, curators and collectors who exhibit and represent them. This book – both a handbook and a guide – presents a cross-section of artwork, galleries and venues, and at the same time aims to capture something of the compelling atmosphere that surrounds them. It is intended for anyone interested in the current modern and contemporary art scene in this vibrant, culturally diverse city. I hope you will find it a useful companion.

Tiddy Rowan

How to use this guide

A-Z of Artists

The central part of the book is an alphabetical cross-section of artists chosen from the early to mid-20th century (modern) period and the present day (contemporary). They have been selected from across the wide range of disciplines on show in London today, and represent painting, drawing, sculpture, photography, video, installation and mixed media.

Each entry illustrates a representative piece of the artist's work accompanied by biographical details, a description of their practice, and details of where their work can be viewed in London. Please be aware that the actual work chosen to illustrate an entry may not always be on view – works held in collections and public galleries can be rotated or loaned out, and work in private galleries can be sold. The public art is permanently installed, apart from those locations that feature a changing programme of work.

To include all the modern, contemporary and vibrant emerging artists who have some presence in London would fill many volumes. So this is a taste of what lies beyond for those who want to explore further, and it is hoped that each artist featured here will lead the reader to another, whose work will be similarly enjoyed. In addition, many artists not included in this section can be found in the gallery and public art listings in the Directory.

Directory

Galleries and venues highlighted in the Artists section are cross-referenced to the Directory. This lists the public and private galleries, public art, art colleges, art institutions, art fairs and other sites where art can be seen or resourced in the city. Fifteen feature pages scattered throughout the Directory focus on must-see galleries, fairs and organizations in London.

The majority of entries are cross-referred to the Maps section (pages 163-87). Also included are significant galleries or artworks that are easily accessible from the city centre but outside the areas covered in the maps, along with relevant transport links.

Maps

A large map of London inside the front cover indicates the 12 areas shown in close-up in the Maps section. Every site plotted on the maps is colour coded to indicate where it is listed in the Directory. See page 163 for a key to the colour coding.

Creating your own art tour

The cross-referencing is designed to lead readers on their own spontaneous tours of the London art world. Reading about Patrick Caulfield's work in the Artists section could lead you to Alan Cristea's Gallery in Cork Street; while there you might see Julian Opie's work and decide to go and look at his portraits in the National Portrait Gallery. That visit might lead you to Sam Taylor-Wood's self portrait and her video of David Beckham sleeping. The gallery that represents her, you will read, is White Cube... and a journey to Hoxton will lead you to... and so on. Opening the Artists section at any page can provide the starting point for such a tour. And, conversely, the Maps section offers the possibility of plotting your own course through the galleries and art sites of any chosen area.

London: Capital of Art?

*T*he British are a literary people. So goes a well-established and common theory. While they may lay claim to the poetry and drama of Shakespeare, they have no Michelangelo, no Monet, no Picasso. Few artists celebrated in Britain have secured a reputation beyond its shores or a position in the great histories of art. William Blake? Perhaps. Turner? Certainly. Henry Moore? Briefly. Francis Bacon? For sure. Bacon is a case in point, however, typical in the way that British artists who have succeeded internationally have tended to be seen as singular figures outside the dominant history of the art of their time.

Even now, the success of a British artist abroad – especially in Paris or New York – is hailed as hugely significant. From the reporting at home of Parisians' recent celebration of John Constable and William Hogarth one would think a great act of cultural injustice had been redressed. It was as if the British had managed to sell sparkling wine to Champagne. And Damien Hirst's first exhibition in New York was as nervously anticipated as The Beatles' first American tour.

Yet, by the end of the 20th century London could claim to have become the world capital of art. Its status was signalled by the opening – in the millennium year – of Tate Modern. The massive international and popular success of the new gallery revealed that the status of art within British culture had grown and with that shift came a change in the nature of galleries. A converted power station in a forgotten part of south London, Tate Modern attracted an audience that had not previously gone to art galleries. Young, fashionable, lower-middle-class, they behaved differently in its unusual spaces. The protocols and established values of the art museum were challenged. A rapid succession of small rooms was in contrast to the more serious spaces of the art museum. That and the abandonment of a chronological history of artistic development for something more open-ended and less prescribed suggested this was an art museum for a new, interactive, internet generation.

Showcase works in the gallery's massive Turbine Hall epitomized its position. Olafur Eliasson's *The Weather Project* (2003) simulated the sun and prompted hundreds of people to collaborate spontaneously by lying on the floor to create patterns that were reflected in the mirrored ceiling. Carsten Höller's *Test Site* (2006) invited visitors to ride down slides from the different floors of the gallery. The screams and laughter of the fairground were brought into the august atmosphere of the museum. For some, this piece of interactive art typified the shallowness of art and the museum at the time. For others, it demonstrated a new accessibility.

Naturally, Tate Modern is not an isolated phenomenon. It is the most visible indicator of a much wider artistic revival that has swept through London over the last 15 years. This situation reflected a new confidence in art itself but was rooted in economic and political change as well as artistic progress. In different ways it can be seen in both the public sector and in the private world of commercial dealers.

When New Labour finally displaced the Conservative government after 18 years, the youthful prime minister, Tony Blair, deliberately invoked memories of the 1960s, an era when Britain seemed at the forefront of radical technological and cultural innovation. That was the time when London really secured a modern and international art scene, although, of course, a commercial infrastructure for art and artists could be traced back to the 18th century at least.

The British art world had been slow to accept modernism. After World War Two there were only one or two commercial galleries showing abstract painting and sculpture. At the end of the 1950s, the arrival of Waddington Galleries and Marlborough Fine Art did a lot to professionalize artistic practice. In the 1960s, however, there was a great boom in galleries with, for example, the Kasmin Gallery showing the latest American artists and the dealer Robert Fraser being seen as intricately tied into the cultural mix

that became known as 'swinging London'. Though victim to the financial turmoils of the 1970s and '80s, the London art market remained significant and the modern was securely embraced.

In 2007, the government could claim the preceding decade of New Labour as a golden age for the arts. There had certainly been a huge capital injection, largely funded by the National Lottery (a Conservative Party invention), which had offset some of the chronic under-investment of the preceding 20 years. This affected all the arts and was nationwide but in the visual arts in London most public art galleries have had recent refurbishments or extensions: The National Gallery, the National Portrait Gallery, Tate Britain, The British Museum, The Hayward, the Barbican Art Gallery, Camden Art Centre and the Whitechapel Art Gallery. A new confidence in contemporary art is reflected in the fact that the exhibition programme of those spaces without collections is almost entirely of international contemporary artists while the contemporary is now an important part of pretty well all galleries and museums, including The National Gallery and The British Museum.

There are two fundamental reasons for London to have become, against all the odds, the great art capital of the early 21st century. Such a status could not be achieved without money. Nor could it have come about without the confidence of a clearly important, internationally validated art.

At the end of the 1980s a group of artists emerged whose innovative work, audacity and professionalism set them apart from their British predecessors and most of their international contemporaries. Many came out of the MA course at Goldsmiths College and were first brought together in a series of exhibitions held at Surrey Docks in 1988, known as *Freeze*. Few actually saw the exhibitions though they would become legendary as the markers of the emergence of a new generation of

internationally renowned artists such as Damien Hirst and Sarah Lucas. Suddenly London was abuzz with news of a new movement that included many artists not shown in *Freeze*, including Tracey Emin, Chris Ofili, Gillian Wearing and Rachel Whiteread. That excited vibe was fed, in large part, by the avaricious collecting of advertising mogul Charles Saatchi, who transferred his allegiance from blue-chip artists like Andy Warhol to this iconoclastic generation that came to be known as the YBAs – young British artists. Saatchi's first gallery, a converted factory in north London, provided a model for the *Freeze* exhibitions. Many have seen connections between Saatchi's advertising expertise and the almost unprecedented level of the YBAs' public profile. The title of a major exhibition of his collection, *Sensation*, signalled his intent, perhaps, and its notoriety was aided by public controversy over individual works on display – both in London and Brooklyn.

Saatchi and his brother were famous as the advertising agents for Margaret Thatcher's Conservative Party. Though her administration was largely philistine in its attitudes to art, she did prepare the ground for the artistic phenomenon that London would become. Liberal tax laws encouraged the hugely rich to settle in Britain and it only takes a small number of such people to participate in the art market for the effects to be felt. More importantly, the reinforcement of Britain as a financial centre and the growth of the City and of City salaries created a generation of financiers and consultants with enough disposable income to have a serious impact on art prices. At the same time, the activities of the artists themselves reflected the dominant culture of entrepreneurship.

As well as creating an enormously buoyant market, with some artists making fortunes, such huge levels of finance have affected the galleries and how they operate. Increasingly, commercial galleries have the confidence to act like the public sector – mounting non-selling exhibitions. Nowhere is the confidence of galleries and the

wealth that it is based upon better seen than at the annual Frieze Art Fair, housed every October in an architect-designed tent in Regent's Park. Such is the international success of Frieze that it has spawned a raft of events around it, not least the Zoo Art Fair. Unusually, it, too, has achieved popular success, as long queues for those without VIP invitations testify.

The Thatcher years also had a massive impact on the cultural geography of London. It has always been a city in which areas are constantly redefined. Yet one also sees continuity in the association of certain areas with particular activities. So the area of Mayfair around Bond Street has been an area for art galleries since the 19th century. Chelsea had been an area for artists since the Victorian period but by the 21st century only its arts club kept the association alive. More importantly, the 1980s saw the establishment of a gradual creep eastwards. Huge areas of the historic docklands along the Thames east of the City were covered with new housing and commercial outlets. Local resistance was fierce. The East End became increasingly an area for artists as cheap accommodation coincided with an unavoidable fashionability. This development had been anticipated in the 1960s, when Bridget Riley and others established SPACE studios in old warehouses at St Katherine's Dock. The boom in the financial sector that Thatcher oversaw stimulated huge, regenerative building projects such as those at Broadgate in the City and at the defunct docks at Canary Wharf. Both provided important opportunities for the installation of public sculpture.

Public sculpture at the end of the 20th century could seem to be an anomalous or anachronistic phenomenon. As entries in this book demonstrate, major building developments – mostly corporate – have often included high-profile sculpture commissions. In this they followed in a long tradition that had been especially strong in London in the era of modernization in the early to mid-20th century with such projects as the London Transport Headquarters and Broadcasting House. Increasingly,

however, the notion of permanence in the display of art was being displaced by change. The drive towards more dynamic museums and a belief that there was always more than a single history of art to be told led to regular re-hangs of collections, such as those of the Tate, which had once been permanent. Change and temporality extended into the sphere of public sculpture too. A long debate was held over the appropriate historic individual to be memorialized on the last vacant plinth in Trafalgar Square. That the era of such artistic veneration was over was signalled by the decision to occupy the Fourth Plinth with a series of temporary sculptures by artists including Bill Woodrow, Rachel Whiteread, Marc Quinn and Thomas Schütte.

Other regular public commissions from artists can be seen in Tate Modern's Turbine Hall from October each year, at Tate Britain and elsewhere, including occasionally the courtyard of the Royal Academy. Over the last 15 years, some of the most exciting commissions have been stimulated or supported by the organization Artangel. One that became a landmark piece for the artist and an eloquent comment on the city in transition was Rachel Whiteread's *House* (1993). Taking her casting of the spaces within or beneath objects to a new height, this was a concrete cast of the interior of an ordinary terraced east London house left after the street had been demolished. Set in a temporary wasteland, this residue of human occupation seemed a compelling and poignant memorial to transient communities. Nevertheless, despite protests, Whiteread's sculpture also succumbed to the wrecker's ball.

The state of British art and the British art world is now much harder to define than in the 1990s when Whiteread and her contemporaries were in the ascendant. As in any period, no doubt, it is too soon to try to characterize British art of the 21st century. Its internationalism is reflected in the cosmopolitanism of exhibition programmes in both public and commercial galleries. That an individual artist might work in a variety of media is firmly established. The term 'relational aesthetics' has secured a place in

discussions of art in Britain as elsewhere, referring to an art based on, prompting or actually producing types of human interaction; Liam Gillick is one of its prime practitioners. A form of neo-conceptualism has descended from the YBAs to artists like Nathan Coley. Abstraction is once again a dominant form in painting and sculpture with, for example, 2006 Turner Prize winning painter Tomma Abts referencing modernist forms and sculptors like Gary Webb echoing the playfulness of 1960s sculpture. As if in reaction to the drama of artists like Damien Hirst, there seems to be a fascination with the understated, the small, the ephemeral and the transient. Miniscule sculptures, fleeting videos and drawing have been popular.

What final historical patterns today's artists will form remains to be seen. The process will be played out in the studios, dealers' galleries and public spaces that are scattered across London. Along with a rich history of British and international modern art as seen through London's eyes, this book will help guide you around that shifting terrain.

Chris Stephens

A-Z of Artists

*Profiling some of the **modern, contemporary** and **emerging artists** to be seen on **London's current art scene**. Explore the extraordinary spectrum of talent and discover new names to add to your list of personal favourites. Highlighted names refer to locations and artworks listed in the Directory.*

Veeke (2005) acrylic and oil on canvas 48 x 38 cm

TOMMA ABTS was born in Kiel, (then West) Germany, in 1967. She works consistently to the same format in acrylic and oil paint, letting her paintings take shape without any preconceived image. Circles, triangles and dynamic rhomboids in muted colours predominate on intimate and yet compelling canvases that explore her own language of abstraction. Her paintings are contemplative and contained, reflecting a solitariness which invites one to one viewing; they are just big enough to command a presence on the wall, yet small enough to make you want to get up close. Like Piet Mondrian and Jackson Pollock, Abts works on her canvases laid flat, not at an easel or upright against the wall. She has shown at the ultra-cult Wrong Gallery in New York (it occupied nothing more than a Manhattan doorway), and at the Kunsthalle in Basle. Selected for her rigorous and consistent approach to painting, demonstrated particularly in her solo exhibitions at the Kunsthalle Basel and greengrassi, London, Abts won the Turner Prize in 2006 – the first woman to win the prize for painting. Tomma Abts has lived and worked in London since 1995. She keeps her private life separate – preferring that the art, not the personality of the artist, should be considered when viewing her work. She is represented by **greengrassi**.

The Door to Happiness (2005) acrylic and pencil
on archival museum board 29.7 x 21 cm

HALUK AKAKÇE was born in Ankara, Turkey, in 1970. Architecture, painting and moving images fuse in work which explores the relation between man and technology. He received a BFA in architecture at Bilkent University in Ankara and studied video and performance art at the school of the Art Institute of Chicago. In 1996 he received his MA Erasmus at the Royal College of Art, London. He takes us with him 'through the looking-glass' into his notion of the future, challenging our perceptions of time and space through his incorporation of both art-historical and futuristic references. The spectrum of his work defies category but, above all, he transmits a sense of hope. In talking about *Sky is the Limit* (2006) – an art work modelled on his interpretation of the city of Las Vegas – art critic Alex Farquharson suggests that Akakçe opens a view into 'a world of seemingly endless possibility where one may become anything simply by believing in its possibility'. His first exploration into photography was the shoot organized by close friend and mercurial fashionista the late Isabella Blow, in which he produced a series of couture photographs for *Tatler* magazine. His group exhibitions include the Shanghai Biennale in 2002 and *British Art Show 6*, at the Hayward Gallery in 2005. Haluk Akakçe lives in New York and London. His work is in **The Drawing Room**, the collections of **Tate** and the British Council. He is represented by **The Approach**.

After A Road to Rome II (2006) oil on canvas 150 x 188.4 cm

HURVIN ANDERSON was born in Birmingham, West Midlands, in 1965 to Jamaican parents. Working from photographic material rather than memory, Anderson constantly reworks the themes and images that interest him. He did his foundation in art course at Birmingham Polytechnic, followed by a degree in fine art at Wimbledon School of Art, achieving BA Hons in painting, and gained his MA in painting at the Royal College of Art. Anderson's inspiration and ideas evolve both from the time he spends in the Caribbean and in London. Conventional associations of lushness and the exotic interchange with pared-down imagery and palette, so a park in England might have the atmosphere of an oasis and the heat of a tropical island be glimpsed through security grilles or under a dull sky. 'The Caribbean is perceived as a centre for relaxation, but there's this undercurrent... an uneasiness,' he says, and it is this atmosphere he creates in his part-abstract, part-landscape, part-figurative paintings. He was the 2006 artist-in-residence at Dulwich Picture Gallery, creating new works inspired by paintings in the collection. Hurvin Anderson lives in London. He is represented by **Thomas Dane Gallery**.

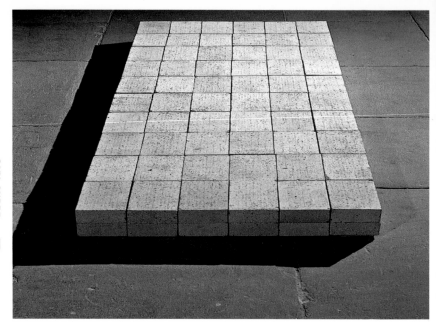

Equivalent VIII (1966) firebricks 229.2 x 68.6 x 12.7 cm

CARL ANDRE was born in Quincy, Massachusetts, USA, in 1935. One of the leading members of the minimalist movement, his work consistently displays that aesthetic, as well as influences from Russian constructivism and Constantin Brancusi. He travelled for a year – to England and France in 1954. Back in New York, in a studio he shared with Frank Stella, he started creating wood sculptures with an apparent simplicity, relying on inherent gravity instead of adhesives and joints. At around this time he created poems in the tradition of Concrete Poetry, displaying words on the page as though they were drawings. His spell working for the Pennsylvania Railroad in New Jersey may have increased his attraction to the grid format evident in much of his work and to industrial materials – monumental chunks of granite and the large steel plates used in ship building. He travelled to Stonehenge in England one summer and those colossal stone slabs also left a strong impression on his artwork. In England, his most controversial piece was *Equivalent VIII* (above). Consisting of 120 fire bricks arranged in two layers, it was bought by the Tate Gallery in 1976 to an outcry about misspent public money – such was the public appreciation (or not) of this minimalist installation. It remains in **Tate**. Carl Andre lives and works in New York. **Sadie Coles HQ** represents much of his work in London and also has books on the artist.

Primrose Hill (1954) oil on canvas 90 x 117 cm

FRANK AUERBACH was born in Berlin, Germany, in 1931 and sent to England in 1939 to escape the Nazis. He prefers to belong to no school, though he has been linked to the School of London, along with his friends Leon Kossoff, Lucian Freud, Francis Bacon and R.B. Kitaj. He took evening classes at Borough Polytechnic under the tutelage of David Bomberg, attended St Martin's School of Art, and graduated at the Royal College of Art. In 1956 he held a one-man exhibition at Beaux Arts Gallery in London. He was stirred as a child by a black and white reproduction of J.M.W. Turner's painting *The Fighting Temeraire* and it is interesting to trace those early influences. He works intensively, his art and life intertwined. His paintings have a raw, vivid energy, achieved in part by his characteristic use of thick, slashed paint and the speed with which it is applied. His medium is mostly oil and charcoal but with later explorations into acrylic. He represented Britain at the Venice Biennale in 1986, winning a Golden Lion, and in 2002 the Royal Academy mounted a retrospective. Frank Auerbach lives and works in north London. His work can be seen in Tate and the Ben Uri Gallery. He is represented by Marlborough Fine Art, and can also be seen at Bernard Jacobson Gallery, Robert Bowman Modern, Hazlitt Holland-Hibbert, James Hyman Gallery, Austin/Desmond Fine Art, Crane Kalman Gallery and Offer Waterman & Co.

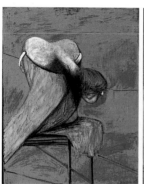

Three Studies for Figures at the Base of a Crucifixion (1944) oil on board 94 x 73.7 cm (each support)

FRANCIS BACON was born in 1909 in Dublin to English parents, the second of five children. His father was a military man and the family lived in London through World War One and then moved between the two cities. Throughout his life, Bacon struggled with themes of revulsion and loneliness – echoed uncompromisingly in his visceral, figurative paintings. Discovering the nightlife of Berlin on a visit in 1927 opened his eyes to the appeals of hedonism and decadence, a keen contrast to his conventional Irish upbringing. His 'education' continued in Paris later that year, where Picasso's depiction of figures also had a profound and lifelong effect on him. Bacon never attended art school, but back in London he worked as an interior designer and started to produce oil paintings influenced by surrealism and cubism. His *Crucifixion* (1933) was published in Herbert Read's *Art Now* but he considered his first mature work to be *Three Studies for Figures at the Base of a Crucifixion* (above), which sealed his reputation as one of the most powerful, disturbing painters of the 20th century. Francis Bacon remained loyal to the Marlborough Gallery, whom he joined in 1958, until his death in Madrid in 1992. His work is in **Tate** and the Arts Council collection. His estate is represented by **Faggionato Fine Art**. Paintings can be seen at **Gagosian Gallery**; prints are available at **Marlborough Fine Art** and **Sims Reed Gallery**.

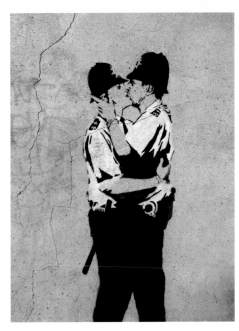

Kissing Policemen (2005)

BANKSY was probably born Robert Banks (although no one is quite certain) in Bristol in 1974 (ditto). Uncertainty and anonymity surround the identity of this skilled tame anarchic, the antithesis to celebrity artist. His street art, combining graffiti with a distinctive stencilling technique, includes topics taken from politics (anti-war, anti-capitalist, pro-freedom), culture (anti-establishment) and social satire. His work as a 'streety' has appeared in London and cities around the world. In August 2004 he produced a quantity of spoof British £10 notes substituting Princess Diana's head for the Queen's and changing 'Bank of England' to 'Banksy of England'. Individual notes have since sold on eBay for about £200 – such is his 'collectability'. And in February 2007 the owners of a house in Bristol with a Banksy mural on its side decided to sell through an art gallery after offers fell through because the buyers wanted to remove the mural. It was listed as 'a mural which comes with a house attached'. The Banksy 'Maid' painted on the side of **White Cube Hoxton Square** is still faintly discernible, although rubbed out. But such is the (considerable) reversal in his fortunes that council workers in London are now occasionally found saving and re-painting his work – rather than obliterating it. Represented by **Lazarides**, his work can also be found at **Elms Lesters** – and can appear anywhere, anytime! Prints are available; contact the galleries.

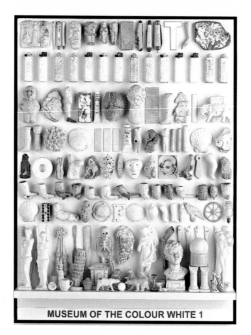

MUSEUM OF THE COLOUR WHITE 1

Museum of the Colour White 1 (1995) mixed media
83.2 x 62.9 x 10.2 cm

PETER BLAKE was born in Dartford, Kent, in 1932. Painter, collagist and illustrator, he is best known as a pioneer of pop art. His early work included images of children, happily reading comics or displaying other symbols of their youth. A contemporary of Joe Tilson and Richard Smith at the Royal College of Art in 1956, in the 1960s he became a central figure in British pop art, mixing imagery from contemporary popular culture and Victoriana. One of the most celebrated examples of his work was the record cover for The Beatles' *Sgt. Pepper's Lonely Hearts Club Band* (1967), which he designed with his then wife, Jann Hawarth. They moved to the west of England for ten years, where they co-founded the Brotherhood of Ruralists (1975). In 1994 he was made the third associate artist of the National Gallery, London, and in 1998 he received an honorary doctorate from the Royal College of Art. Still working hard in his studio in London, Peter Blake describes himself as a 'barmy collector'. His assemblages (above is the first in a series) are composed of panels on which he places collections of wood, stone, paper, found objects, mementoes of family holidays, moments with friends and walks on the beach. His work was central to *Pop Art Portraits*, a major international exhibition at the National Portrait Gallery (2007-08), and can be seen at Tate and the National Portrait Gallery. He is represented by Waddington Galleries.

Coronation (1996) wood and steel 156 x 135 x 135 cm

ANTHONY CARO was born in New Malden, Surrey, in 1924. Bold colours and powerful abstract forms in steel are hallmarks of his ground-based works. He introduced the practice of creating sculpture that rested directly on the ground without a pedestal or support in Britain. His early table-top sculptures are not maquettes but 'sculptures in their own right with reference to the table edge'. He attended the Royal Academy Schools in London and, while there, started working as a part-time assistant to Henry Moore. In 1960 (after a visit to the USA in 1959) he made a radical break from his bronze cast sculptures of the human form to concentrate on abstract, steel sculpture which drew on his early training as an engineer. Much of his work follows the route of composition in action, evolving without maquettes or preliminary drawings. Anthony Caro himself has likened the process to that of a musical composer who adds one note to another. He continues with the vigour of earlier years to produce work from his industrial-scale workshop and studio in Camden Town. He collaborated with architect Norman Foster on the *Millennium Footbridge* over the Thames at Bankside, effectively linking Tate Modern to St Paul's Cathedral. His work is in **Tate** and in the grounds of West London College, Ealing. He is represented by **Annely Juda Fine Art** and can also be seen at **Offer Waterman & Co**. **Bernard Jacobson Gallery** holds edition prints.

Sue Ware Jar (1989) acrylic on board 77.5 x 52.1 cm

PATRICK CAULFIELD was born in London in 1936. After leaving school, he worked for the food company Crosse & Blackwell, where one of his jobs was varnishing chocolates for display. He trained at Chelsea School of Art, then at the Royal College of Art, and soon became associated with the pop artists of the 1960s. A signature style of brightly coloured, seemingly trivial subjects and impersonal interiors delineated in thick black outline characterizes much of his work, but he was reluctant to be locked in to any movement or ism. So much so that in some pieces he adopted several different styles. His interiors are mostly unpopulated and, despite their wit and colour, evoke an atmosphere that is at times melancholic, as though people have left hurriedly. He exhibited at the influential *New Generation* show at the Whitechapel in 1964 and had his first solo exhibition at Robert Fraser Gallery, London, in 1965 (then the hippest gallery in town). A major retrospective organized by the British Council was shown at the Hayward Gallery in 1999, and toured to Luxemburg, Lisbon and New Haven, Connecticut. Patrick Caulfield was joint winner of the Jerwood Painting Prize in 1995. He died in 2005. His work is in many collections, including **Tate** and the Chelsea & Westminster Hospital. Represented by **Waddington Galleries**, he can also be seen at **Bernard Jacobson Gallery**. **Alan Cristea Gallery** holds original prints.

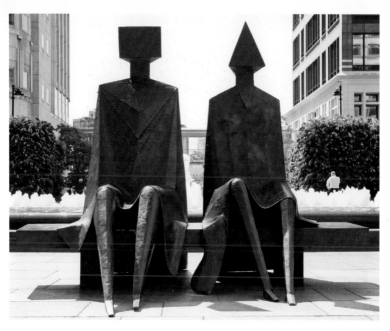

Couple on Seat (1984) bronze

LYNN CHADWICK was born in London in 1914. Chadwick's fascination with figurative and animal forms, already present in his early work with mobiles and in the animalistic sculptures of the 1950s, continued throughout his career. Following his training as an architectural draughtsman, he worked as a furniture and textile designer before devoting himself fully to sculpture, concentrating initially on the construction of sculptural mobiles made of metal, aluminium and balsa wood. His working method involved building a metal skeleton which he filled with materials to create a solid sculpture. Throughout his career, he drew upon the natural world. From the 1960s his sculptures were largely based on the human figure, characterized by spiky angular forms. He was awarded the International Prize for Sculpture at the Venice Biennale in 1956. In 2003, Tate Britain gave him his first London retrospective, showing over thirty works spanning his career. Sadly Lynn Chadwick had died in April, five months before the exhibition opened. *Couple on Seat* (above) is at Canary Wharf. His work is also in the collections of **Tate** and the Arts Council. It can also be seen in numerous galleries, including **Beaux Arts**, **Osborne Samuel**, **James Hyman Gallery**, **Dominic Guerrini** and **Offer Waterman & Co.**

Zygotic acceleration, Biogenetic de-sublimated libidinal model (enlarged x 1000) (1995)
mixed media 150 x 180 x 140 cm

JAKE AND DINOS CHAPMAN Dinos was born in London in 1962 and Jake in Cheltenham in 1966.
The brothers enrolled at the Royal College of Art, both graduating in 1990. As conceptual artists working
almost exclusively in collaboration, they first received critical acclaim in 1991 for a diorama sculpture
made of remodelled plastic figurines enacting scenes from Francisco Goya's *Disasters of War* etchings.
Part of the YBA 'movement' promoted by advertising mogul Charles Saatchi, they had their first solo
exhibition at the Institute of Contemporary Arts in 1996. The most ambitious piece was arguably an
apocalyptic sculpture entitled *Hell*, depicting 30,000 5cm-high male figures, many in Nazi uniform on a
table-top tableau in the shape of a swastika. The work was destroyed in a warehouse fire in 2004 and
they are rebuilding it, says Dinos, as 'a newer, improved hell – bigger and brighter'. The brothers maintain
that the 'fetishizing' of artists is overplayed; it is the art that is important – not the celebrity status. Artists
are simply part of a historical chain of influence and development. The notion is borne out in their work:
children's colouring books as well as old masters (Goya, Blake, Rodin and Poussin) can be a starting
point. The Chapmans work in east London. Their work is at **Tate**. They are represented by **White Cube**,
and can also be seen at **Andipa Gallery** and **Pollock Fine Art**. **Paragon Press** has prints.

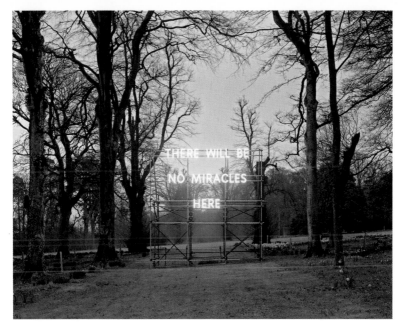

There Will Be No Miracles Here (2006) scaffolding and illuminated text 6.3 x 6.3 x 4 m

NATHAN COLEY was born in Glasgow in 1967. His installation work is architecturally oriented. He graduated from Glasgow School of Art in 1989 with a BA in fine art. In 2001 he won a Creative Scotland Award, and in 2002 he was an unofficial artist-in-residence at The Hague for the Lockerbie bombing trial. In 2004 he staged an exhibition in Edinburgh, *Lamp of Sacrifice*, with cardboard models of the 286 places of worship he found in the Edinburgh *Yellow Pages* phone book. He questions and explores the way society relates to architecture and public places, identifying with 19th-century artist and academic John Ruskin's view that architecture is distinguished from mere building by the level of personal and financial sacrifice invested in it. The 6m-high installation (comprising scaffolding and illuminated text), shown here on the Mount Stuart estate, Isle of Bute, was one of the works that led to his Turner Prize nomination in 2007. In September 2006 the installation had been among many international artists' work reproduced at the Bethlehem Peace Centre in a groundbreaking exhibition by two British curators, Charles Asprey and Kay Pallister. The words were drilled into the walls of the building: a fitting statement by an artist exploring the relationship between society, art, architecture and public places. Nathan Coley lives and works in Glasgow. He is represented in London by **Haunch of Venison** (in Scotland by doggerfisher).

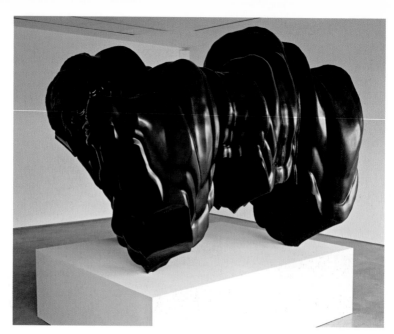

Discussion (2005) bronze 170 x 190 x 240 cm

TONY CRAGG was born in Liverpool in 1949. He is a central figure in the New British Sculpture Group, a band of avant-garde sculptors (including Richard Deacon, Julian Opie, Richard Wentworth and Bill Woodrow) who came to prominence in the 1980s. He was a laboratory technician with the National Rubber Producers' Association in the mid to late 1960s, and this has had a lasting influence on his work. He enrolled at Wimbledon School of Art and attended the Royal College of Art. He taught at École des Beaux-Arts, Metz, and in 1977 moved to Wuppertal, (then West) Germany, teaching at the Kunstakademie in Düsseldorf from 1978. Nature and the state of the environment are constant themes in Cragg's work; he sees our environmental problems as 'just one by-product of our lack of respect and understanding towards the world we live in'. He continues to experiment with different materials, ranging through the discarded objects of society as well as traditional ones such as bronze, steel, plastic, rubber, glass, wood and plaster. Cragg was first nominated for the Turner Prize in 1985, for his contribution to the Hayward Annual of the same year; he won in 1988 for his exhibition as the British representative at the Venice Biennale. Tony Cragg lives in Wuppertal. His work is in the collections of **Tate**, **Saatchi Gallery** and **Deutsche Bank** (*Secretions*, 1998). He is represented by **Lisson Gallery**.

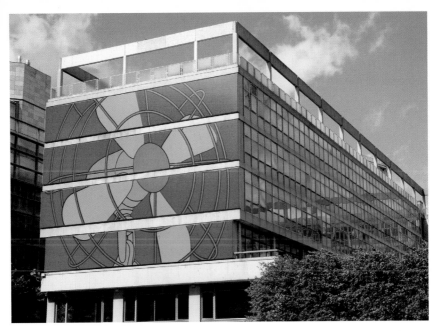

Big Fan (2002)

MICHAEL CRAIG-MARTIN was born in Dublin in 1941, but grew up and was educated in the USA, studying fine art at Yale University School of Art and Architecture. A then recent teacher at Yale, Josef Albers, became his inspiration. Craig-Martin moved to Britain in 1966, once his studies were complete. His first solo exhibition was at the Rowan Gallery, London, in 1969 and his work has attracted high interest ever since. The influences of his early life and education, combined with his capacity for irony and keen observation of everyday objects, underlie some of the thinking behind his distinctive work in murals, prints, computer works and installations. His first outdoor commission, *Big Fan* (above), was constructed as a four-panel lightbox; pulsating pink, blue, orange and green counterpoint the blandness of a city square. At night the vibrant colours take on even greater intensity. It is characteristic of his work that he can transform an ordinary object, like a fan, into an icon. He advised on colour in the Laban Centre for Movement and Dance, in Deptford, and designed the painting that circles the outer wall of its auditorium. Michael Craig-Martin lives in London. His *Swiss Light* (2000), the light feature that caps **Tate Modern's** tall chimney, is visible for miles at night, and there are a mural and a glass etching at Saint Alban restaurant, St James's. He is represented by **Gagosian Gallery**, and **Alan Cristea Gallery** holds prints.

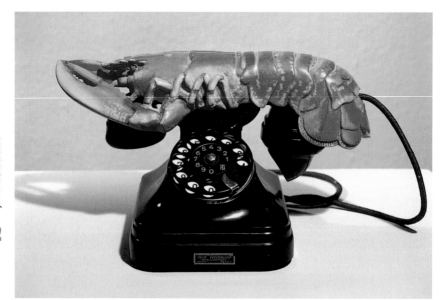

Lobster Telephone (1936) plastic, painted plaster and mixed media 17.8 x 33 x 17.8 cm

SALVADOR DALÍ was born in Figueras, Catalonia, Spain, in 1904. He was a painter, sculptor, engraver, illustrator, film collaborator – and one of the Paris surrealists. It was while studying at the Real Academia de Bellas Artes de San Fernando in Madrid in the early 1920s that he became interested in cubism and futurism, and in the work of Giorgio de Chirico, with whom he shared a poetic philosophy based on ideas promoted by Nietzsche. By 1926 he was one of the leaders of a group of Madrid intellectuals which included the writer Federico García Lorca and the filmmaker Luis Buñuel. In 1928 he wanted to see Picasso in Paris and, in typical style, chose to travel by taxi all the way from Madrid. He was warmly received by the surrealists and from then on his mature style and talent were apparent. In 1934 he had his first one-man show in Britain, at Zwemmer Gallery. He made *Lobster Telephone* (above) for Edward James, a British collector and enthusiastic patron of surrealist artists in the 1930s. Salvador Dalí later lived in the USA (1940-48), in Spain and again in Paris, before finally returning to settle in Spain in 1981, where he died in 1989. His work is in **Tate**, and in *Dalí Universe* at County Hall Gallery, with more than five hundred pieces on permanent exhibition (including sculpture, drawings and lithographs); outside is one of his famous ripe-camembert-inspired clock sculptures, *Nobility of Time*.

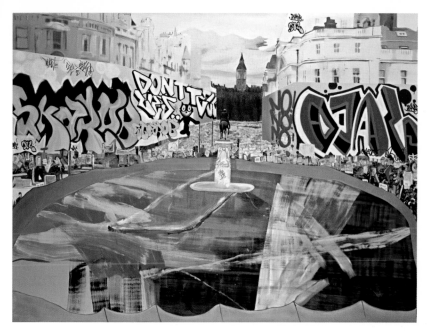

The Poll Tax Riots (2005) oil on canvas 250 x 340 cm

DEXTER DALWOOD was born in Bristol in 1960. He received a BA at St Martin's School of Art and an MA at the Royal College of Art before his first solo exhibition at the Clove Building, London, in 1992. His paintings during the late 1980s and '90s were figurative, often based on his travels in India. In 1998, Dalwood exhibited the paintings *Sharon Tate's House, Paisley Park, Laboratoire Garnier* and *Apollo 12* in a critically acclaimed show of new British art, *Die Young, Stay Pretty* at the Institute of Contemporary Arts. The following year, paintings including *The Queen's Bedroom* and *Studio 54* were shown at the Saatchi Gallery in London. This much publicized exhibition, *Neurotic Realism: Part Two*, aimed to demonstrate the changed character of the British art scene, and revealed Dalwood as a major talent within it. His work uses images – or imaginings – of the interiors of the homes of the rich and famous as well as historical happenings, including the poll-tax riots in London (above). By the end of the 1990s his work included art-historical references, and focused more on political, rather than celebrity, environments. Still based on fantasy spaces constructed from simple collage, he draws parallels between the cult status of art and political movements. Dexter Dalwood lives and works in London. His work is in the **Saatchi Gallery** collection. He is represented by **Gagosian Gallery**.

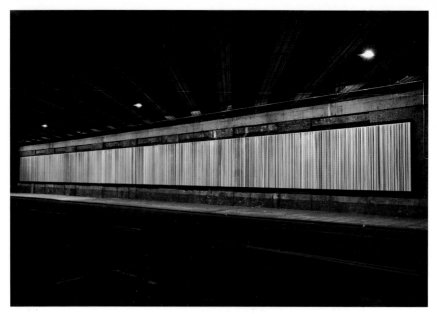

Poured Lines Southwark Street (2006) fluid enamel on metal 2.9 x 50 m

IAN DAVENPORT was born in Sidcup, Kent, in 1966. He studied painting, graduating from Goldsmiths College in 1988. In the same year, he participated in *Freeze*, the exhibition curated by Damien Hirst. Using industrial paints in bright electric colours, he pours the paint from a container with a pouring lip which he guides by hand, building up the layers to achieve the effect he wants and finishes with a marine varnish. He was shortlisted for the Turner Prize in 1991 on the basis of his ability to demonstrate 'the expressive possibilities of abstract paintings', as seen in his debut exhibition at Waddington Galleries. His passion for gloss stripes runs through his work; he covered a whole wall of Tate Britain with hypnotic lines of rainbow hues for the *Days Like These* exhibition in 2003. He exhibits extensively – Modern Art Oxford, Tate Liverpool, Museo Nacional Centro de Arte Reina Sofia (Madrid), The Box Association (Turin), Galerie Xippas (Paris) – and regularly at Waddington Galleries in London. For *Poured Lines Southwark Street* (above) he used fluid enamel on metal panels fired at very high temperatures. It took two years to create, and is sited in an underpass beneath the rail tracks leading across the river to Blackfriars station. Ian Davenport lives and works in London. He is represented by **Waddington Galleries**, and prints are available at **Alan Cristea Gallery**.

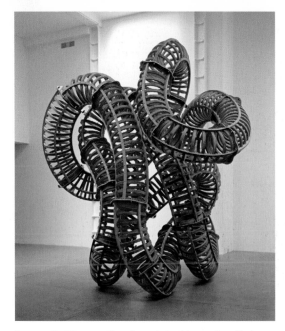

Laocoon (1996) steamed beechwood, aluminium and steel bolts
430 x 364 x 357 cm

RICHARD DEACON was born in Bangor, Gwynedd, North Wales, in 1949. He is a sculptor who creates both large- and small-scale work, manipulating material in many different ways to explore innovative forms. He studied at St Martin's School of Art, the Royal College of Art and the Chelsea School of Art. His first solo show was held in 1975 at the Royal College of Art gallery. After a stay in the USA (1978-79), he returned to Britain to become a central figure in the New British Sculpture Group in the 1980s. Skeletal forms such as *Laocoon* (above) make space itself part of the work, and diverse materials – wood, metal, leather, polycarbonate, used singly or in combination – are frequently pieced together with rivets, screws and bolts. From 1981 with *If the Shoe Fits*, he started titling his work, inspired in part by his interest in the German poet Rainer Maria Rilke. In 1987 he was awarded the Turner Prize for his touring exhibition *For Those Who Have Eyes*. More recently his work with materials has extended to clay, and in *Range*, shown at Lisson Gallery in 2005-06, he explored hand-built, thrown and carved forms. Richard Deacon lives and works in London, and lectures at the École des Beaux-Arts in Paris. His work is in the collections of the British Council, Arts Council of England, Government Art Collection and **Tate**. He is represented by **Lisson Gallery**.

Starfield Dandelion (2003) unique Ilfochrome print 61 x 51 cm

SUSAN DERGES was born in London in 1955. She studied painting at Chelsea College of Art, in Berlin on a DAAD scholarship and at the Slade School of Fine Art. She gained her first successes in Berlin, Japan and Poland, where she had solo exhibitions before her first solo show in Britain. She lives in Devon and has become associated with the River Taw, where many of her now famous photograms (photographs made without a camera) are created. She explains: 'They are made at night, when the landscape is dark enough to take light sensitive paper to the river in order to submerge it beneath the surface of the water. The traces of my own presence [and] of others involved in the making, along with ambient moonlight and other illuminations, merge with the many imprints carried in the water.' Her work was included in the 1978 Hayward Annual and in exhibitions at the Photographers' Gallery (1993 and 1995), the Victoria & Albert Museum (1998) and the Science Museum (2002). It is held in collections at the **Victoria & Albert Museum**, the Arts Council and **Deutsche Bank**. She is represented by **Purdy Hicks Gallery**.

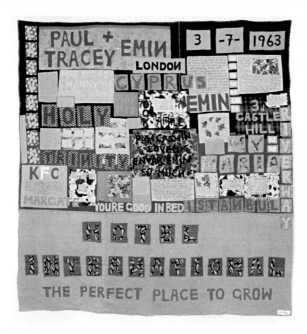

Hotel International (1993) appliqué quilt 257 x 240 cm

TRACEY EMIN was born in London in 1963 and grew up in Margate, a seaside town on the coast of Kent. Famous for being Tracey Emin the artist as well as the work she produces, Emin studied at Maidstone College of Art and for an MA in painting at the Royal College of Art. In 1993 she opened The Shop in the East End of London with fellow artist Sarah Lucas, selling work by both of them. Later she ran her own gallery – the Tracey Emin Museum (1995-98). A prominent member of the YBAs, she had caught the attention of Charles Saatchi, who bought and exhibited her work, launching her colourful career. A childhood and adolescence of abuse and confusion shapes her confessional art, drawing on intimate experiences in her life. Her most famous work includes two installation pieces: a tent embroidered with the names of all the people she had shared a bed with since birth; and the unmade bed, *My Bed*. She was nominated for the Turner Prize in 1999 (won that year by Steve McQueen). In 2007 she represented Britain at the Venice Biennale. Tracey Emin lives and works in the East End of London. Her work is in the collections of **Tate**, the **Victoria & Albert Museum**, **Saatchi Gallery**, the Arts Council, **The Hayward** (Waterloo Sunset Pavilion) and **South London Gallery**. She is represented by **White Cube**, where prints are available, and **Gagosian Gallery**.

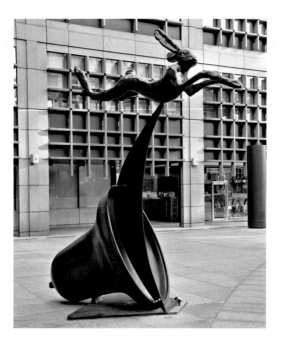

Leaping Hare on Crescent & Bell (1988) bronze

BARRY FLANAGAN was born in Prestatyn, Powys, North Wales, in 1941. He first studied architecture and sculpture in Birmingham before enrolling in the sculpture course at St Martin's, where he was a student of Phillip King. He experimented in different artistic fields, including the use of traditional sculptural materials and techniques. After the rigorous lines of minimalism, his interest turned to creating organic forms in a range of materials. He held his first solo exhibition at the Rowan Gallery, London, in 1966, and in the same year was included in the touring international exhibition *When Attitudes Become Form*, shown in London at the Institute of Contemporary Arts. In 1979 he made a leaping hare, a subject he has returned to often over the years, creating bronze hares in various poses. In 1982 he represented Britain at the Venice Biennale. Barry Flanagan lives in Dublin. His work is in the collections of the Arts Council, British Council, **Tate** and **Victoria & Albert Museum**, as well as in the Government Art Collection and Phoenix Community Garden in Camden (a privately managed membership garden which can be visited by arrangement); examples of his public art include *Leaping Hare on Crescent & Bell* (above), Broadgate, and *Camdonian* in Lincoln's Inn Fields. He is represented by **Waddington Galleries**.

Minutes to Live (2005) ink on paper on board 100 x 88 cm

MATT FRANKS was born in Yorkshire in 1970. He attended a foundation course in art and design at Hull School of Art, gained a BA Hons in fine art at Staffordshire University and a MA in fine art at Goldsmiths College. Drawing on references from high art and popular culture, he is one of a new generation of British sculptors transforming mass-produced industrial plastics and throw-away material into extraordinary, humorous and seemingly bizarre pieces. Shock waves of colour, material and imagery – incorporating both figures from art history, including the Italian baroque sculptor Bernini, and popular cartoons such as the Simpsons and the comics of Robert Crumb – refer to, and parody, the large-scale, colourful abstract sculpture that appeared in Britain in the 1960s, by artists such as Anthony Caro and Phillip King. In 2001 he won the British Council Individual Artists Award and in 2002 he was included in Tate Britain's *Art Now* programme. His work was selected for inclusion at the 2007 ARTfutures exhibition curated by the **Contemporary Art Society** at Bloomberg SPACE. Matt Franks lives and works in London. He is represented by **Houldsworth Gallery**.

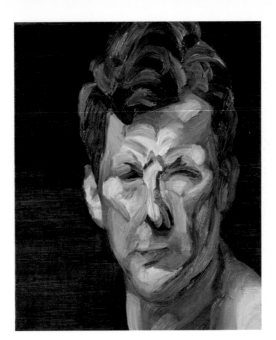

Self Portrait (1963) oil on canvas 30.5 x 25.1 cm

LUCIAN FREUD was born in Berlin in 1922. A grandson of Sigmund Freud, he came to England with his family in 1933. He attended Dartington Hall School in Devon, Bryanston School, the Central School of Art in London and Goldsmiths College. His first solo exhibition was in 1944 at the Lefevre Gallery and featured an early brush with surrealism, *The Painter's Room* (private collection). A friend of Frank Auerbach and Francis Bacon, Freud is associated with the School of London. His visceral approach to representing people translates into paintings of gritty realism: 'I paint people not because of what they are like, not exactly in spite of what they are like, but how they happen to be.' His subjects are often friends, family, fellow painters, lovers, children. 'The subject matter is autobiographical, it's all to do with hope and memory and sensuality and involvement really.' Lucian Freud lives and works in London. His work is in numerous collections, including **Tate**, the Wallace and the **National Portrait Gallery** (including *Self Portrait*, above). It can also be seen at **Marlborough Fine Art**, **Browse and Darby**, **Jonathan Clark Modern British Art**, **Faggionato Fine Art**, **Hazlitt Holland-Hibbert**, **James Hyman Gallery**, **Timothy Taylor Gallery**, **Austin/Desmond Fine Art** and **White Cube**.

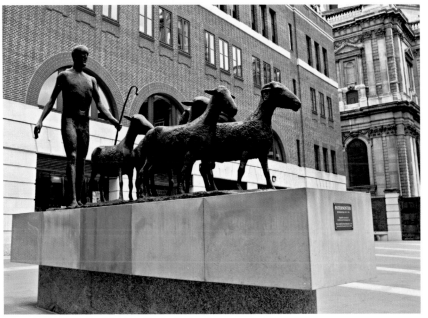

Shepherd and Sheep (1975) bronze 3.23 x 1.25 x 5.6m (including plinth)

ELISABETH FRINK was born in Thurlow, Suffolk, in 1930. Sculptor and printmaker, her central themes were the relationship between men and animals (for example, in her famous horse and rider prints), birds (especially birds of prey) and animals. She was not concerned with simply reproducing the appearance of things – what counted was capturing the spirit. She studied at Guildford School of Art and Chelsea School of Art. Primarily known for her sculpture, she modelled in clay and then cast and carved in plaster and bronze. Like many sculptors, she was attracted to printmaking, working with Curwen Studio over many years to produce lithographs and screenprints. While living in France (1967-70), she began a series of monumental male heads wearing goggles. Back in England, she concentrated on the male nude. 'I have focused on the male because to me he is a subtle combination of sensuality and strength with vulnerability,' she said. *Shepherd and Sheep* (above) was commissioned for Paternoster Square (once the site of a livestock market) near St Paul's Cathedral, in 1975, and given a new plinth after the square was redeveloped. Elisabeth Frink died in 1993. Other examples of her public art include *Horse and Rider* in Dover Street and the *Four Season* reliefs (1961) at Carlton Tower Hotel, Knightsbridge. Her work is also to be found at **Beaux Arts**, **Browse and Darby**, **Dominic Guerrini** and **Mumford Fine Art**.

Right Slant (2003) acrylic and collage on canvas 82.6 x 106.7 cm

TERRY FROST was born in Leamington Spa, Warwickshire, in 1915. Widely regarded as an important post-war British abstract artist (using both paint and collage), his work is characterized by regular forms in bright and boldly contrasting colours. He first began to paint as a prisoner of war in Germany in 1943. Returning to England, he received an ex-serviceman's grant and attended Camberwell School of Art. His career took shape in the 1950s, when he moved to Cornwall and became part of the St Ives School, which included the painters Ben Nicholson, Patrick Heron, Roger Hilton, Peter Lanyon and the sculptor Barbara Hepworth. In the late 1950s he divided his time between St Ives and Leeds, where he taught at the university. Abstract expressionism was emerging in the USA and influences were beginning to flow both ways across the Atlantic. Frost's intention in evaluating any subject was to convey the 'total experience'. Arrangements of form and colour evoked for him a particular feeling and it was that – more than the subject itself – he wanted to capture. Terry Frost died in 2003. His work is in the collections of the **British Museum**, **Tate**, **Victoria & Albert Museum** and at the Chelsea & Westminster Hospital, Fulham Road. It is also found in many galleries, including **Beaux Arts**, **Austin/Desmond Fine Art**, **Caroline Wiseman Modern Art** and **Martin MacLeish**.

Revolving Torsion, Fountain (1972) steel
309.9 x 335.3 x 335.3 cm

NAUM GABO was born in Bryansk, Russia, in 1890. His real name was Naum Pevsner and he was the younger brother of the artist Antoine Pevsner. His interest in art took root in extra-mural studies while he was studying medicine and natural sciences in Munich. In 1912 he went to Italy to see art treasures and to Paris to visit his brother, who introduced him to cubism and his fellow artists. At the outbreak of war, Antoine joined Naum in Oslo. It was here, in 1915, that Naum made his first constructions, signing them 'Gabo'. The brothers returned to Russia, proclaiming their constructivist programme, though it soon became clear that Russia at that time was not interested in their politics in particular or abstract art in general. Gabo left the USSR, lecturing at the Bauhaus in 1928 before taking himself and his new ideas to England. He lived in Cornwall for seven years, close to Barbara Hepworth, Ben Nicholson and Peter Lanyon. In 1946 he moved to the USA, becoming a US citizen in 1962. Naum Gabo died in Connecticut in 1977. *Revolving Torsion, Fountain* (above), in the grounds of St Thomas's Hospital, was restored in 1987 by the hospital trustees and the Tate Foundation. Other examples of his work are in **Tate**. It is also found at **Annely Juda Fine Art**, **Hazlitt Holland-Hibbert** and **Offer Waterman & Co**; **Alan Cristea Gallery** has prints.

Fates (2005) 426 x 760 cm

GILBERT & GEORGE Gilbert Proesch was born in Italy in 1943. He studied at the Wolkenstein School of Art and Hallein School of Art (both Austria), and the Akademie der Bildenden Künst (Munich). George Passmore was born in Devon in 1942. He attended Dartington Hall College of Art, where a tutor suggested he enrol at St Martin's School of Art. It was here, in 1967, that he met Gilbert. They have lived and worked in east London since 1968. When they moved to the then working-class neighbourhood of Spitalfields, they were making a statement about what they perceived as art's elitism, declaring their house to be Art for All. Their early work was performance based. Calling themselves 'living sculptures', they were identified not least by their matching suits and bronze make-up. But from the early 1970s they exhibited in prestigious galleries: Anthony d'Offay (London), Sonnabend (New York) and Konrad Fischer (Düsseldorf). In 1986 they won the Turner Prize, for an exhibition at the Guggenheim, New York, and a major European touring show. Their work, identified largely by colourful photo-based collages on black grids, deals with challenging subjects (sexuality, social dysfunction, bodily fluids and wastes) and, more recently, life and death. Their aim: to 'bring about new understanding, progress and advancement'. Their work is in **Tate** and **Hayward** (Waterloo Sunset Pavilion). They are represented by **White Cube**.

Home Office façade (2003-05) glass and bonded coloured acrylic film

LIAM GILLICK was born in Aylesbury, Buckinghamshire, in 1964. As both a literal and visual artist, Gillick's responses to social and environmental concerns are embodied in his work. He considers how different materials, structures and colour influence our behaviour – often through the use of perspex panels in sweet-wrapper colours to highlight his diverse planes of thought. He studied art at Hertfordshire College of Art and Goldsmiths College, gaining a BA Hons. For his first solo exhibition in London, at the Karsten Schubert Gallery in 1989, Gillick used a computer programme to devise a series of architectural-style drawings, deliberately making them functionally inaccurate. His work was included in the Tate Britain exhibition *Intelligence: New British Art 2000*. In 2002 he was shortlisted for the Turner Prize, cited for his solo exhibition *The Wood Way* at the Whitechapel Art Gallery and his outdoor installation *Annlee You Proposes* at Tate Britain. (The prize that year was awarded to Keith Tyson.) Liam Gillick lives and works in London and New York. Apart from his commission for the façade of the Home Office building (above), in Marsham Street, his work is in Tate, and he produced a series of prints for the Hayward exhibition *How to Improve the World* (2006), on sale at the gallery bookshop. For information, contact Corvi-Mora.

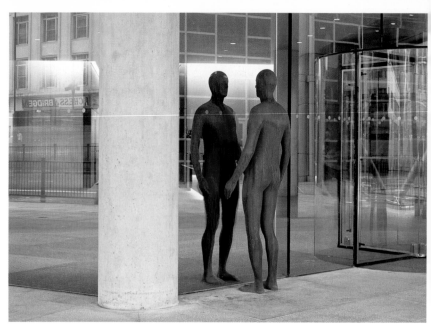

Reflection (2001) cast iron

ANTONY GORMLEY was born in London in 1950. After studying anthropology at Cambridge University, he travelled in India and considered becoming a Buddhist monk. He returned instead to London in 1974, to study at the Central School of Art, Goldsmiths and the Slade. His art is all about the human form in space and social landscapes, and in particular his own tall body, which he often casts in plaster to create his sculptures. In 1994 he won the Turner Prize for his work *Field*, an expanse of 40,000 miniature terracotta figures. His ambitious large-scale human-form sculptures have been commissioned for site-specific installations and community projects. He is best known in Britain for *Angel of the North* (Gateshead, 1998), a towering sculpture of a winged man with a 54m wing span. *Reflection* (above) is as much to do with inner as outer, physical, reflection. This is no mirrored image but two figures facing each other on either side of the entrance to an office/residential block. The Hayward mounted a solo exhibition in 2007, including *Event Horizon*: 31 life-size, human-form sculptures dotted around the city, all visible from the gallery's sculpture terraces. Other public art includes *Quantum Cloud*, near The O2, and *Resolution*, in the City. Antony Gormley lives and works in London. His work is also in Tate, British Museum and South London Gallery. Contact White Cube for more information.

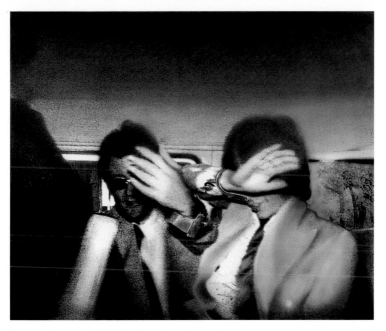

Swingeing London 67 (f) (1968-69) acrylic, collage and aluminium on canvas support
67.3 x 85.1 cm

RICHARD HAMILTON was born in London in 1922. His art education at the Royal Academy Schools was interrupted by World War Two. He returned in 1946, only to be expelled for not 'profiting from the instruction', and went on to the Slade School of Fine Art. The Whitechapel exhibition *This Is Tomorrow* (1956) featured his groundbreaking collage *Just what is it that makes today's homes so different, so appealing?*, consisting of fragments of text and images taken from advertising. It was a work that anticipated pop art. His painting *Swingeing London 67 (f)* (above) is a zeitgeist image, the title a punning reference to 'Swinging London'. The figures are Robert Fraser (an influential art dealer) and Mick Jagger after arrest. Imposing a six-month jail term on Fraser for drug possession, the judge said, 'There are times when a swingeing sentence can act as a deterrent.' The work epitomized Hamilton's view that Britain was still bound by its conservative past. He became friends with Paul McCartney and produced the cover design and poster collage for The Beatles' *White Album*. Richard Hamilton lives and works near Henley-on-Thames. His work is in **Tate** and the **National Portrait Gallery** (self portrait). It is also found at **Gagosian Gallery**, **Alan Cristea Gallery** and **Sims Reed Gallery**.

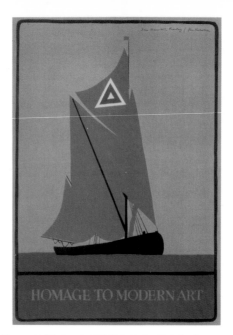

Homage to Modern Art (1972) (with Jim Nicholson)
serigrafia/screenprint on paper (edition of 70) 76 x 53.5 cm

IAN HAMILTON FINLAY was born in Nassau, in the Bahamas, in 1925 but moved to Glasgow, Scotland, when still a child. After a short period in London, he joined the army in 1942. After World War Two he worked as a shepherd, studied philosophy, and began to write short stories and plays, some of which were broadcast by the BBC. He was to become a life-long pacifist, anti-war in all its forms. His study of the classics and ancient philosophers informed much of his work, and the thread in his diverse production is the use of language in landscape. For his combination of linguistic and visual imagery he was dubbed a 'concrete poet', but he was a true conceptual artist, collaborating with artists and artisans who shared his love and experience of the sea and rural life. In 1966 he moved to Stonypath in the southern uplands of Scotland, his home for virtually the rest of his life. He was shortlisted for the Turner Prize in 1985 for his engraved sculpture *The World Has Been Empty Since The Romans* (Bath stone and steel). He took part in the *Art of the Garden* exhibition (2004) and the Tate Triennial 2006: *New British Art*, both at Tate Britain. Ian Hamilton Finlay died in 2006. His work is in the **Serpentine Gallery** garden, The Ark Hammersmith (*Sea Flower*, visible from the offices' elevated walkway at Open House London events) and at 30 St Mary Axe (stone benches beside the 'Gherkin'). Contact **Victoria Miro Gallery**.

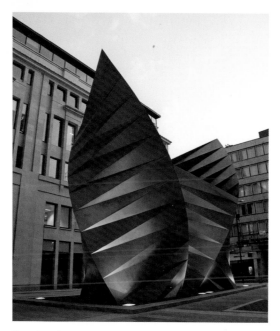

Vents (2000) stainless steel

THOMAS HEATHERWICK was born in London in 1970. He trained in three-dimensional design at Manchester Metropolitan University and the Royal College of Art. In 1994 he founded Heatherwick Studio, in King's Cross, to bring together architecture, design, sculpture – and high-profile public works of art. *Vents* (above) was designed as a ventilation structure for an electricity substation sited below a public space near St Paul's Cathedral. Developed by folding a sheet of A4 paper, the final tower form was scaled up to the height of a three-storey building. Looking like giant angel wings, each of the towers is welded from 63 identical isosceles triangles of 8mm stainless-steel plate, bead-blasted to a satin finish, and requires no additional reinforcement, due to the nature of the folded surfaces. His work is also seen in *Rolling Bridge*, a spectacular footbridge designed for the Paddington Basin development; it usually lies flat, but on Fridays, at noon, one end of the bridge rears up and arches back on itself to form an octagon. 'It's a piece of moving art,' says the hydraulics engineer who worked on it... Art and science and engineering should get together more often, with a view to marriage.' Thomas Heatherwick lives in London. *Bleigiessen* (at **Wellcome Trust**'s headquarters) is another example of his work: 150,000 glass spheres containing reflective film hang in a void, forming a sculpture that constantly changes colour.

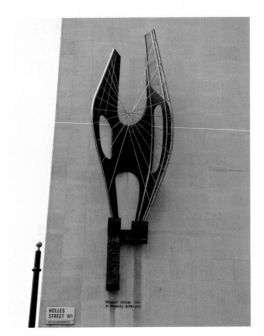

Winged Figure (1973) copper and resin 9 m height

BARBARA HEPWORTH was born in Wakefield, Yorkshire, in 1903. After completing her training at the Royal College of Art in 1924, where she studied figurative sculpture, she began to explore a lifelong interest in carving. Although her work was largely abstract, she stayed close to the rhythm and contours she found in natural forms. Hepworth was a friend and contemporary of Henry Moore in the 1930s, and, together with her husband Ben Nicholson and Moore, became the centre of an artistic community in north London once called by the critic Herbert Read 'a gentle nest of artists'. For a while, it included Piet Mondrian and Naum Gabo. Hepworth, Nicholson and Gabo moved down to the artists' colony at St Ives in Cornwall at the outbreak of World War Two, where they were to influence a younger generation of abstract artists. She enjoyed working in bronze and stone and particularly liked public sculpture commissions. Barbara Hepworth died tragically in a fire at her St Ives studio in 1975. In her will, she asked for the studio and garden to be opened to the public; Tate has administered the museum since 1980. *Winged Figure* (above) appears on the side of the John Lewis store in Oxford Street; other public art includes *Single Form* and *Two Forms (Divided Circle)*. Her work is in many collections. It can also be seen at **Browse and Darby**, **Hazlitt Holland-Hibbert**, **Connaught Brown** and **Offer Waterman & Co**.

Rumbold Vertical Three: Orange Disc in Scarlet with Green (July 1970)
oil on canvas 198.1 x 121.9 cm

PATRICK HERON was born in Leeds in 1920. He studied at the Slade School of Fine Art. His early work as a painter was influenced by Henri Matisse and Georges Braque, and with the influence of American expressionism he turned to abstract painting. But his response to natural shapes and colour remained a thread throughout his work, and his thoughts on colour and the pleasure of sight were later expressed in a book: *The Shape of Colour* (1978). Known for his work as an art critic as well as a painter and tapestry designer, in the late 1940s he had contributed to *The New Statesman* and *Nation* magazine and then, in the 1950s, he became the London correspondent of the New York newspaper *Arts*. Heron spent much of his time in St Ives – his love of Cornwall had begun early, when he worked as an assistant to Bernard Leach at his pottery in St Ives (1944-45) – and he finally settled there in 1956, moving soon after his arrival into Ben Nicholson's old studio. Patrick Heron died in 1999. *Big Painting Sculpture*, a piece of public art at Stag Place in Victoria, is testament to his passion for colour and shapes; his portraits of T.S. Eliot, A.S. Byatt and others are in the **National Portrait Gallery** and he designed a kneeler to encircle the Henry Moore altar at St Stephen Walbrook (39 Walbrook, EC4). His estate is represented by **Waddington Galleries**, and his work can also be seen at **Offer Waterman & Co**.

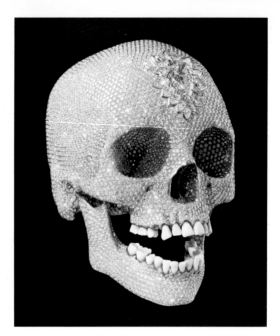

For the Love of God, The Diamond Skull (2007) silkscreen print
with glazes and diamond dust on paper 100 x 75 cm (paper size)

DAMIEN HIRST was born in Bristol in 1965. He studied at Goldsmiths College. In 1988, still a student, he put together the groundbreaking exhibition *Freeze* in an old warehouse in London's Dockland. Here he exhibited his own work with that of fellow artists, including Angela Bulloch, Mat Collishaw, Angus Fairhurst, Gary Hume, Abigail Lane, Sarah Lucas and Anya Gallaccio. The nucleus of that group, and others of the same art-set, became known as the YBAs. Described as the alpha-male of contemporary British art, Hirst earned his bad-boy label through his engaging, often shocking, art. His giant tiger shark in a glass tank of formaldehyde – *The Physical Impossibility of Death in the Mind of Someone Living* – was shown at the Saatchi Gallery in 1991, and the publicity made him a household name. But the bravura belies his response to beauty and poetry in death. He won the Turner Prize in 1995. His diamond-encrusted *For the Love of God* was cast from an 18th-century skull and covered in jewels (8,601 of them). In August 2007, within months of going on show, it sold for the asking price of £50 million, a record for a living artist. Damien Hirst lives and works in London, Gloucestershire and Devon. His work is in Tate and Saatchi Gallery. He is represented by White Cube (which has signed *For the Love of God* prints) and Gagosian Gallery; work can also be seen at Dominic Guerrini and Paul Stolper.

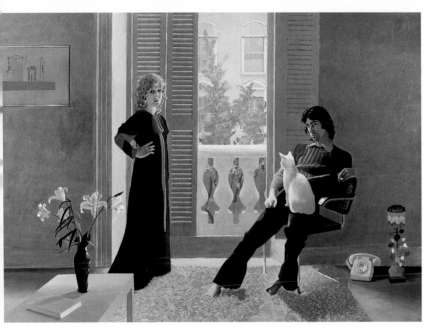

Mr and Mrs Clark and Percy (1970-71) acrylic on canvas 213.4 x 304.8 cm

DAVID HOCKNEY was born in Bradford, Yorkshire, in 1937. He studied art at Bradford School of Art and at the Royal College of Art, where he was awarded the gold medal in recognition of his innovative paintings and draughtsmanship. Along with Peter Blake, R.B. Kitaj and others, he contributed to the Whitechapel exhibition *Young Contemporaries* (1962), which gave birth to British pop art. At a time when some art schools were beginning to undervalue drawing's place in an artist's tool box, he continued to show his independence and skill as a draughtsman. California suited this independence of spirit, and he made his home there until eventually returning to his beloved Yorkshire in the late 1990s. From 1963 Hockney was represented by John Kasmin, an influential and successful art dealer, and his success was exponential, a reflection of a prolific talent expressed in printmaking, drawing, photomontage, set design and, above all, in painting, where his ability as a colourist is most evident. He also constantly experimented with mechanical media: polaroid and 35mm photography, then 'home-made prints' on photocopiers, reproduction by fax machine, images devised on computer, and studies of perspective using a camera obscura. David Hockney lives in Yorkshire and California. His work is in the John Madejski Fine Rooms at the **Royal Academy of Arts** and **Tate**. He is now represented by **Annely Juda Fine Art**.

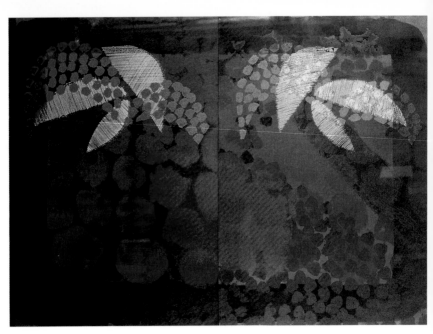

For Bernard Jacobson (1979) lithograph 105 x 149.9 cm

HOWARD HODGKIN was born in London in 1932. He attended Camberwell School of Art and Bath Academy of Art. At first he taught at Bath Academy, Chelsea School of Art, the Slade and the Royal College of Art. There are some similarities to pop and minimalism in his work but he has always been resolutely individualist in his painting style, while remaining fully aware of contemporary ideas. When asked to define his work, he once spoke of painting representational pictures of emotional situations. Certainly people are a major theme in his work, even if human beings are not always evident. His portraiture forms part of the crucial development of his work. But it is his eye for colour and the ways in which he manipulates paint to reflect the emotions he represents that distinguish his work. In 1964 he made the first of many trips to India, beguiled by the tradition of Indian miniature painting and the rich colours of the country. He won the Turner Prize in 1985. Howard Hodgkin lives in London. A beautiful mosaic mural, *Wave*, borders the length of the swimming pool at Virgin Active Broadgate at 1 Exchange Place, EC2 (though ironically now partially obscured from swimmers by a frosted window). His work is in **Tate**. He is represented by **Gagosian Gallery**, and his graphic work is published by **Alan Cristea Gallery**.

Water Painting (1999) household paint on aluminium panel
305 x 241.3 cm

GARY HUME was born in Kent in 1962. One of the luminous group of British artists who graduated from Goldsmiths College in 1988, Hume achieved early critical acclaim, not least for daring to use household gloss paint on large-format sheets of hardware material or shiny aluminium. His images are neither figurative nor abstract, though they take from both traditions: 'I do flora, fauna and portraiture' is his answer when asked whether he is a figurative painter. He applies the paint immaculately – often in layers – referring to his paintings as 'the thinnest sculptures in the world'. He doesn't mix the colours but allows the separated palette to create hard edges. In 1988 his work was in group exhibitions at Karsten Schubert, London, and in *Freeze: Part II*, using his thereafter celebrated theme of hospital doors in the *Door Painting* series. These were straightforward, minimalist representations in simple forms of hospital doors. The following year he had his first solo show at Karsten Schubert and quickly established an international reputation. In 1996 he was nominated for the Turner Prize for solo shows at the Kunsthalle in Berne and the Institute of Contemporary Arts in London; in 1997 he won the Jerwood Painting Prize. Gary Hume lives and works in London. His work is in the collections of the Arts Council, British Council, **Tate** and **Saatchi Gallery**. He is represented by **White Cube**. Prints are available at **Paragon Press**.

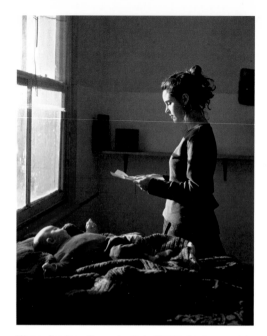

Woman Reading a Possession Order (1997) cibachrome print
152.5 x 122 cm

TOM HUNTER was born in Bournemouth, Dorset, in 1965. Evening classes in photography led on to full-time study at the London College of Printing (now the London College of Communication) and the Royal College of Art, where he graduated with an MA in 1997. In his first year at the Royal College he won the First-Year Award for Best Photography (Fuji Film UK Ltd), and in 1998 the John Kobal Photographic Portrait Award. The strength of his work lies in his story-telling and the connection he makes with people and places in his immediate community. In *Woman Reading a Possession Order* (above), Hunter emulates the composition and lighting of Johannes Vermeer's painting *A Girl Reading a Letter by an Open Window*. It is a theme he returns to – recreating the story in a painting from another time. The first photographer to be exhibited at the National Gallery, in 2005, his work was seen as an appropriate blending of the gallery's tradition and a contemporary view. He took part in *How We Are: Photographing Britain*, a major exhibition at Tate Britain in 2007. Tom Hunter lives in London. His work is in the print collection at the **Victoria & Albert Museum** and at Hackney Museum. Other permanent collections include the Museum of London and **Saatchi Gallery**. He represents himself in London.

You Mistake My Horror For Love (2007) steel, perspex with vinyl printing, mirror-polished steel and tree trunks
2 x12.3 x 6 m

JAMES IRELAND was born in Derby in 1977. He graduated with BFA Hons from Ruskin School of Drawing and Fine Art, Oxford, in 1999, and first came to attention in the *New Contemporaries 2000* exhibition. Ireland explores the theme of nature in his work, creating paradoxical landscapes with combinations of travel-brochure imagery, coloured glass, mirrors, branches. 'The work is about how the world we do live in produces a desire for a world we don't live in,' he explains. Creating illusions of escape to the far away through the familiar, it is low key rather than minimalist and uses materials – polystyrene, found objects, everyday artefacts – that can be transformed or recycled. The installation sculpture *You Mistake My Horror For Love* (above) was exhibited in **The Economist Plaza**. He has exhibited extensively. Recent exhibitions include *Joke, Satire, Irony and Serious Meaning* at the European Triennial of Small-Sized Sculpture in Slovenia; *Beyond the Country: perspectives of the land in historic and contemporary art* at the Lewis Gluckman Gallery, Cork; *Uncaring Nature* at the Australian Centre for Contemporary Art, Melbourne; *Into My World: Recent British Sculpture* at the Aldrich Contemporary Art Museum, Connecticut, and Contemporary Art Centre, Vilnius; and solo shows at Spike Island, Bristol, and Angel Row Gallery in Nottingham. James Ireland lives and works in London. He is represented by **f a projects**.

Acrobat (1993) 18.28 m height

ALLEN JONES was born in Southampton in 1937. From the early 1960s his international reputation was established as a painter, printmaker and sculptor. He studied painting at Hornsey College of Art and the Royal College of Art. In 1958 he went to Paris and was influenced by the work of Robert Delaunay. In the mid-1960s he taught in the USA and in Berlin, returning to live and work in London, where he was associated with the pop art movement. His subject matter included curvaceous women in underwear, stockings and stiletto heels – images drawn from magazines and erotica – and in 1970 he created the designs for the erotic stage musical *Oh! Calcutta!*, produced by theatre critic and impresario Kenneth Tynan. *Acrobat* (above), at almost 18.3m the tallest indoor sculpture in the world, is at the Chelsea & Westminster Hospital, which has pioneered art in hospitals and built up a fine art collection for the benefit of patients and visitors. *Dancers*, another tall indoor sculpture, is sited in the atrium of the Cotton Centre, south of the river. He has had three major retrospectives: travelling exhibitions at the Serpentine Gallery, the Institute of Contemporary Arts and The Barbican. Allen Jones lives and works in London and Oxfordshire. His work is in Tate, the Victoria & Albert Museum and National Portrait Gallery. It can be seen at Hazlitt Holland-Hibbert, Alan Cristea Gallery and Sims Reed Gallery.

Turning the World Inside Out (1995) stainless steel 148 x 184 x 188 cm

ANISH KAPOOR was born in Bombay, India, in 1954. He is renowned for his enigmatic and sensual sculptural forms, and his inventiveness and versatility have resulted in works ranging from powdered-pigment sculptures to site-specific installations. In 1973 he moved to London, studying at Hornsey College of Art and Chelsea School of Art. His first solo exhibition was held at Patrice Alexandre in Paris in 1980, and his international reputation was quickly established, with a string of solo shows held annually around the world. The colours he used in his early work echoed the intensity of Indian colours: cobalt blues, crimson reds, dense blacks. The materials of his uncompromising sculptures speak for themselves – shapes hewn from blocks of stone or rock, or highly polished mirrors or voids. He represented Britain, with Stephen Farthing and Bill Woodrow, at the Paris Biennale in 1982, and again in 1990 at the Venice Biennale, for which he won the Premio Duemila. In 1991 he was awarded the Turner Prize. In 2002 he produced *Marsyas* for the Turbine Hall at Tate Modern, a powerful sculpture which took site-specific art to a new level. Anish Kapoor lives and works in London. He created the *Holocaust Memorial* in St John's Wood, and his work is also in **Tate**, **South London Gallery** and **Deutsche Bank** (*Turning the World Upside Down III*, 1996). He is represented by **Lisson Gallery**; prints are available at **Sims Reed Gallery**.

Black Square with Blue (1970) oil on canvas, two joined panels
304.8 x 304.8 cm

ELLSWORTH KELLY was born in Newburgh, New York, in 1923. Recognized as one of the major abstract artists, Kelly influenced many British artists who looked across the Atlantic to the new ideas of post-painterly abstract art in the late 1950s and '60s. It was visits to the studios of Constantin Brancusi and Jean Arp in the 1940s that had turned Kelly himself from paintings of the human figure influenced by Pablo Picasso and Paul Klee to abstract art. He began to create pictures abstracted from fragments of his everyday world, such as windows, plant forms and shadows falling onto a flight of steps, along with composite works assembled from a number of panels each painted a single, uniform colour. For him, colour is an element independent of representation, and from the mid-1960s onwards he was using a modular structure and opposing areas of colour. His sculptures – sometimes in relief, sometimes free-standing – consist of painted, cut-out, metal shapes that relate to the forms in his paintings. A career retrospective in 1996, organized by the Guggenheim Museum, New York, travelled to Tate, and ten years later the Serpentine Gallery held a major retrospective. Ellsworth Kelly lives and works in Spencertown, New York. His work is in **Tate** and the **Saatchi Gallery** collection. Original work and lithographs are found at **Archeus**.

Clarion (1981) painted steel 507 x 608 x 456 cm

PHILLIP KING was born in Tunis in 1934. He came to London at the age of 11. In 1957, after preliminary art studies, he studied sculpture at St Martin's School of Art under the tutelage, among others, of Anthony Caro. His early sculptures in clay and plaster were small brutalist pieces. In 1959-60 he was Henry Moore's assistant and, under him, developed the confidence to produce work on a larger scale. In the early 1960s, during a spell of lecturing in the USA, he met David Smith, who encouraged him to work in steel. He produced his first steel sculpture the following year. King held a solo show in London at the Rowan Gallery in 1964. From then on he explored new materials in works that created elemental planes with the occasional use of cones in fibreglass, plastic or metal, coloured to emphasize fusion and spatial relationships. In 1990 he became professor of sculpture at the Royal Academy Schools and professor emeritus at the Royal College of Art. From 1999 to 2005 he was president of the Royal Academy of Arts. His training, influences and talent combined to secure his place at the forefront of contemporary British sculptors. Phillip King lives in London. *Clarion* (above), commissioned by Romulus Construction, is on Fulham Broadway. His work is also seen at **Tate**. He is represented by **Bernard Jacobson Gallery**.

Moving World (Night & Day) (2008) digital neon, glass and steel

LANGLANDS & BELL Ben Langlands was born in 1955, Nikki Bell in 1959. They studied fine art at Middlesex Polytechnic, where they began collaborating as Langlands & Bell. Their practice is extremely varied, ranging from sculpture and film to innovative new media projects and architecture. Characterized by simplicity and formal elegance, their work focuses on our relationship with the built environment and the coded systems of mass communications and exchange. In 2004 they won the BAFTA Award for Interactive Arts Installation for their interactive digital projection *The House of Osama Bin Laden* (an Imperial War Museum commission); the same year they were nominated for the Turner Prize. *Moving World (Night & Day)* was curated by the Contemporary Art Society for Heathrow's Terminal 5. It consists of two 6m-radius semicircles of moving blue light, installed one at either end of an outdoor plaza. Three-letter acronyms, generated by intense neon light, represent the air-transport codes for worldwide destinations connected to Heathrow. Langlands & Bell live in London. Other public art includes *Opening/Capture* at Triton Square, Euston, *111 Strand* (a Portland stone relief) and the monumental steel and glass *Paddington Bridge* at Paddington Basin. Work is also held by the **British Museum**, **Tate** and the **Victoria & Albert Museum**. **Alan Cristea Gallery** has prints, including *A Muse Um* (2008).

Whaam! (1963) acrylic and oil on canvas 172.7 x 406.4 cm

ROY LICHTENSTEIN was born in New York City in 1923. He studied at the Art Students League in New York in 1939 and the following year at the School of Fine Arts at Ohio State University, Columbus. He is best known as one of the leading figures in the pop art movement. Until about 1957 he worked in a non-figurative, abstract-expressionist style, but then began painting cartoon characters derived from advertising and bubblegum wrappers. In the early 1960s he lived in New Jersey, teaching at Douglass College. Around this time he met Jim Dine, Allan Kaprow, Claes Oldenburg, George Segal and others also experimenting with images based on everyday life. In 1961 he started making paintings of comic-strip figures and introduced the Benday-dot grounds, lettering and balloon dialogue that would make him internationally famous. With his one-man exhibition at the Leo Castelli Gallery in New York in 1962, his work achieved instant success. Sometimes he selected a comic-strip scene, recomposed it, projected it onto canvas and stencilled in the dots. 'I want my painting to look as if it had been programmed,' he explained. Comic images depicted emotional subject matter using a mechanized technique. *Whaam!* (above), in **Tate**, is based on an image from *All-American Men of War* published by DC Comics in 1962. Roy Lichtenstein died in 1997. **Alan Cristea Gallery** has prints from the *Brushstroke Figure* series.

Jungle Queen 2 (2003) wood, cardboard, glue, mixed media
275 x 160 x 40 cm

HEW LOCKE was born in Edinburgh in 1959 to artist parents. He grew up in Guyana (between the ages of six and twenty) and his early contact with Western art was seeing famous works reproduced in books. It wasn't until he saw the original works in London – specifically at the National Gallery, standing in front of Rembrandt's portrait of Hendrickje Stoffels wearing a fur stole – that he understood what all the excitement was about. Locke obtained his BA in fine art at Falmouth School of Art and an MA in sculpture at the Royal College of Art in 1994. As a child living in the Commonwealth, he was exposed to images of Queen Elizabeth II, and his art reveals a continuing fascination with Britain's preoccupation with the royal family. His interest in the royals as iconic signs of status, history and culture is apparent in his series of large portraits of the Queen. He breaks down the image and then interprets this famous face in his own terms, creating an elaborate effigy out of a mixed bag of materials such as plastic lizards, sequin waste, fake machine-gun parts and silk flowers. Hew Locke lives and works in London. His work is in the **British Museum** and **Victoria & Albert Museum**, as well as many private and public collections internationally. He is represented by **Hales Gallery**.

Sardinian Cork Arc (2005) and *China Clay Fast Spiral* (2005) dimensions variable

RICHARD LONG was born in Bristol in 1945. He studied at West of England College of Art, in Bristol, and St Martin's School of Art, where Anthony Caro, among others, was his tutor. Early childhood adventures in the muddy low tide of the River Avon were seminal in his development as an artist, and he has used this local mud in much of his work, thus keeping the connection with his roots. He has travelled extensively all over the world, including Nepal, the Sahara, Peru and Lapland, crossing great areas by foot. His work is always connected to the land he touches – in installation work, photographing the marks of his footsteps on the ground, tracing his walks on Ordnance Survey maps, drawing a circle with pebbles or cutting two squares in a meadow. Each piece is unique, often unmovable and ephemeral. The motifs he uses are those used by landscape artists of the past – crosses, circles, spirals – and his materials are the ancient ones – stone, slate, wood, seaweed and earth. He has said, 'I consider my landscape sculptures inhabit the rich territory between two ideological positions, namely that of making "monuments" or conversely of "leaving only footprints".' Long was awarded the Turner Prize in 1989, and subsequently made *White Water Line* (an installation piece first created in the Duveen Galleries at Tate Britain). Richard Long lives in London. He is represented by **Haunch of Venison**.

Spamageddon (2004) chair, tights, kapok, spam, helmets 81.5 x 105 x 100.5 cm

SARAH LUCAS was born in London in 1962. She studied art at the Working Men's College in London, the London College of Printing and Goldsmiths College. It was at Goldsmiths that she met, among others, Damien Hirst. Lucas came to prominence as one of the YBAs, taking part in Hirst's trail-blazing *Freeze* exhibition in 1988. Her (mostly sculptural) artworks involve a mixed bag of material, including photographs, stuffed stockings, tin hats, cucumbers, fried eggs, buckets, concrete casts and neon lights. She explores the sexual stereotyping found in British tabloid newspapers, with working-class associations of hard hats, donkey jackets, beer cans and cigarettes. She had her first solo show in 1991 at City Racing (an early artist-run exhibition space in a former bookmaker's shop next to Oval Cricket Ground in south London, 1988-98). With fellow artist Tracey Emin, she set up a joint art sale and exhibition project – The Shop – in the East End. She contributed to group shows, including the now infamous *Sensation* exhibition (1997), and in the same year her art dealer Sadie Coles organized her first major solo exhibition, *The Law*, in an empty building in Clerkenwell. Sarah Lucas lives and works in London. Her work is in the collections of **Tate** and **Saatchi Gallery**, and her self portraits are in the **National Portrait Gallery**. She is represented by **Sadie Coles HQ**.

Knife Edge Two Piece (1962-65) bronze 3.66 m length

HENRY MOORE was born in Castleford, Yorkshire, in 1898. He reputedly said, 'I believe I was about 11 years old when I decided to become a sculptor.' After military service in World War One, he attended Leeds School of Art, winning a scholarship to study sculpture at the Royal College of Art. While there he became interested in ancient Egyptian, pre-Columbian, African and Polynesian art at the British Museum. He concentrated on natural materials, wood and stone, and despite a feel for abstraction and hollowed shapes, his major interest remained the human figure. During World War Two he was an official war artist, and in 1948 won the International Prize for Sculpture at the first post-war Venice Biennale. His reputation grew exponentially, as did the large-scale commissions for public sculptures in bronze. *Knife Edge Two Piece* (above), one of four casts, stands near the Houses of Parliament. Henry Moore died in 1986; his body is interred in St Paul's Cathedral. His public art is seen on New Bond Street (*Time Life Screen*), in Battersea Park (*Three Standing Figures*), at Kenwood House (*Two Piece Reclining Figure No. 5*), Charing Cross Hospital and London Underground HQ. He gave many pieces to Tate, and his work is in the National Portrait Gallery, British Museum, Victoria & Albert Museum and Imperial War Museum. It can also be seen at Browse and Darby, Connaught Brown and Marlborough Fine Art.

Study for Earthwalker (Caribou) (2006) Lambda print 42 x 42 cm

HEATHER & IVAN MORISON Heather Peak was born in Desborough, Northamptonshire, in 1973, and Ivan Morison in Nottingham in 1974. They merge fact and fiction in evocative images drawn from a wealth of subjects, including horticulture, wild life, science fiction and mythology. Their work raises awareness of our spatial relationship with ordinary subjects – by looking at them from different angles or by assuming the perspective of another point of view, as in the *Earthwalker* series, in which alien, multi-coloured prisms appear as though part of nature. The medium-format photographic slides they use suggest images that seem to blend the Victorian explorer or collector's fascination with the natural world with flight-of-fantasy forms. The Morisons have acquired a 20-acre wood of ancient and mature trees in Wales and are developing an arboretum that will become integral to the work they produce based on global art expeditions designed to further explore our relationship to nature. The South London Gallery presented their *Dendrology Field Trip and Tree Tour* in 2005, and Danielle Arnaud showed the *Earthwalker* series (above) in 2006. The Morisons represented Wales in the Venice Biennale in 2007, and in the same year contributed to **Platform for Art**. Heather & Ivan Morison live in North Wales. They are represented by **Danielle Arnaud**.

Proximity Machines (2007) double 16mm projection 1 minute and 3 minutes

ROSALIND NASHASHIBI was born in Croydon, Surrey, in 1973 to Irish and Palestinian parents. Through her films and videos she reflects seemingly inconsequential everyday moments in Palestine, Scotland, the USA and the UK. She titles her work but offers no more explanation – in subtitle or translation – preferring to rely on the viewer's response to shared concerns irrespective of cultural or linguistic differences. She received her BFA Hons at Sheffield Hallam University, followed by an MFA at Glasgow School of Art. In 2004-05 she had a Scottish Arts Council New York studio residency. An unobtrusive filmmaker who favours 16mm, she observes everyday life with a flow of detailed images. With *The State of Things*, her black and white film of a Glasgow jumble sale, she won the Becks Futures Prize in 2003. The artist Michael Landy, chairman of the judges, said the decision was unanimous, 'Rosalind's work is simply exceptional.' Art curator Russell Ferguson has described it as 'exploring nostalgia without itself being nostalgic.' In 2007 she represented Scotland at the Venice Biennale and had a solo show at Chisenhale Gallery. Solo exhibitions of her work have been mounted at Counter Gallery and Tate Britain, in London, Harris Lieberman (New York) and the Kunsthalle (Basle). Rosalind Nashashibi lives and works in London. Her work is in the collections of **Tate** and **Saatchi Gallery**. Contact **Store** for more information.

AMNESIAC SHRINE or Double coop displacement (2006) mixed media (dimensions variable)

MIKE NELSON was born in Loughborough, Leicestershire, in 1967. He attended Reading University, gaining a BA Hons (first class) in fine art, and then Chelsea College of Art, for an MA in sculpture. An artist producing labyrinthine and immersive installations, his work *AMNESIAC SHRINE or Double coop displacement* (above), commissioned by Matt's Gallery in 2006, was an extraordinary structure made of wood and chicken wire, reflecting the unsettling circumstances of his, and our, lives. Later in 2006, an extension of the piece appeared in the Hayward Gallery's touring exhibition *A Secret Service*, curated by Richard Grayson, and at London's Frieze Art Fair *Mirror Infill* also gained considerable attention. This was a photographic darkroom constructed between galleries, making a 'secret space' where visitors had to find a doorway. Nelson's intention is to lead his viewers away from the inhibitions of the art gallery, transporting us to another place. The experience is not dissimilar to walking through a waking dream. His work is complex and difficult to access, both literally and essentially. But there is in this complexity a strange, compelling attraction which is well rewarded. He was a Turner Prize nominee in 2001, for work including a dusty storeroom, but lost out to Martin Creed; and was nominated again, in 2007, for *AMNESIAC SHRINE.* Mike Nelson lives and works in London. He is represented by **Matt's Gallery**.

1924 (first abstract painting, Chelsea) (c. 1923-24) oil and pencil on canvas
55.4 x 61.2 cm

BEN NICHOLSON was born in Denham, Buckinghamshire, in 1894, the eldest son of the painter William Nicholson. He is widely acknowledged as having had a greater influence on the development of abstract art than any other British artist, interpreting cubist and constructivist themes from Europe in his abstract reliefs and paintings. He attended the Slade School of Fine Art, then travelled in Europe and the USA. In 1920 he married the artist Winifred Roberts, and in 1921 had his first one-man show at the Adelphi Gallery, London. He travelled in France, Italy and Spain, and lived briefly in Pasadena, California, before settling in London. After divorcing Winifred, he married the artist Barbara Hepworth. Together they visited Paris and met Pablo Picasso, Georges Braque, Constantin Brancusi and Jean Arp. On later visits to Paris (1933-34) they met Piet Mondrian and László Moholy-Nagy. They moved to Cornwall, becoming members of the St Ives School. Influenced by cubism, Mondrian, Naum Gabo and his own father, his style had matured by the 1940s. The reliefs with their simple circular or rectangular motifs and semi-abstract paintings with their overlapping formal planes explored a cubist language. Ben Nicholson died in 1982. *1924* (above) is in **Tate**. His work can also be seen at **Alan Cristea Gallery**, **Hazlitt Holland-Hibbert**, **Bernard Jacobson Gallery**, **Offer Waterman & Co**, **Browse and Darby** and **Waddington Galleries**.

Spire (2004) mural approx. 10.7 m height

AARON NOBLE was born in Portland, Oregon, USA, in 1961. He studied art at the San Francisco Art Institute. After touring as a performance artist in Europe in the early 1990s, he was awarded an individual artist's fellowship from the California Arts Council in 1992. In the same year he co-founded the Clarion Alley Mural Project and was a co-director until 2001. By 1996 he had turned his attention largely to painting murals, and in 2000 began a series of wall paintings influenced by comic books and graffiti, sometimes in collaboration with Andrew Schoultz. In 2001 he moved to Los Angeles, and he had his first solo painting show as a project of the UCLA Hammer Museum in 2002. His murals have become internationally renowned – images inspired by comic-book heroes reconfigured to achieve his particular form of visual drama. *Spire* (above) was commissioned by a firm of solicitors specializing in human rights for their offices at the corner of Mundy Street in Hoxton. Aaron Noble lives in California. For more information, contact **Peer**.

*Twenty five and a half Henry Moore sculptures as a Chinese
scholar's stone* (2005) pencil on paper 99 x 200 cm

PAUL NOBLE was born in Dilston, Northumberland, in 1963. He received his degree in fine art at Humberside College of Higher Education in 1986 and, after a brief spell living in Manchester, moved to London. He exhibited at City Racing (an artist-run gallery space occupying an old betting shop in South London, of which he was a founder member). In 1998 he had an exhibition at the Chisenhale Gallery, featuring a series of very large and detailed graphite drawings of an imaginary city called Nobson. His work brings together a rich talent and interest in drawing, architecture, philosophy and satire. His sources are diverse – from Chinese sculpture and calligraphy to Sufi poetry and animal rights. His themes of uninhabited cities, poor urban planning and public housing can appear bleak but they also offer an insight into new territory. Sometimes parodying fantastical doodling, his combinations of surprise elements – as in *Twenty five and a half Henry Moore sculptures as a Chinese scholar's stone* (above) – are rich in content, visual delight and, above all, mastery of the pencil. Recent solo shows include Whitechapel Art Gallery (2004) and Gagosian Gallery, New York (2007). Paul Noble lives and works in London. His work is in the British Council Collection. He is represented by **Maureen Paley**.

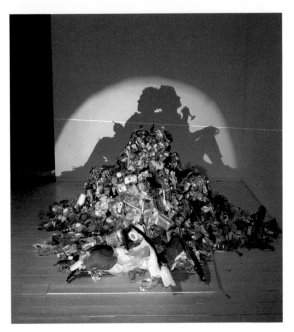

Dirty White Trash (with Gulls) (1998) six months' worth of artists' rubbish, two taxidermy seagulls, light projector (dimensions variable)

TIM NOBLE & SUE WEBSTER Tim Noble was born in Stroud, Gloucestershire, in 1966, and Sue Webster in Leicester in 1967. They met while on the BA Hons fine art course at Nottingham Trent University in the 1980s. They became partners in art – and in life, living and working together in Shoreditch, east London. Some of their notable pieces are made from piles of rubbish collected from London streets, and often include their own images. In *Dirty White Trash (with Gulls)* (above) it was their own garbage too. A light projected against the pile creates an entirely unexpected image on the wall, playing on the duality of meaning and association between object and shadow. It is an art of magic and illusion, but also an art of direct experience, combining sculpture, theatre, advertising and persona. They have succeeded in making their lives and the viewer's experience part of the art. Their work was included in the exhibition *Apocalypse: Beauty and Horror in Contemporary Art* at the Royal Academy in 2000, as well as in the opening show of the Saatchi Gallery at County Hall. In 2003 they featured in the first Frieze Art Fair. Recent solo exhibitions include *Polymorphous Perverse*, at the Freud Museum (2006), and *Serving Suggestion*, at The Wrong Gallery, Tate Modern, in 2007. Tim Noble & Sue Webster live in The Dirty House, a studio/home designed by David Adjaye. They are represented by **Gagosian Gallery**.

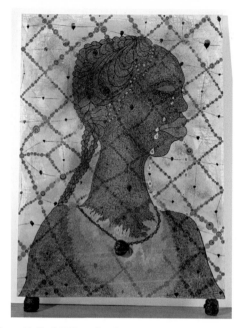

No Woman No Cry (1998) acrylic, oil, resin, pencil, paper collage, Letraset, map pins and elephant dung on linen 243.8 x 182.8 x 5.1 cm

CHRIS OFILI was born of Nigerian parents in Manchester in 1968. He did his foundation course in art at Tameside College of Technology, his degree in fine art at Chelsea College of Art, and his postgraduate degree at the Royal College of Art. His paintings have to be seen for the beauty to be believed. You get a sense of it when looking at reproductions because the colours, the composition and the evocative content, as well as political and cultural story-telling, are all there. But standing before the work the full impact is astounding. Rich colours are painted, layered, glittered and bejewelled – but earth-bound by the inclusion of supports made of elephant-dung (which he first brought back to London in a suitcase from Zimbabwe, where he had been studying on a scholarship in 1992). In 1998 he won the Turner Prize. In *No Woman No Cry* (above), the focal painting of the award, he represents the grieving mother of the murdered black teenager Stephen Lawrence, and in each of her teardrops is a tiny image of her son. It is a moving, universal portrayal of grief. In 2003 he represented Britain at the Venice Biennale. Chris Ofili lives and works in London and Trinidad. His work is in the collections of **Tate** (including *No Woman No Cry*) and the **Victoria & Albert Museum**. He is represented by **Victoria Miro Gallery**. Besides the paintings, seek out his etchings on paper, especially the *North Wales* portfolio.

Alex James (2000) C-type colour print on paper laid on panel
86.8 x 75.8 cm

JULIAN OPIE was born in London in 1958. He studied at Goldsmiths College. By the mid-1980s he was having one-man exhibitions at Groninger Museum, in Groningen, The Netherlands, and the ICA, London, and was linked to the New British Sculpture Group. Perhaps better known today for his paintings and prints, his early work in sculpture, which paid homage to the cool, minimal aesthetics of industrial design with shiny textures and clean colours, remains outstanding. His 2000 *Roadscape* series of paintings achieves the same effect through line and simplicity. Almost neon-like in appearance, they recall American highway diners of the 1950s. His portraits are extraordinary for the degree of expression transmitted with minimal description. The painting *Alex James* (above), of the bass player with the band Blur, is typical. Opie's website – www.julianopie.com – gives a look-in on his work; the list of exhibitions, both solo and group, and the bibliography indicate the volume of work he produces and the international acclaim achieved. Julian Opie lives and works in London. His work is in collections at Tate (including *H*, a sculpture), the **National Portrait Gallery** (four Blur portraits), **Saatchi Gallery**, the **British Museum** (Print Department), Government Art Collection and **Victoria & Albert Museum**. He is represented by **Lisson Gallery** and his limited-edition prints can be seen at **Alan Cristea Gallery**.

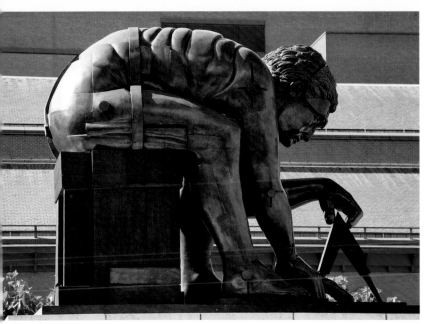

Newton after William Blake (1995) bronze

EDUARDO PAOLOZZI was born in Leith, Edinburgh, in 1924. Sculptor, collagist, printmaker, filmmaker and writer, he was an artist who combined his interest in mass media with new developments in science and industrial techniques. In 1944 he was much taken by an exhibition of Kurt Schwitters' collages at a gallery in London. He attended the Slade School of Fine Art, and in 1947, after graduation, went to live in Paris, where he met avant-garde artists Jean Arp, Constantin Brancusi, Alexander Calder and Alberto Giacometti, among others. Back in London he became a member of the Independent Group at the ICA in 1952. By the 1970s his interest in architecture and the environment was leading to many international commissions for large-scale pieces of public art. Many of his human images have mechanistic characteristics, as in *Newton after William Blake* (above) outside the British Library. Other examples of his public art can be seen at High Holborn (*The Artist as Hephaestus*), Pimlico underground station (*Cooling Tower Panels*), Shad Thames (*Invention*), near Euston railway station (*Piscator*) and in Tottenham Court Road underground station (the *Underground Murals*). Eduardo Paolozzi died in 2005. His work is in Tate. It can also be found in premier galleries of 20th- and 21st-century art, including **Flowers East** and **Offer Waterman & Co**.

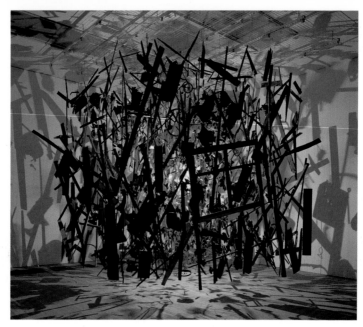

Cold Dark Matter: An Exploded View (1991) mixed media 400 x 500 x 500 cm

CORNELIA PARKER was born in Cheshire in 1956. She studied at Gloucestershire College of Art & Design, followed by Wolverhampton Polytechnic, graduating with BA Hons, and Reading University, where she gained an MFA. Her work is consistently informed by an interest in the physicality of objects combined with essentially poetic concepts and the ways in which the process of deterioration can sometimes be used in the creation of a work of art. In *Cold Dark Matter: An Exploded View* (above) the subject is a garden shed filled with the junk that sheds absorb. Parker arranged for the British Army to explode the shed, and then suspended the pieces from the ceiling, lighting them with a single bulb. The resultant shadows contribute to the drama of the piece. Her sculpture has constantly challenged; in 2003, in a comment on the nature of relationships, she temporarily wrapped Rodin's *The Kiss*, on display in Tate Britain, with a mile of string, a bold yet Christo-like concept. But that rigour is counterpointed by her delicate drawings and her interest in fixing the transient. She was nominated for the Turner Prize in 1997 (won that year by Gillian Wearing). Cornelia Parker lives and works in London. Her work is in the collections of **Tate**, **Saatchi Gallery**, **Victoria & Albert Museum** (a commissioned permanent installation, *Breathless*, 2001) and **The Drawing Room**. She is represented by **Frith Street Gallery**.

Benidorm (Blue Lady) (1998) colour photograph (dimensions variable)

MARTIN PARR was born in Epsom, Surrey, in 1952. His interest in photography started when he was a boy, encouraged by his grandfather, a keen amateur photographer. Parr studied photography at Manchester Polytechnic. In 1975 he was awarded the Arts Council Photography Award. By the beginning of the 1980s he was documenting ordinary British people in the Margaret Thatcher era. He gained a reputation for capturing uncompromising, fresh imagery in an approach that matched pathos with provocation. He joined Magnum Photos in 1988, becoming a full member in 1994. *Benidorm (Blue Lady)* (above) is from his *Common Sense* series, a worldwide study of cultural cliché and globalization. A committed believer in the photobook, much of Parr's work is available between covers. The Barbican mounted a retrospective in 2002, which transferred to, among others, the Museo Nacional Centro de Arte Reina Sofia (Madrid), the Maison Européenne de la Photographie (Paris) and the Deichtorhallen (Hamburg). In 2004 he was made professor of photography at the University of Wales (Newport campus) and guest artistic director for Rencontres d'Arles. He took part in *How We Are: Photographing Britain*, a major exhibition at Tate Britain in 2007. Martin Parr lives and works in London. His work is in Tate, the Victoria & Albert Museum and British Council collection. See www.magnumphotos.com.

The Great Bear (1992) four-colour lithograph in glass and aluminium frame (edition of 50)
102.7 x 128 cm

SIMON PATTERSON was born in Leatherhead, Surrey, in 1967. He studied at Hertfordshire College of Art and Design and Goldsmiths College of Art. He is fascinated by the information that orders our lives, and distorting or playing with the way we categorize it is a recurrent theme. He humorously dislocates and subverts sources of information such as maps, diagrams and constellation charts, and is probably best known for *The Great Bear* (above), a reproduction of the London Underground map on which he replaced names of underground stations with those of philosophers, explorers, engineers and other famous people. Religious fervour and football fever combined in *The Last Supper Arranged According to the Flat Back Four Formation (Jesus Christ in goal)* (1990), a wall drawing in which he arranged the names of Christ and his disciples in the formation used by the English football team in the 1990 World Cup. 'Being an artist is about getting people to look at the world in a different way or to look again – and question it,' he says. In 1996 he was nominated for the Turner Prize (won by Douglas Gordon) for solo exhibitions at Lisson Gallery, the Gandy Gallery in Prague and three in Japan. Simon Patterson lives and works in London. His public art includes *Time and Tide* (a mixed-media work) at Plantation Place and a wall drawing in the BBC White City foyer. He is represented by **Haunch of Venison**.

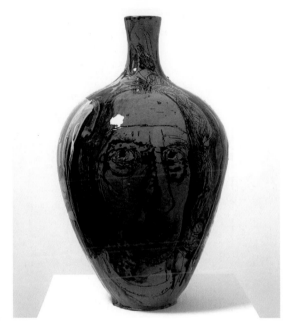

Self Portrait with Eyes Poked Out (2004) glazed ceramic
55 x 34 x 34 cm

GRAYSON PERRY was born in Chelmsford, Essex, in 1960. He studied fine art at Portsmouth Polytechnic, where he also enrolled in pottery classes. In the early 1980s he was a member of the Neo-Naturists, taking part in performance and film works. He later experimented with textiles, performance and photography but was in his early twenties before he found his *métier* as a potter. In 2003 he was awarded the Turner Prize for his use of the traditions of ceramics and drawing in his uncompromising engagement with personal and social concerns. He was instantly famous, not only for his pottery but his transvestism, while bringing ceramics to the forefront of contemporary art appreciation. Quote: 'I think my work has what you might call taxi-driver appeal, by which I mean you won't get anyone coming up to me saying, "My three-year-old daughter could do that," because they couldn't. There's some craft in it.' To critics he quips, 'If you call your pot art you're being pretentious. If you call your shark art you're being bold and philosophical.' The often dark subject matter depicted on his pots is initially disguised by their decorative appearance. Topics include images of himself, his transvestite *alter ego*, his family, political events and cultural stereotypes. Grayson Perry lives and works in London. His work is in **Tate** and **Saatchi Gallery**. He is represented by **Victoria Miro Gallery** and can also be seen at **Archeus**.

Bernal's Picasso (1950) graphite pencil on lathe and plaster (later wax-crayon tracing and colour wash)
135 x 227.1 cm

PABLO PICASSO was born in Málaga, Spain, in 1881. In 1939, a trade union group in London sympathetic to the republican cause in the Spanish Civil War used the Whitechapel Art Gallery for a fundraising exhibition for Aid Spain. The centrepiece was Picasso's *Guernica,* painted in Paris in 1937 after the bombing of the Basque town. Apparently the one stipulation Picasso made was that everyone who came to see the painting should donate a pair of shoes for the Spanish freedom fighters. It was the first and only time the painting has been shown in London. *Bernal's Picasso* (above) is so named because it was drawn at the home of the scientist Professor John Desmond Bernal: the only mural Picasso ever produced in England. Bernal, a pacifist and, like Picasso, a member of the communist party, met the artist in London after a meeting they were both to attend was cancelled. A group went back to Bernal's Bloomsbury flat and late into the evening, after a few drinks, Bernal asked Picasso to draw on his sitting-room wall. Picasso outlined two figures, adding laurel wreaths and wings to symbolize peace. When the flat was later listed for demolition, the mural was carefully removed and donated to the ICA. It is now in the **Wellcome Trust** collection. Pablo Picasso died in 1973. There are important pieces in **Tate** (including *Girl in a Chemise*, a cubist *Seated Nude*, and *The Three Dancers*); his work is also seen in **Dalí Universe**.

Zemran (1972) stainless steel

WILLIAM PYE was born in London in 1938. His source of inspiration is the natural world, and his observations of natural forms, combined with his creative use of geometry, lie at the heart of his sculpture. Pye studied at Wimbledon School of Art and the sculpture school of the Royal College of Art. In the 1960s his sculptures were abstract forms, using predominately the traditional materials of metal and stone. His first solo show was at the Redfern Gallery in 1966. Since then his work has been commissioned and exhibited internationally. As a child, Pye had developed a fascination and love for water. Although brought up in London, he had spent a lot of time at his family's home in Surrey, and water abounded in the area. By the age of 17 he had made his first waterfall, and that interest had stayed with him. In the 1970s water became central to his artistic expression as he began combining it with highly polished stainless steel to produce his often kinetic sculptures. He has received many awards and was elected honorary fellow of the Royal Institute of British Architects in 1993. William Pye lives and works in south London. *Zemran* (above), an example of his public art, is on the South Bank.

Sphinx (2005) painted bronze (edition of 3) 88 x 65 x 50 cm

MARC QUINN was born in London in 1964. He studied history and history of art at Cambridge University. Quinn had his first solo show in London in 1988 and was represented in *Young British Artists II* at the Saatchi Gallery (1993) and in the *Sensation* exhibition at the Royal Academy (1997). His statement piece, and the work with which he first became famous, was *Self*: the ultimate self portrait. He had cast his head and then filled it with eight pints of his own blood (the amount in the human body) before freezing it. The next piece that caught public imagination was the frozen garden he made for Miuccia Prada in 2000, putting plants that never grow naturally together in cryogenic suspension. He also explored the theme of human vulnerability by casting people with health problems, mixing wax with the medicine they took to keep alive. His interest in plants, the environment and the human body indicates the diversity of his subject matter. A dramatic Carrara marble statue of Alison Lapper, a woman born without arms or fully developed legs, was exhibited on the Fourth Plinth in Trafalgar Square (2005-07). *Sphinx* (above), a white-painted bronze sculpture of Kate Moss, was completed in 2005: lithe beauty in an advanced yoga pose. Marc Quinn lives and works in London. His work is in the collections of **Tate**, the **Wellcome Trust**, Saatchi Gallery and **National Portrait Gallery**. He is represented by **White Cube**.

Life is full of pleasant gifts and surprises, you know! (2007)
oil and acrylic on canvas 183 x 150 cm

FIONA RAE was born in Hong Kong in 1963. Art studies at Croydon College of Art were followed by Goldsmiths College. It was here that she met fellow artist Damien Hirst, who included her in *Freeze*, the seminal group exhibition for YBAs he largely organized in 1988. Her first solo exhibitions came in 1990, in Glasgow and Nice. The following year she exhibited at Waddington Galleries and as a consequence was nominated for the Turner Prize for her contribution in 'extending the range of subject matter explored in abstract painting'. From then her career continued on an upward spiral. She was shown at the Saatchi Gallery with Gary Hume and in the notorious *Sensation* exhibition that started at the Royal Academy and ended with uproar after a three-month stint at the Brooklyn Museum of Art, New York, in January 2000. She remains loyal to paint and canvas, and enjoys exploring the language of signs. Her ambiguous marks encourage and yet frustrate any attempt to construct narratives from her paintings, thus challenging our expectation. Every viewer will identify the imagery differently, so any universal interpretation is impossible. The colour, composition and energy of her paintings are both enchanting and cool. Fiona Rae lives and works in London. Her work is in the collections of **Tate** and **Saatchi Gallery**. She is represented by **Timothy Taylor Gallery**.

Crivelli's Garden, detail (1990-91) acrylic on paper on canvas 190 x 260 cm (right panel)

PAULA REGO was born in Lisbon, Portugal, in 1935. She first won acclaim in Portugal with semi-abstract paintings that often included collage elements taken from her own drawings. Rich veins of imagination, childhood memory and folklore combine in her work as a painter and draughtswoman. She attended the Slade School of Fine Art in London, returning to Portugal in 1957. A bursary from the Gulbenkian Foundation, Lisbon, in 1962 helped her to live between Portugal and London before settling in London in 1976 with husband and fellow artist Victor Willing and their three children. After her husband's death in 1988 Rego began to receive the acknowledgment she deserved as a painter with an individual narrative-figurative style. Her subject matter centres on the female form, often the stocky Portuguese women among whom she grew up. Echoes of childhood predominate: toys, animals, experiences, secrets and dreams. Balancing dark and light, magic and realism, her work is powerful, disturbing – and enchanting. She says: 'How one was as a child is how one is now – one modifies the childhood a bit, corrects certain abuses.' Paula Rego lives and works in London. Her work is in **Tate, National Gallery** (*Crivelli's Garden*, above), **National Portrait Gallery, University College London Art Collections** (Strang Print Room) and **Saatchi Gallery**. She is represented by **Marlborough Fine Art.**

Nataraja (1993) oil on canvas 165.1 x 227.7 cm

BRIDGET RILEY was born in London in 1931. Riley is a leading exponent of op art – work that focuses on visual game-play, creating the sense of movement on a static canvas. She was also a pioneer of screenprinting. After spending the war years in Cornwall, she studied at Goldsmiths College and the Royal College of Art. In 1958 she was so impressed by a large Jackson Pollock exhibition at the Whitechapel Art Gallery in London that she decided to leave her job as an illustrator in advertising to pursue her own art full time. Influenced by pointillism, she took up op art in the early 1960s, working initially in black and white. In 1966 she turned to colour with *Chant* and *Late Morning*, by which time her work was already receiving considerable recognition. She uses subtle variations in the size, shape and position of blocks within an overall pattern to characteristically intense and often disorientating effect. Relatively early in her career, in 1968, she won the International Prize for Painting at the Venice Biennale. Bridget Riley lives and works in London, Cornwall and France. Her work is in **Tate**. She is represented by **Karsten Schubert**, and can also been seen at **Timothy Taylor Gallery**, **Robert Sandelson** (including limited-edition screenprints from the series illustrated above), **James Hyman Gallery** and **Offer Waterman & Co**.

Homo sapiens sapiens (2005) audio video installation (continual loop)

PIPILOTTI RIST was born in Rheintal, Switzerland, in 1962. Named Elizabeth Rist, she combined her childhood nickname with the first name of Pippi Longstocking, the heroine of a series of Swedish children's stories, to create the name she now uses. She studied art at the Institute of Applied Arts in Vienna and the School of Design in Basel. In 1986, while still studying, she produced her first video: *I'm Not The Girl Who Misses Much*. She played in an all-woman feminist rock band called Les Reines Prochaines (1988-94), and music continues to play a part in her poetic, personal and dream-like video art. In 1997, for her work *Ever is Over All*, she was awarded a Premio 2000 Award at the Venice Biennale. Her work reaches large screens: in 2000 her series of one-minute video segments commissioned by the New York Public Art Fund, titled *Open My Glade*, was shown on the largest video screen in Times Square, and in 2007 moving images of *A la belle étoile* were screened in the piazza in front of the Pompidou Centre, Paris, as part of its thirtieth-anniversary celebrations. Pipilotti Rist lives in Switzerland. Her work is in Tate *(I'm Not the Girl Who Misses Much)*. She is represented by **Hauser & Wirth London**.

Black on Maroon (1959) mixed media on canvas support 266.7 x 457.2 x 3.8 cm

MARK ROTHKO was born Marcus Rothkowitz in Dvinsk, Russia, in 1903. In 1913 he left Russia and settled with the rest of his family in Portland, Oregon, USA. He attended Yale University, New Haven, on a scholarship, but left without receiving a degree and moved to New York. His first solo exhibition was at the Contemporary Arts Gallery in New York in 1933. He co-founded The Ten, a group of artists sympathetic to abstraction and expressionism. By the late 1940s his style had emerged: paintings in which haunting, rectangular shapes shimmer on the surface of huge canvases. Nine of his masterpieces are now housed in their own space at **Tate Modern** – The Rothko Room. They were originally commissioned for a newly designed, exclusive dining room – the Four Seasons restaurant at the Seagram Building in New York – in 1959. In keeping with his distrust of the business of art and concerned, perhaps, that their setting would compromise his artistic integrity, Rothko suddenly and vehemently withdrew them and repaid the commission money. He then decided to donate the paintings to the Tate Gallery and negotiated the gift with its then director, Norman Reid. The fact that we became heirs to these masterpieces is not without a shadow. The day they arrived at the gallery – 25 February 1970 – was the day Mark Rothko committed suicide.

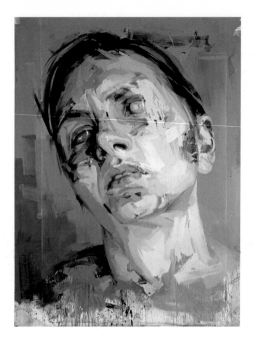

Rosetta 2 (2005-06) oil on watercolour paper, mounted on board 252 x 187.5 cm

JENNY SAVILLE was born in Cambridge in 1970. Despite associations with the YBAs, Saville's work has strong connections with the traditional art of oil painting. Her painterly style has been compared to that of both Lucian Freud and Rubens. Her large nudes are strongly pigmented and give a highly sensual impression of the surface of the skin as well as the mass of the body. She studied for her degree at Glasgow School of Art, gaining a BA in 1992. She exhibited early in her career: at *Contemporary '90* at the Royal College of Art (while she was still at Glasgow), in Edinburgh and at the Cooling Gallery in London. Her work, which challenges any romanticized view of the naked female body, became widely known following the publicity generated by her showing at *Young British Artists III* at the Saatchi Gallery in 1994. She studies journals on reconstructive surgery, giving her sculpted oil paintings of butchered flesh an anatomical understanding. On large canvases – some measuring 3.6m across – her images of naked female forms are uncompromising, visceral, shocking, bold and seductive. Listening to music while she is working, she says, gives her painting 'pace' – and looking at their textures closely you get a sense of busy and quiet areas. Jenny Saville lives and works in London. Her work is in the **Saatchi Gallery** collection. She is represented by **Gagosian Gallery**.

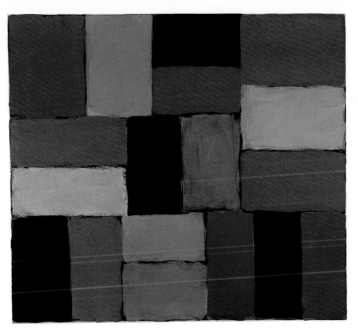

Wall of Light Red Day Leaving (2005) oil on linen 214 x 243.5 cm

SEAN SCULLY was born in Dublin in 1945, but the family moved to London in 1949. A superb colourist, Scully did much to revitalize abstract art in the 1980s, holding firm to its fundamental concerns. He studied art at Croydon College of Art, the University of Newcastle upon Tyne and Harvard University. He had his first solo exhibition at the Rowan Gallery in London in 1973. He moved to the USA in 1975, establishing a studio in New York and becoming an American citizen in 1983. Throughout his career he has remained faithful to the stripe in all its forms and he is as associated with it as Piet Mondrian with his grids. He says, 'The reason I don't use the diagonal much is because the diagonal is everything that is in between what the horizontal and the vertical have stated... I've come to believe that, in my work, the best way for me to represent everything in between is not to state it, but to capture it by stating the two ends, and somehow imply everything in between.' Sean Scully lives and works in the USA, Spain and Germany. His work is in **Tate**. He is represented by **Timothy Taylor Gallery**.

Rush Hour (1983) bronze

GEORGE SEGAL was born in New York City in 1924. He became known as part of the pop art movement, though his distinctive style separated him from that mainstream. He grew up in the Bronx and in 1940 moved to New Jersey to study at Rutgers University. He received his MFA degree at New York University in 1949, and had his first one-man show of figurative paintings at the Hansa Gallery in New York in 1956. Two years later he was experimenting with different forms of sculpture – plaster made with chicken wire and burlap and then casting. He made plaster casts of his body, assembling them to create complete figures. His first cast sculpture, a self portrait *Man at a Table*, came in 1961. He perfected this technique, using friends and family as models. Simple gestures of human behaviour feature in much of Segal's work, and his figures often convey a sense of melancholy or detachment, even when presented in groups. *Rush Hour* (above), a knot of life-size figurative bronze sculptures frozen in time, is an unsettling piece of work encountered either alone or in the midst of fast-moving office workers on the Broadgate Estate. George Segal died in 2000.

Fulcrum (1987) free-standing Corten steel
16.8 m height

RICHARD SERRA was born in San Francisco in 1939. Working in steel mills to support himself, he attended the University of California at Berkeley and Santa Barbara, receiving a BA in English literature, before studying painting at Yale University, New Haven. He came into contact in the early 1960s with fellow artists Josef Albers, Philip Guston, Robert Rauschenberg, Ad Reinhardt and Frank Stella. Serra had his first solo exhibition at the Leo Castelli Warehouse, New York. 'What Michelangelo is to marble, the American sculptor Richard Serra is to steel,' is how one critic described him, and his reputation as one of the most important sculptors of our times is equal only to the monumental work he produces. Gaining from his early experience in the steel mills, he has used industrial steel to explore new dimensions in terms of scale. *Fulcrum* (above) is typical of his work: his sculptures are not welded together but rely solely on the forces of weight and gravity to produce monumental, powerful and yet seemingly precarious, minimalist pieces. The space within or surrounding a work becomes in itself a 'material', something in which the spectator participates. Richard Serra lives and works in New York and Nova Scotia. He is represented by **Gagosian Gallery**.

Le Boulevard (The Boulevard) (1910-11) oil on canvas 63.5 x 91.5 cm

GINO SEVERINI was born in Cortona, Italy, in 1883. He studied at the Scuola Tecnica in Cortona before moving to Rome in 1899. It was while studying art at the Villa Medici in 1901 that he met Umberto Boccioni, also recently arrived in the city. Together they met Giacomo Balla, who was already painting with separate colours rather than a mixed palette. Severini moved to Paris in 1906, where he came to know most of the Parisian avant-garde, including Pablo Picasso, Georges Braque, Juan Gris, and the poets and authors of the time. In 1910 he was invited to join the futurist movement by Filippo Tommaso Marinetti and his old friend Boccioni. Unlike the other artists in the movement, who favoured the image of the machine as an expression of futurist theories, Severini was more attracted to the form of the dancer. In 1912 he was part of a group show at the Sackville Gallery in London, which launched futurism and the Italian futurists in this country. In 1913 he had a solo exhibition at the Marlborough Gallery. The legacy of his work, and that of other important futurists, lives on in the **Estorick Collection**, and his painting *Suburban Train Arriving in Paris* (1915) is at **Tate**. Gino Severini died in Paris in 1966.

Garden of Earthly Delights X (2004) mixed media on board 2.438 x 4.572 m (triptych), 2.438 x 1.524 m (panels)

RAQIB SHAW was born in Calcutta, India, in 1974. Raised in his family of carpet makers and shawl traders in Kashmir, he was surrounded and influenced by intricate patterns and rich colours from an early age. At 16 he travelled to London, seeing Western art for the first time outside reproductions in books. *The Ambassadors* by Hans Holbein at the National Gallery had a lasting impact, revealing just how much a painting could transmit. He studied fine art at Central St Martin's College of Art and Design, gaining a BA Hons and MFA. His imagery is powerful, vibrant and erotically charged. Visual narratives, fairy-tales and exotic dreams are conjured out of paint, car enamel, glitter, gold leaf and rhinestones with reference to the works of Western old masters and Eastern cultures. His series of paintings titled *Garden of Earthly Delights* (*X*, above) echoes images from Hieronymus Bosch but there is less threat or melancholy in his own colourful underworld. Raqib Shaw lives and works in London. His work is in **Tate** and the **South London Gallery**.

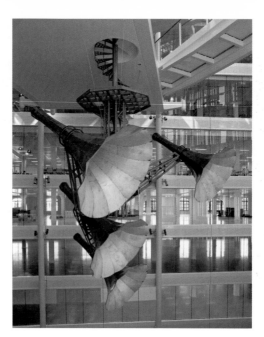

Space Trumpet (2007) renewable oak 9 x 9 x 9 m

CONRAD SHAWCROSS was born in London in 1977. After completing his foundation course at Chelsea College of Art and Design in 1996, he studied at the Ruskin School of Drawing and Fine Art, Oxford, taking a BA Hons, and in 2001 gained an MFA at the Slade School of Fine Art. His sculptures have gained him swift recognition. At first glance his large, complex works, often with moving parts, look like some form of machine. Much inspired by science, they are indeed functioning 'machines' in that they fuse art and mathematics, but they are without a practical purpose. Commenting on this duality, the artist says: 'When something is beautiful, allowing it to be ambiguous is important.' From early in his career, his work has been collected and exhibited in Britain and abroad, including solo exhibitions at the National Maritime Museum (2004) and the Victoria Miro Gallery (2006), and in Spain and Germany. Group exhibitions have included *New Contemporaries* (2001) and *New Blood* at the Saatchi Gallery (2004). *Space Trumpet* (above) is in the lobby of the Unilever Building, near Blackfriars Bridge. Conrad Shawcross lives and works in a large, converted factory space in east London. He is represented by **Victoria Miro Gallery**.

Diary of a Victorian Dandy: 14.00 hours (1998) C-type print (edition of 3) 122 x 183 cm

YINKA SHONIBARE, MBE was born in London in 1962. He moved to Lagos, Nigeria, at the age of three, returning to London to study art and gaining his BA at Goldsmiths College in 1991. A self-proclaimed bi-cultural artist, Shonibare exposes the social, cultural and political issues that shape our history and identity. He playfully challenges stereotypical Western categorizations of high art and African art, adopting a range of media that includes painting, photography, sculpture, installation and film, and using a rich palette of colours and textiles. He often makes himself the protagonist in his work. The photograph *Diary of a Victorian Dandy: 14.00 hours* (above) is one in a series of tableaux depicting a day in the life of its subject. Operating both as a commentary on an aspect of British colonialism and on his own life, living in a multicultural society, the work has been compared to William Hogarth's *A Rake's Progress*, on which it is loosely based. He exhibited the sculptural installation *How To Blow Up Two Heads At Once* in the first African Pavilion at the Venice Biennale in 2007. Yinka Shonibare, MBE lives and works in London. *The Swing (after Fragonard)*, a theatrical and telling installation piece, is in **Tate**. He is represented by **Stephen Friedman**.

Self Portrait in a Single Breasted Suit with Hare (2001)
C-type print (edition of 6) 161 x 113 cm

SAM TAYLOR-WOOD was born in London in 1967. She graduated from Goldsmiths College in 1990. Her work is a consistent exploration, using photography, film and video, of the vulnerability of the human body and of relationships and emotions, particularly at the height of tension or point of fragmentation. She often features herself in portraiture. Her first solo exhibition was at White Cube in 1995. In 1997 she was awarded the Illy Café Most Promising Young Artist Prize at the Venice Biennale and in 1998 she was nominated for the Turner Prize for her presentation at the Venice Biennale the previous year, as well as her solo exhibitions at the Kunsthalle, Zurich, and the Louisiana Museum of Modern Art in Humlebaek, Denmark. Her work was selected because of its 'acutely perceptive explorations of human relationships through photography and film'. In 2002 she was given a major solo exhibition at the Hayward Gallery. *Self Portrait in a Single Breasted Suit with Hare* (above) documents a confrontation with her own mortality, following treatment for breast cancer. She explains, 'The hare symbolizes lust and passion, so here I am with a head of hair, in a single-breasted suit, holding on to lust and passion.' Sam Taylor-Wood lives and works in London and is married to the art dealer Jay Jopling. Her work is in **Tate** and at the **National Portrait Gallery**. She is represented by **White Cube**.

Freischwimmer 117 (2007) C-type print 180 x 240 cm

WOLFGANG TILLMANS was born in Remscheid, Germany, in 1968. Surrounded by a family of amateur photographers, he began taking photography seriously before he left secondary school. In 1990 he moved to England and studied at the Bournemouth and Poole College of Art and Design, swapping the rave scene in Germany for that in England. He lived and worked in London for a time (1992-94), relocating to New York in 1994. After his partner, the painter Jochen Klein, died in 1997, Tillmans returned briefly to Cologne before settling in east London. His photography includes a long list of portraits of both known and unknown sitters. *Freischwimmer 117* (above) is from a series of abstract works (*Freischwimmer* denotes a person who swims or lives freely). In 2000 Tillmans was awarded the Turner Prize for a series of photographs that included portraits, still lifes and images of Concorde in flight. He was not only the youngest artist to receive the prize – he was also the first photographer. Wolfgang Tillmans lives and works in London. His work is in **Tate**. He is represented by **Maureen Paley**, and he welcomes visitors to his nearby studio, where he has established a small but influential gallery (Between Bridges, 223 Cambridge Heath Road E2 0EL, Tues-Sun, 12.00-6.00pm).

Ziggurat II (1964) acrylic on wood relief 203 x 157 cm

JOE TILSON was born in London in 1928. He worked as a carpenter and joiner before military service with the Royal Air Force until 1949. He studied art at St Martin's School of Art and at the Royal College of Art, receiving the Rome Prize which led him to live in Italy in 1955. He has worked in a wide variety of materials – combining painting, woodcuts, collage – and explored many themes. His early work was based on a relatively conventional interpretation of subject matter taken from his surroundings and his travels. But then he began to produce reliefs in wood, taking advantage of his skills as a carpenter. A highly formalized abstract language was developed, often consisting of simple geometric forms. He is perhaps particularly noted as a pop artist and for the silkscreen prints he produced between 1964 and 1969. He first gained international recognition in 1964, when he represented Britain at the Venice Biennale, and his first one-man shows were held at the Marlborough Gallery, London (1962) and at the Walker Art Gallery, Liverpool (1963). Joe Tilson lives and works in London and Tuscany. He is represented in London by **Waddington Galleries**, and his prints are available at **Alan Cristea Gallery**.

If You Can Dream It You Must Do It (2003)
transparency in a light box 180 x 120 x 20 cm

MARK TITCHNER was born in Luton, Bedfordshire, in 1973. He studied at Hertfordshire College of Art and Design and for his degree in fine art at Central St Martin's College of Art and Design. It was while at St Martin's that he realized he wanted more in his work than geometric abstraction, and he found expression for his ideas and values in the banners and billboards that combine political entreaty and advertising speak. The slogans can come from anywhere as long as the language is simple and direct. 'We react to language in a completely different way [than we do to visuals]; you can't stop yourself from reading a word. It's a real moment of power,' he says. In 2004 he was commissioned by Platform for Art to produce a series of huge billboard pieces. The style of trade-union banners, protest art and revolutionary slogans, and the associations of the Arts and Crafts movement of William Morris, form a highly stylized background for his texts. He was nominated for the Turner Prize in 2006 (won that year by the painter Tomma Abts). Not all his work is 'slogan driven', but in his diverse sculpture, installation pieces and video, his belief in the power of language still finds expression in his titles, as in the stirring *When We Build Let Us Think That We Build Forever*. Mark Titchner lives in London. His work is in the collections of Tate and Saatchi Gallery. He is represented by Vilma Gold.

Me as Him, detail (2007) silkscreen ink on acrylic paint on canvas 100 x 100 cm

GAVIN TURK was born in Guildford, Surrey, in 1967. He studied at the Royal College of Art but was denied his final degree because the tutors apparently did not understand his show. *Cave* consisted of a whitewashed studio space and a single piece of sculpture – a replica of a blue English Heritage plaque bearing the words 'Borough of Kensington, Gavin Turk, Sculptor 1989-1991 worked here'. The notoriety surrounding him attracted attention, not least that of Charles Saatchi, who immediately collected his work. Ambiguity, arrogance and self-effacement all combine in Turk's sculpture, prints, painting and videos. He continues to reflect something of himself in his work, either by the paintings of his signature (which raise issues of authorship and ownership) or by casting himself in life-size sculptures of 'famous' people, including Sid Vicious, Elvis Presley and Che Guevara. He mixes materials to create mischief or magic, casting in bronze and then painting to produce what appears to be a rubbish bag or a down-and-out's sleeping bag, or painting an industrial skip in immaculate gloss black. *Me as Him* (above) is from a series of the artist portraying Andy Warhol in his fright wig. Gavin Turk lives and works in London. His work is in many collections, including **Tate** and **Saatchi Gallery**. He is represented by **White Cube** and can also be seen at **Riflemaker**.

9 - (1963) oil on canvas 152.4 x 101.6 cm

WILLIAM TURNBULL was born in Dundee, Scotland, in 1922. He studied at the Slade School of Fine Art, where he met, and became friends with, Eduardo Paolozzi. Together they visited Jean Dubuffet's Foyer de l'Art Brut in Paris in 1947. Subsequently Turnbull spent two years in Paris, where he met other avant-garde artists, notably Fernand Léger, Alberto Giacometti and Constantin Brancusi. Back in London he was reunited with Paolozzi and another friend, Richard Hamilton, and joined the Independent Group, a discussion forum at the Institute of Contemporary Arts. During the 1950s he began to feel that a lot of contemporary art was becoming self-conscious. The way forward, he decided, was to rethink the process of making meaningful art. Beginning with a blank space (in sculpture) or a blank canvas (in painting), he built works from elementary forms or marks, allowing the spaces between shapes to contribute to the composition. In 1952 Turnbull exhibited at the Venice Biennale, with, among others, Kenneth Armitage and Henry Moore, under the banner 'New Aspects of British Sculpture'. Mark Rothko and Clyfford Still made a big impression when he visited New York in 1957, influencing his work from that point onwards. Other inspirations include oriental art and philosophy. William Turnbull lives and works in London. His work is in **Tate**. It can also be seen at **Waddington Galleries** and **James Hyman Gallery**.

Five Angels for the Millennium (2001) video/sound installation: five channels of colour video projection on walls in large, dark room; stereo sound for each projection (channels variable duration)

BILL VIOLA was born in New York City in 1951. He studied at the College of Visual and Performing Arts at Syracuse University, New York, graduating with a BFA. He is recognized as one of the pioneers in the medium of video art, now established as a vital form of contemporary art. He uses the medium, including video tapes, flat-panel video pieces, architectural video installations, sound environments and electronic music, to reflect his interest in the universal human experiences of birth, death and the unfolding of consciousness. Influences from diverse spiritual traditions, as well as Eastern and Western art, combine to inform his work. Water is a constant theme, stemming from the dramatic experience of nearly drowning as a young boy. In the image above, from the video/sound installation *Five Angels for the Millennium* (above), bodies burst through water. Bill Viola represented the USA at the Venice Biennale in 1995. He lives and works in Long Beach, California. His work is in **Tate**. He is represented in London by **Haunch of Venison**.

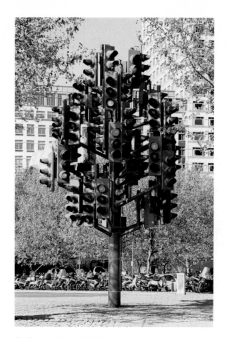

Traffic Light Tree (1998) painted steel and lights
8m height

PIERRE VIVANT was born in Paris in 1952. Since 1973 he has been producing and exhibiting works on both sides of the Channel. During 1990 he was sculptor-in-residence at the University of Warwick. Around this time his touring exhibition *Made in England* demonstrated an interest in the ways in which the readily available materials of any place – a park, a field, a building falling apart – can be turned to use in the creation of (often temporary) sculpture. His work is sometimes site-specific installations for galleries and museums, much more frequently commissioned pieces created for specific urban or rural spaces, and it demonstrates his continuing investigation of sculpture's place and meaning within landscape. In 1998 he was commissioned and funded by the Public Art Commissions Agency to replace a dying London plane tree at Canary Wharf. *Traffic Light Tree* (above), situated on a roundabout, is a sculpture made up of 75 sets of traffic lights, which change arbitrarily. The form of the work suggests natural landscape, while the changing patterns of the lights reflect the rhythm of life in the surrounding financial and commercial quarters. Pierre Vivant commutes between his Oxford and Paris studios.

State Britain (2006) mixed media

MARK WALLINGER was born in Chigwell, Essex, in 1959. He studied art at Chelsea School of Art and at Goldsmiths College. In the early 1990s he began using his love of horse-racing to explore issues of class and pedigree. In 1991 he exhibited a series of full-length portrait paintings of the homeless called *Capital* at the Institute of Contemporary Arts; they were bought by Charles Saatchi and later exhibited at his gallery, along with Wallinger's paintings of racehorses. His painting of another racehorse, *Half-Brother (Exit to Nowhere – Machiavellian)* (1994-95), earned him a first nomination for the Turner Prize in 1995 (won that year by Damien Hirst for *Mother and Child Divided*). In 1998 he was awarded the Henry Moore Fellowship at the British School in Rome. In 1999 he was commissioned to create a piece of public sculpture for the Fourth Plinth in Trafalgar Square: *Ecce Homo* (in 'marble-ized' resin, barbed wire and gold leaf) is a dramatic and moving life-size cast of a young man representing Christ, placed on the very edge of the plinth. He represented Britain at the Venice Biennale in 2000, and in 2007 he won the Turner Prize for his installation/exhibition *State Britain* (above) – a faithful re-creation of the peace campaigner Brian Haw's Parliament Square protest. Mark Wallinger lives and works in London. His work is in collections including **Tate** and **Saatchi Gallery**. He is represented by **Anthony Reynolds Gallery**.

Self Portrait as my Mother Jean Gregory (2003) black and white print 135 x 116 cm

GILLIAN WEARING was born in Birmingham in 1963. She moved to London and studied art at Chelsea School of Art and Goldsmiths College. Describing her working method as 'editing life', she uses photographs and video to interact with the public, reflecting their insights into everyday life. A significant project was a series called *Signs That Say What You Want Them To Say and Not Signs That Say What Someone Else Wants You To Say*, begun in 1992, in which she photographed people in the street holding placards on which they had been asked to write their spontaneous thoughts. Wearing's first solo exhibition was at City Racing in 1993, and that year she won the BT Young Contemporaries Prize. Her work was included in *Sensation* with other YBAs from the Saatchi Collection in London, Berlin and New York (1997-2000). In 1997 she also won the Turner Prize – for the development of her work at the Henry Moore studio and a video work, *10:16*, shown at the Chisenhale Gallery. A major solo show followed at the Serpentine Gallery in 2000. Gillian Wearing lives and works in London. Her work is in the collections of **Tate**, **National Portrait Gallery** and the Arts Council. She is represented by **Maureen Paley**.

Mr Miami (2004) steel, Q-Cell, glass, electronics and speakers
167 x 104 x 90 cm

GARY WEBB was born in England in 1973. He studied at Goldsmiths College, gaining a BA in fine art. He had his first solo exhibition in a public space at Chisenhale Gallery in 2004. Fascinated by our obsession with pop culture, consumer goods and mass-production, he employs a range of materials, including glass, marble, plastic, metal, rubber – and sound. In *Mr Miami* (above) mini speakers are perched on the uppermost bough of a glass-blown, bubblegum tree, emitting mumblings and noises created by the artist: 'to up the personal level – you need the sound just to talk to you a bit'. The shapes bring to mind Constantin Brancusi, Barbara Hepworth, Henry Moore, but with a shiny playfulness that roots them in the present. He works with drawings initially, letting ideas build until they synthesize in a 3D representation. He suggests references as they develop – a sushi meal, say, or a pole-dancing frame – to create an identity for what might evolve. Several people are then separately involved in producing the parts until the whole is arrived at by design, invention or surprise. In 2006 he was part of *British Art Show 6*, a Hayward touring exhibition organized on behalf of the Arts Council. Gary Webb lives and works in London. His work is in the collections of **Tate** (an installation titled *Sound of the Blue Light*, 2002) and **Saatchi Gallery**. He is represented by **The Approach** and can also be seen at **Karsten Schubert**.

Untitled (Stairs) (2001) mixed media 375 x 580 cm

RACHEL WHITEREAD was born in London in 1963. She tackles ambitious, often monumental, sculpture, using plaster, resin, rubber and cement, and seeks to make the invisible visible in casts of empty spaces. She studied painting at Brighton Polytechnic and the Slade School of Fine Art, where she turned her attention to sculpture. The year after she graduated, she had her first solo exhibition at the Carlyle Gallery, London. In the early 1990s she was linked to the diverse group of YBAs, young artists in London who had mainly studied at Goldsmiths College. *House*, her full-size cast of the inside of a house in the East End of London, brought a mixture of critical acclaim and public derision. To the latter the local council responded – pulling the piece down as soon as it won a prize. But not all her work is monumental. She treats the same theme of unseen space in domestic contexts: under a bed, behind a bookshelf, spaces we do not consider. Her innovative body of work soon received accolades: the Turner Prize for *House* in 1993 and a medal at the 1997 Venice Biennale. In 2001 her upside-down transparent resin cast of the plinth itself, *Monument*, was installed on the Fourth Plinth in Trafalgar Square. Rachel Whiteread lives and works in east London. Her work is in collections including **Tate**, **Saatchi Gallery** and **University College London Art Collections** (Strang Print Room). She is represented by **Gagosian Gallery**.

20:50 (1987) wood, steel and used sump oil (dimensions variable)

RICHARD WILSON was born in London in 1953. He studied design at the London College of Printing but, deciding he wanted to make things, switched to sculpture, studying at Hornsey College of Art and completing his MFA at Reading University. Tweaking our preconceptions of space is what Wilson does in spades. His masterpiece of spatial perplexity appeared in 1987, when he created *20:50* (above), a new piece for Matt's Gallery. Thanks to the enterprising (if not courageous) spirit of Matt's, he filled the gallery with discarded 20:50 sump oil (which explains the title). The effect was magical and mesmerizing. The beauty of the still, inky liquid transformed the space it reflected, turning the room and the world literally upside down. In the decades since that installation, his work has continued to be ambitious and groundbreaking. In his 2006-07 Curve exhibition at The Barbican he bored giant holes in a London cab, suspended a spinning caravan and reconfigured a crushed burger stand. Richard Wilson lives and works in London. A permanently sited work, *Slice of Reality*, is on the River Thames near The 02; a vertical section of a sand dredger, it was commissioned for the Millennium Dome New Sculpture Project in 2000. His work is in the collections of the **British Museum**, **Tate**, Government Art, Arts Council, British Council and **Saatchi Gallery** (*20:50* is shown in Saatchi's most recently opened gallery, in Chelsea).

Sitting on History 1 (1995) bronze 100 x 107 x 300 cm

BILL WOODROW was born in Oxfordshire in 1948. He studied at Winchester School of Art, St Martin's School of Art and Chelsea School of Art, and had his first solo exhibition at Whitechapel Art Gallery in 1972, when in his final year at Chelsea. His early sculptures were created out of discarded materials found in junkyards and carbreaker's lots. Turning scrap into new forms was in part a comment on the excesses of consumerism. He began working in bronze in the late 1980s, taking up the theme of story-telling in his work. In 1986 he was nominated for the Turner Prize for *Self Portrait in the Nuclear Age* (1986). *Sitting on History 1* (above) was originally designed for an exhibition at the Tate Gallery in 1996; the open book tethered by a ball and chain views the book as the keeper of information. The volumes used for the maquette had been discarded as unsaleable, and to Woodrow's wry amusement included three volumes of Labour Party history. *Regardless of History* was exhibited on the Fourth Plinth in Trafalgar Square in 2000. Bill Woodrow lives and works in south London, his vast studio in the same building as that of Anish Kapoor. His work is in the collections of **Tate**, British Library (another cast of *Sitting on History*), **British Museum**, **Imperial War Museum**, Arts Council, British Council and Government Art. He is represented by **Waddington Galleries**.

Sad Cowboy (first version) (2007) oil on canvas 115.5 x 133 cm

TOBY ZIEGLER was born in London in 1972. He studied at Central St Martin's College of Art and Design and had a residency at Delfina Studios between 2004 and 2006. While gaining an international presence, his work is also increasingly on view in London. He has exhibited in group shows such as *Archipeinture: painters build architecture* at the Camden Arts Centre and *Recent Abstraction* at Tate Britain. He had his first solo show, *Enter Desire,* at the Chisenhale Gallery in 2005. His work has its origin in computer aided design. For both his paintings and sculptures he creates virtual three-dimensional models. These are actualized in a series of rigorous schematic processes and then sabotaged in spontaneous and random acts of violence. His paintings juxtapose a geometric grid – to create the pictorial space – and more expressive, painterly gesture. The sculptures are constructed from hundreds of tessellating polygons of paper, cardboard and plywood, often assembled using more visceral and less predictable material, such as resin, gesso and horse hair. The motifs that he chooses to work with tend to reflect art-historical models that have some resonance with current socio-political situations. Toby Ziegler lives and works in London. His work can be found in the collections of the Arts Council, Tate and Saatchi Gallery. He is represented by Simon Lee Gallery.

Directory

Detailing over **300 public** and **private galleries, art venues, public art, art schools** and **art fairs** in **London**, plus **15 special features**, covering **must-see galleries, fairs** and **organizations**. Opening days and times vary considerably, especially among private galleries. Ring ahead or check websites before visiting.

PUBLIC GALLERIES, ART VENUES AND ORGANIZATIONS

Adventure Ecology
125 Charing Cross Road
WC2H 0EW
t: 020 7758 4717

www.adventureecology.com
See The Gallery

Apt
Harold Works
6 Creekside SE8 4SA
t: 020 8694 8344
⊖ *New Cross* ⇌ *Deptford*

www.aptstudios.org

A registered charity committed to promoting the value of creativity through the visual arts. Artists include Heather Burrell, Mali Morris, Andy Parsons, David Webb.

Architecture Foundation
2a Kingsway Place
Sans Walk EC1R 0LS
t: 020 7253 3334

www.architecturefoundation.org.uk

Non-profit organization in the grounds of Kingsway House. Arranges competitions, lecture series, events and debates as well as exhibitions. New premises in Southwark Street in 2009, designed by Zaha Hadid.
MAP 9/33

Artangel
www.artangel.org.uk

A non-profit art trust set up to commission artists to produce work on a challenging scale for site-specific projects. James Lingwood and Michael Morris, co-directors of Artangel since 1991, have pioneered a new way of collaborating with artists and engaging audiences in an ambitious series of highly successful commissions. With Rachel Whiteread, for example, the chance to cast a whole house in 1993 was a logical progression from her casting of smaller domestic spaces. For each project, Artangel sends out a leaflet detailing the artist(s), work and venue, and patrons or 'angels' enjoy a unique engagement with a commission's development and presentation. Both angels and earthlings can benefit freely from exhibitions.

Autograph ABP
6-8 Standard Place
Rivington Street EC2A 3BE
t: 020 7739 8748

www.autograph-abp.co.uk
See Rivington Place

Bankside Gallery
48 Hopton Street SE1 9JH
t: 020 7928 7521

www.banksidegallery.com

Home to the Royal Watercolour Society and the Royal Society of Painter-Printmakers, it has exhibitions of contemporary watercolours and original prints.
MAP 9/8

The Barbican
Silk Street EC2Y 8DS
t: 0845 121 6828

www.barbican.org.uk
SEE PAGE 117

Beaconsfield
22 Newport Street SE11 6AY
t: 020 7582 6465

www.beaconsfield.ltd.uk
This gallery has charity status

and aims to reflect the diversity of London through contemporary art in all disciplines.
MAP 10/1

Ben Uri Gallery
The London Jewish Museum of Art
108a Boundary Road NW8 0RH
t: 020 7604 3991

www.benuri.org.uk

A showcase for British and international artists of Jewish descent. Includes photography, installation and painting.
MAP 2/1

Bloomberg SPACE
50 Finsbury Square EC2A 1HD
t: 020 7330 7959

www.bloombergspace.com

In the European headquarters of an information service-provider, this gallery is dedicated to commissioning and exhibiting contemporary art. Emerging and established international artists are encouraged to experiment.
MAP 12/14

Bow Arts Trust and Nunnery Gallery
181-83 Bow Road E3 2SJ
t: 020 8980 7774
⊖ *Bow Road DLR Bow Church*

www.bowarts.com

An educational arts charity, working with artists, curators and art organizations. About five exhibitions a year reflect issues in contemporary art.

The British Museum
Great Russell Street
WC1B 3DG
t: 020 7323 8299

www.thebritishmuseum.ac.uk
Alongside the collections of

archaeological and ethnographic material, there are works by living artists in the departments of Prints and Drawings, Africa, Oceania and the Americas.
MAPS 8/31, 9/21

Café Gallery Projects
Southwark Park SE16 2UA
t: 020 7237 1230

www.cafegalleryprojects.org

Bermondsey Artists' Group was established by artists living and working in Southwark. Now a charity managing a lottery-funded, purpose-built gallery in the centre of Southwark Park. In the south-west corner of the park is Dilston Grove, a raw space also used for exhibitions. A diverse programme.
MAP 1/14

Camden Arts Centre
Arkwright Road NW3 6DG
t: 020 7472 5500

www.camdenartscentre.org
SEE PAGE 119

Cell Project Space
258 Cambridge Heath Road E2 9DA
t: 020 7241 3600

www.cell.org.uk

A non-profit, artist-led initiative exhibiting the work of young, emerging and undiscovered artists alongside more established names.
MAP 13/34

C4RD
Centre for Recent Drawing
2-4 Highbury Station Road N1 1SB
t: 020 7871 7367

www.c4rd.org.uk

Provides an exhibition space and webservice dedicated to current thinking about drawing as a fundamental medium of human experience outside the contexts of commerce and institutional education.
MAP 11/23

CHELSEA space
Chelsea College of Art and Design
16 John Islip Street SW1P 4JU
t: 07841 783 129

www.chelseaspace.org

Contemporary artists and designers are invited to show on college campus. Shows also include Chelsea's interesting collection of artists' books and editions. Check website for regular talks and public events.
MAP 6/6

Chisenhale Gallery
64 Chisenhale Road E3 5QZ
t: 020 8981 4518
⊖ Bow Road ⇌ Cambridge Heath

www.chisenhale.org.uk

This is a charitable organization promoting artists in the early stages of their careers. Five high-calibre solo shows of British and international artists' work a year in a converted factory space.

Coleman Projects Space
94 Webster Road SE16 4DF
t: 020 7237 9120

www.colemanprojects.org.uk

Actively supported by local funding, this space exhibits local artists working in various media.
MAP 1/16

Contemporary Art Society
www.contempart.org.uk
SEE PAGE 123

Courtauld Institute of Art
Somerset House
Strand WC2R 0RN
t: 020 7848 2777

www.courtauld.ac.uk
www.eastwingcollection.org.uk

A biennial exhibition of contemporary art takes place in the communal spaces and teaching rooms of the institute. Also curates exhibitions on the River Terrace. *The East Wing Collection* is a biennial exhibition curated by a committee of students and showcases the work of contemporary artists.
MAP 9/13

Dalí Universe
County Hall Gallery
Riverside Building SE1 7PB
t: 020 7450 7612

www.countyhallgallery.com

On the Thames, next to the London Eye, County Hall hosts Dalí Universe, dedicated to the works of Salvador Dalí, including a collection of his sculpture. The gallery also has original works by Pablo Picasso and Marc Chagall.
MAP 10/12

Design Museum
28 Shad Thames SE1 2YD
t: 0870 833 9955

www.designmuseum.org

For those interested in the increasing cross-over between art and design, the museum is a champion of British design.
MAP 12/9

Deutsche Bank
Winchester House
1 Great Winchester Street EC2N 2DB
t: 020 7545 8000

www.deutsche-bank-art.com
Works installed in the lobbies are

visible from the reception desk and through the street windows. They include Anish Kapoor's *Turning the World Upside Down III* and Damien Hirst's *Biotin-Malemide. Secretions,* a sculpture by Tony Cragg, is in the rear foyer, as is the enormous mural *The Swimmer in the Econo-mist* by American pop artist James Rosenquist.
MAP 12/27

The Drawing Room
Brunswick Wharf
55 Laburnum Street E2 8BD
t: 020 7729 5333

www.drawingroom.org.uk

Dedicated to the investigation and support of contemporary drawing practice, the gallery provides a unique resource for the promotion of the theory and methodology of drawing. Drawings for sale include work by Charles Avery, Polly Abfelbaum, Matt Hale, Rachel Lowe and Aaron Kasmin.
MAP 13/17

Elastic Residence
22 Parfett Street E1 1JR
t: 020 7247 1375

www.elastic.org.uk

In a 1779 house in Whitechapel, this is a gallery space for projects and performance.
MAP 12/32

Estorick Collection of Modern Italian Art
39a Canonbury Square N1 2AN
t: 020 7704 9522

www.estorickcollection.com

In six galleries in a Grade II-listed Georgian villa, the collection is known for its core of futurist works, as well as figurative art and sculpture. Artists include Umberto Boccioni, Giorgio de Chirico, Amedeo Modigliani, Giorgio Morandi, Gino Severini.
MAP 11/22

Fieldgate Gallery
14 Fieldgate Street E1 1ES
t: 07957 228 351

www.fieldgategallery.com

A 930-square-metre, non-commercial contemporary art gallery and project space.
MAP 12/31

Fleming Collection
13 Berkeley Street W1J 8DU
t: 020 7409 5730

www.flemingcollection.co.uk

Great collection of Scottish artists' work from 1770 to the present day.
MAP 7/54

Freud Museum
20 Maresfield Gardens NW3 5SX
t: 020 7435 2002

www.freud.org.uk

Freud's home preserved very much as during his lifetime. As well as lectures and exhibitions relating to Freud, there are, on an irregular schedule, exhibitions by contemporary artists.
MAP 2/5

The Gallery
125 Charing Cross Road WC2H 0EW
t: 020 7287 1779

www.thegallerysoho.com

Four floors of versatile space: a collaborative workplace shared by artists, photographers, environmentalists and designers. There is a bar on floor 2. Adventure Ecology, a charity founded by David de Rothschild and a significant new voice on ecology, is based here. Focused arts and education programmes address the real current and future issues surrounding the relationship between people and the environment worldwide.
MAP 8/42

Gasworks
155 Vauxhall Street SE11 5RH
t: 020 7587 5202

www.gasworks.org.uk

Hosts up to six exhibitions and 12 residences per year, profiling emerging or mid-career international or British artists.
MAP 1/18

The Hayward
Southbank Centre
Belvedere Road SE1 8XZ
t: 020 7921 0813

www.hayward.org.uk
SEE PAGE 129

Imperial War Museum
Lambeth Road SE1 6HZ
t: 020 7416 5000

www.iwm.org.uk

Impressive collection of official commissions during two world wars, including pieces by Paul Nash, Stanley Spencer, John Piper, Graham Sutherland. More recent commissions include John Keane, Peter Howson and (in 2002) Langlands & Bell.
MAP 10/4

Institute of Contemporary Arts (ICA)
12 Carlton House Terrace
The Mall SW1Y 5AH
t: 020 7930 0493

www.ica.org.uk

Established in 1947 by a collective of artists, poets and writers associated with the avant-garde to showcase and

The Barbican

Silk Street EC2Y 8DS
t: 0845 121 6828
www.barbican.org.uk
MAP 12/13

Designed in the 1960s, constructed in the 1970s and opened in 1982, The Barbican is owned and managed by the City of London, the third largest funder of the arts in the UK. The entire complex is Europe's largest multi-arts venue, presenting a year-round programme of art, music, film, theatre, dance and education, as well as being the London home of the London Symphony Orchestra. When discussions were initiated about how to use the 35-acre bomb site where The Barbican now stands, Sir Edward Howard, a former Lord Mayor of London, was less than convinced there was a need for such an arts centre. The architects, Chamberlin, Powell and Bon, designed the building in the belief that within five years private cars would not be used in London. After much delay and over-budget, The Barbican came into being and today, after 25 years, the venue has finally found its form. Opinion remains divided over the brutalist design, but once inside, the pulse of contemporary culture is captivating.

A 33m wall of light sculptures by Alex Hartley features in the foyer at the Silk Street entrance. On the third floor the Barbican Art Gallery puts on large-scale exhibitions by leading international figures of contemporary art in photography, fine art and design, including past exhibitions by Nobuyoshi Araki, Yves Klein and Christian Marclay. The smaller, horse-shoe gallery on the ground floor, The Curve, is a curated space for commissions; contemporary artists have included Andy Goldsworthy, Lucy Orta, Toby Paterson, Grayson Perry and Richard Wilson.

The Barbican Art Gallery is now part of Arts Council England's Own Art scheme (an interest-free way to buy art). This includes limited-edition prints, available from the Barbican Art Gallery bookshop.

The Barbican Art Gallery and The Curve are part of *Time Out* magazine's First Thursdays programme. On the first Thursday of every month the galleries and museums of East London open until late and The Barbican until 10.00pm. A map of the 80 participating exhibitors and details of the bus tours guided by leading curators, academics and artists are on the website: www.firstthursdays.co.uk

champion contemporary culture across a wide range of art forms. Today, the ICA has two galleries, two cinemas, a theatre, a great bookshop, a bar, café and private function rooms. Through the ICA Club, it offers a forum for the creative industries, networking opportunities and organized events. The bookshop carries a wide selection of art books, magazines and DVDs, available both in-store and on-line.
MAP 6/16

Institute of International Visual Arts (inIVA)
6-8 Standard Place
Rivington Street EC2A 3BE
t: 020 7729 9616

www.iniva.org

See Rivington Place

Jerwood Space
171 Union Street SE1 0LN
t: 020 7654 0171

www.jerwoodspace.co.uk

In a refurbished Victorian school, the 240-square-metre gallery encourages young and emerging artists. Focus is on the Jerwood prizes in painting, sculpture, drawing and photography. The café showcases new art, and Don Brown's sculptures are in the glass-covered courtyard.
MAP 10/7

Louise T. Blouin Foundation
3 Olaf Street W11 4BE
t: 020 7985 9600
⊖ Latimer Road/Holland Park

www.ltbfoundation.org

Exhibitions of contemporary art are supported by an ambitious arts foundation. Recent projects include cultural exchanges with China and the Middle East.

Mall Galleries
17 Carlton House Terrace
The Mall SW1Y 5BD
t: 020 7930 6844

www.mallgalleries.org.uk

Home to the Federation of British Artists (FBA), an umbrella organization for nine leading art societies. Its aim is to bring fine art by contemporary artists to the public. An artist is usually in attendance during exhibitions.
MAP 6/15

MOT
Unit 54 Floor 5
Regent Studios
8 Andrew's Road E8 4QN
t: 07931 305 104

www.motinternational.org

A non-profit exhibition space that gives artists the freedom to explore areas of art practice. Don't be put off by the industrial setting. MOT is artist-run and mixes shows by new talent with established artists.
MAP 13/25

The National Gallery
Trafalgar Square WC2N 5DN
t: 020 7747 2885

www.nationalgallery.org.uk

Houses the national collection of Western European art from about 1250 to 1900, but contemporary art exhibitions are also held here - often with some link to the past, as, for example, in the work of photographer Tom Hunter (see page 56). The Associate Artist Scheme enables leading contemporary artists to create work that connects to the National Gallery collection, and is designed to demonstrate the continuing inspiration of the old-master tradition. Past associate artists include Peter Blake, Ron

Mueck, John Virtue, and Paula Rego, whose *Crivelli's Garden* mural is in the National Dining Rooms (see page 86).
MAP 9/16

National Portrait Gallery
St Martin's Place WC2H 0HE
t: 020 7312 2463

www.npg.org.uk

The most recent portraits may be viewed on the ground floor. *The BP Portrait Award* is an annual exhibition featuring the best in contemporary portrait painting.
MAP 9/17

New Contemporaries

www.newcontemporaries.org.uk

Sponsored by Bloomberg, *New Contemporaries* is an annual travelling exhibition providing galleries such as Camden Arts Centre with the very best of the newest contemporary art. The aim is to give artists still at, or just after, art school a chance to show their work with professional galleries. Candidates face open competition for a place, with curator Sacha Craddock heading a rigorous selection committee.

176
176 Prince of Wales Road
Chalk Farm NW5 3PT
t: 020 7428 8940

www.projectspace176.com

The Zabludowicz Art Trust turned a Victorian chapel into this vast gallery, housing the collection Anita Zabludowicz put together over 12 years. The focus is on emerging artists of the late 20th and 21st centuries, including many from Britain, Germany and North America. Artists include Vanessa Beecroft, Tracey Emin, James Ireland,

Camden Arts Centre

Arkwright Road NW3 6DG
t: 020 7472 5500
www.camdenartscentre.org
MAP 2/4

Camden Arts Centre is certainly worth a dedicated visit. You can count on seeing fresh and risk-taking work from artists new to the art scene, well-known figures heading in an unexpected direction and artists from the past who are providing inspiration for today's practitioners. Since its £4.2 million refurbishment in 2004, Camden has re-affirmed its status as a focal point in London's cultural landscape, showing the work of British and international artists in a broad range of work including installation, film and video, light-sensitive drawings, sculpture and live art performances.

The commitment to contemporary artists is constantly reinforced by the director, Jenni Lomax. The centre has been acclaimed for its artist-curated exhibitions, and exhibiting artists are involved in the talks and events programme. An artist-in-residence scheme also offers the opportunity to meet and discuss ideas with artists at work. Older or more established artists' work is often shown alongside that of younger generations, tracing a development of ideas or influences.

The three spacious galleries are sometimes given to one artist, sometimes shared between two exhibitions. Each year there is also a group show, presenting a stimulating selection of work. The needle of the centre's contemporary art compass certainly indicates directions worth following - and these can be further researched in the reading room and in the excellent bookshop. Late openings on Wednesday evenings include talks, open studios and live art performances.

The Grade II listed former library was built in 1897 and has been an art centre since 1960. Tony Fretton Architects, who co-ordinated the redevelopment in 2004, have combined original features with functional contemporary design and lighting to make the galleries among the best in London for viewing contemporary art. A landscaped garden and large terraced area stretch out beyond the café.

Past exhibitions include artists Sophie Calle, Martin Creed, Francis Picabia, Christopher Wool and Cerith Wyn Evans and artist-selected exhibitions such as *An Aside* by Tacita Dean (2005) and *Thinking Aloud* by Richard Wentworth (1998).

Sarah Lucas, Tim Noble & Sue Webster, Keith Tyson.
MAP 1/8

Outset

www.outset.org.uk

Outset Contemporary Art Fund, founded in 2003 by Yana Peel and Candida Gertler, is dedicated to supporting new art. The charitable foundation focuses on bringing private funding from its supporters and trustees to public museums, galleries and art projects. Supporters are a diverse group, from early-stage enthusiasts to experienced collectors and professionals. Members enjoy lectures, gallery previews, advice on collecting and visits to private studios.

Parasol unit
14 Wharf Road N1 7RW
t: 020 7490 7373

www.parasol-unit.org

A non-profit gallery space and art foundation, set up by the curator Ziba de Weck, showcases the work of leading international contemporary artists in 800 square metres of architecturally impressive space designed by Claudio Silvestrin.
MAP 11/15

Platform for Art
www.tfl.gov.uk/tfl/corporate/projectsandschemes/artmusicdesign/pfa/about.asp

London Underground's public art programme designed to showcase a vibrant art scene while enhancing the journeys of passengers.

Pump House Gallery
Battersea Park SW11 4NJ
t: 020 7350 0523

⇌ *Battersea Park/Queenstown Road Battersea*

www.wandsworth.gov.uk/gallery

Four contemporary-art exhibition and venue spaces are housed in a Victorian listed building in a beautiful setting.

Rivington Place
6-8 Standard Place
Rivington Street EC2A 3BE
t: 020 7729 9616

www.rivingtonplace.org

The building, by David Adjaye, houses inIVA (Institute of International Visual Arts) and Autograph ABP. inIVA promotes artists from culturally diverse backgrounds, and has worked with Zarina Bhimji, Sonia Boyce, Mona Hatoum, Isaac Julien, Chris Ofili, Yinka Shonibare, MBE. Autograph ABP (Association of Black Photographers) is a photographic agency run by Mark Sealy (also joint CEO of Rivington Place), publishing and exhibiting work that addresses issues of cultural identity and human rights. Rivington Place also hosts solo shows, installation commissions, exhibitions of young and emerging artists, and large-scale international exhibitions as well as talks, seminars and film screenings.
MAP 13/6

Royal Academy of Arts
Burlington House
Piccadilly W1J 0BD
t: 020 7300 8000

www.royalacademy.org.uk
SEE PAGE 139

Royal Institute of British Architects (RIBA)
66 Portland Place W1B 1AD
t: 020 7580 5533

www.riba.org

Mainly architecturally orientated exhibitions - some photography. Check out if in the area: a great space. Restaurant and bookshop.
MAP 8/12

Saatchi Gallery
Duke of York's Headquarters
King's Road SW3 4RY
t: 020 7823 2332

www.saatchi-gallery.co.uk
SEE PAGE 143

Serpentine Gallery
Kensington Gardens W2 3XA
t: 020 7402 6075

www.serpentinegallery.org
SEE PAGE 147

Sketch
9 Conduit Street W1S 2XG
t: 08707 706 515

www.sketch.uk.com

Although known as a restaurant, the main space functions by day as a video exhibition hall. The video programme features high-profile and up-and-coming artists, including Kader Attia, Brice Dellsperger, Tracey Emin, Guy Richards Smit. Each show runs for six weeks.
MAP 7/21

South London Gallery
65 Peckham Road SE5 8UH
t: 020 7703 6120
⇌ *Peckham Rye*

www.southlondongallery.org
SEE PAGE 149

Tate Britain
Millbank SW1P 4RG
t: 020 7887 8888

www.tate.org.uk/britain
SEE PAGE 153

Tate Modern

Sumner Street SE1 9TG
t: 020 7887 8888

www.tate.org.uk/modern

SEE PAGE 153

Unit 2

Central House
59-63 Whitechapel High Street
E1 7PF
t: 020 7320 1970

www.unit2.co.uk

Part of London Metropolitan University, the gallery offers solo shows, group exhibitions, collaborative projects, talks and other live events.

MAP 12/29

University College London (UCL) Art Collections

Strang Print Room
University College London
Gower Street WC1E 6BT
t: 020 7679 2540

www.art.museum.ucl.ac.uk

The Strang Print Room's fine collection has work illustrating the history of Slade School of Fine Art, with pieces by alumni David Bomberg, Augustus John, Gwen John, Paula Rego, Stanley Spencer, Rachel Whiteread.

MAP 8/18

Victoria & Albert Museum

Cromwell Road SW7 2RL
t: 020 7942 2000

www.vam.ac.uk

World-renowned museum of art and design with collections covering 3,000 years of civilization to the present day. Good programme of exhibitions, talks, events and study.

MAP 4/20

Wallspace

All Hallows on the Wall Church
83 London Wall EC2M 5ND
t: 07794 586 203

www.wallspace.org.uk

An exhibition space designed to explore the relationships between art and spirituality. Created by in-church curator Meryl Doney, it offers a range of surprising and enlightening exhibitions that demonstrate the richness, diversity and risk of contemporary work in this field. Artists have included Sokari Douglas Camp, Makato Fujimura, Damien Hirst, Sam Taylor-Wood.

MAP 12/26

Wellcome Trust

183 and 215 Euston Road
NW1 2BE
t: 020 7611 8888

www.wellcome.ac.uk

The trust has acquired the only mural produced in England by Picasso (see page 82), on view in the Wellcome Collection (183 Euston Road), which houses a great assembly of contemporary art. An intriguing, perhaps unique, collection of art focusing on the body - in medicine and health - is also housed in the Wellcome headquarters (215 Euston Road) and there are two historical pieces in the foyer.

MAP 8/20

Whitechapel Art Gallery

80-82 Whitechapel High Street
E1 7QX
t: 020 7522 7888

www.whitechapel.org

SEE PAGE 159

PRIVATE GALLERIES

Adam Gallery

24 Cork Street W1S 3NJ
t: 020 7439 6633

www.adamgallery.com

Specializes in modern masters, including Carl Andre, Joseph Beuys, Sol LeWitt, Joan Miró, Pablo Picasso. Also exhibits solo shows of international contemporary artists.

MAP 7/27

The Agency

15a Cremer Street E2 8HD
t: 020 7729 6249

www.theagencygallery.co.uk

Represents international young and mid-career artists.

MAP 13/15

Agnew's

43 Old Bond Street W1S 4BA
t: 020 7290 9250

www.agnewsgallery.co.uk

Founded in the early 19th century, this gallery continues its tradition of dealing in old master and English paintings, but also holds exhibitions of contemporary work.

MAP 7/63

Alan Cristea Gallery

31 Cork Street W1S 3NU
t: 020 7439 1866

www.alancristea.com

Alan Cristea has been publishing limited-edition prints for the past 30 years. For the last 13 years he has run his own gallery, which specializes in prints by both 20th-century masters and by some of the best living artists. An essential place to visit in Cork Street - in fact, in London. Artists include Gillian Ayres, Patrick

Caulfield, Jim Dine, Julian Opie. Expanded gallery next door shows work in other media.
MAP 7/31

Albemarle Gallery
49 Albemarle Street W1S 4JR
t: 020 7499 1616

www.albemarlegallery.com

Specializing in contemporary figurative, still-life and *trompe-l'oeil* work, together with urban and rural landscapes, the Albemarle represents both established and emerging artists and has regular group and solo shows.
MAP 7/57

Albion Gallery
8 Hester Road SW11 4AX
t: 020 7801 2480

www.albion-gallery.com

Designed by Foster and Partners, this gallery, with over 1,115 square metres of space, specializes in international artists, sculptors and photographers. Six to seven exhibitions a year; each one incorporates three solo shows. An impressive space on the Battersea side of the Thames.
MAP 4/1

Alexandre Pollazzon Ltd
11 Howland Street W1T 4BU
t: 020 7436 9824

www.alex-pollazzon.com

Focuses on eight exhibitions per year by international emerging and mid-career artists. Chelsea School of Art graduate Ben Wright designed the gallery.
MAP 8/14

Alexia Goethe Gallery
7 Dover Street W1S 4LD
t: 020 7629 0090

www.alexiagoethegallery.com

Exhibits a wide range of contemporary art as well as modern masters. Also publishes prints by represented artists.
MAP 7/58

Alison Jacques Gallery
16-18 Berners Street W1T 3LN
t: 020 7631 4720

www.alisonjacquesgallery.com

Artists include Uta Barth, Tomory Dodge, Graham Little, Robert Mapplethorpe, Tom Ormond, Tim Stoner, Catherine Yass.
MAP 8/36

Alla Bulyanskaya Gallery
31 Bury Street SW1Y 6AU
t: 020 7930 8100

www.allabulgallery.com

Collaborates with contemporary Russian artists, from recognized masters to painters and sculptors making their debut.
MAPS 6/22, 7/74

Allsopp Wedel
Allsopp Contemporary
8-10 Conlan Street W10 5AR
t: 020 8960 5355

www.allsoppwedel.com
www.allsoppcontemporary.com

These two galleries share the space to pool resources and experience, and specialize in contemporary artists from China, Britain, Europe and the USA.
MAP 1/4

Alma Enterprises
1 Vyner Street E2 9DG
t: 07769 686 826

www.almaenterprises.com

Run by a group of artists and curators, has a programme of experimental and interdisciplinary exhibitions and events.
MAP 13/26

Andipa Gallery
162 Walton Street SW3 2JL
t: 020 7589 2371

www.andipamodern.com

Shows a wide range of modern and contemporary artists, including a group of emerging names. Original works on paper, including drawings, paintings and signed limited editions.
MAP 4/15

Anne Faggionato
Floor 4
20 Dering Street W1S 1AJ
t: 020 7493 6732

www.annefaggionato.com

Modern and contemporary paintings, sculptures and works on paper. Artists' work previously sold includes Alberto Giacometti, Henry Moore, Roy Lichtenstein, Pablo Picasso.
MAPS 7/11, 8/5

Annely Juda Fine Art
Floor 4
23 Dering Street W1S 1AW
t: 020 7629 7578

www.annelyjudafineart.co.uk

Represents contemporary British, European and international artists. The gallery also exhibits masters of the 20th century avant-garde, with a special emphasis on the work of the Russian constructivists.
MAPS 7/13, 8/3

Anthony Reynolds Gallery
60 Great Marlborough Street W1F 7BG
t: 020 7439 2201

www.anthonyreynolds.com

Discovers young artists working in all media. Many of the artists who exhibited first in this gallery are now international names.

Contemporary Art Society

11-15 Emerald Street WC1N 3QL
t: 020 7831 1243
www.contempart.org.uk

2010 celebrates the centenary of the Contemporary Art Society, a unique non-profit agency that supports contemporary artists through its programme of collecting and commissioning by individuals and public and private bodies. The society has played a unique, visionary role in the formation of public and private collections in Britain, by buying work and giving it to collecting museums. Among the hundreds of artists whose work has been bought (often at the outset of their careers) are Paul Gauguin, Augustus John and Francis Bacon and contemporary artists Tony Cragg, Ian Davenport, Douglas Gordon, Hew Locke, Paul Noble, Simon Patterson, Yinka Shonibare, MBE, Richard Wentworth, Jane and Louise Wilson. The CAS also works with individuals and companies to build collections and commission public art, including a programme of outdoor public art commissions for The Economist Group at The Economist Plaza in St James's, London.

For the individual the CAS has a lot to offer too. The hundreds of galleries, art spaces and artists' studios in London make it a playground for anyone with an interest in art. For a professional guide to some of the best there is, join a CASt gallery tour. Held on the last Saturday of each month, CASt must be the friendliest and most rigorous alternative coach tour of the capital. Making seven or eight stops (plus one for lunch) in under six hours, it aims to uncover the cutting-edge of contemporary art, visiting far-flung and temporary venues alongside more established spaces. These tours are perfect for every type of art collector, for curators, art students or the simply inquisitive. Open to non-members, it is an event well worth exploring. If you live in London or visit frequently, the CAS runs various membership programmes for individuals, ranging from those with little experience of buying contemporary art through to those with significant collections. These programmes include visits to private homes, artists' studios, international trips, curator-led tours of exhibitions and much more.

Last but definitely not least, each year the CAS stages ARTfutures, the must-go place to buy contemporary art. The exhibition is open to the public and offers a snapshot of contemporary art practice, with work by artists ranging from recent graduates to established household names. For more information, see page 158.

Artists include Leon Golub, Lucy Harvey, Mark Wallinger.
MAPS 7/15, 8/37

The Apartment
9 Palace Court W2 4LP
t: 020 7221 1422

www.theapartment.uk.com

Leading contemporary artists and designers in an intimate living space. Pieces include furniture, paintings and photographs.
MAP 3/5

The Approach
Floor 1
47 Approach Road E2 9LY
t: 020 8983 3878

www.theapproach.co.uk

Located above a Victorian pub. Artists include Brett Cody Rogers, Jacques Nimki, Michael Raedecker, John Stezaker, Mari Sunna, Gary Webb, Martin Westwood. Second site opening at 74 Mortimer Street, W1.
MAP 13/36

The Aquarium L-13
63 Farringdon Road EC1M 3JB
t: 020 7206 0008

www.theaquariumonline.co.uk

Calling themselves the 'finest and roughest in art and publishing', The Aquarium's artists include James Cauty, Billy Childish, Daniel Johnston, Sexton Ming, Anne Pigalle, Jamie Reid.
MAP 9/31

Archeus
3 Albemarle Street W1S 4HE
t: 020 7499 9755

www.archeus.co.uk

Specialists in British and international contemporary art with an emphasis on established names. Artists include Dan

Flavin, Ellsworth Kelly, Yves Klein, Donald Judd, Andy Warhol.
MAP 7/61

Arte Vista
17 George Street W1U 3QL
t: 020 7935 5363

www.artevista.co.uk

Relocated from Amsterdam to London to bring the most established pop artists to a wider audience. Artists include Keith Haring, Benton, Ron English, Plusminus Produkties.
MAP 5/11

Art First
Floor 1
9 Cork Street W1S 3LL
t: 020 7734 0386

www.artfirst.co.uk

A contemporary art gallery exhibiting both established and less-known and younger British and international artists. It has a special 'Afro-Hebridean' focus on Scottish and South African art.
MAP 7/39

Art Space Gallery
Michael Richardson
Contemporary Art
84 St Peter's Street N1 8JS
t: 020 7359 7002

www.artspacegallery.co.uk

Art Space has a reputation for discovering emerging artists as well as exhibiting established names.
MAP 11/18

Associates
92 Hoxton Street N1 6LP
t: 020 7729 8173

www.associatesgallery.co.uk

A non-profit gallery. Twelve artists who have not had an exhibition in London are offered

a month each in the annual programme of shows run by Ryan Gander, an artist himself.
MAPS 11/14, 13/13

August art
Wharf Studios
Baldwin Terrace N1 7RU
t: 020 7354 0677

www.augustart.co.uk

Features British artists, including Emma Holden, Catherine Hughes, Paul Whittering.
MAP 11/17

Austin/Desmond Fine Art
Pied Bull Yard
68-69 Great Russell Street
WC1B 3BN
t: 020 7242 4443

www.austindesmond.com

Known initially for its focus on modern British and Irish artists, it now also includes international artists.
MAPS 8/30, 9/22

Barbara Behan
50 Moreton Street SW1V 2PB
t: 020 7821 8793

www.barbarabehan.com

Promotes young, mostly Italian, artists, influenced by the art movements of the 1950s. The gallery has six exhibitions a year, including abstract paintings, sculpture and photography.
MAP 6/3

Beardsmore Gallery
22-24 Prince of Wales Road
NW5 3LG
t: 020 7485 0923

www.beardsmoregallery.com

Exhibits contemporary painting, sculpture, ceramics and works on paper.
MAP 1/9

Beaux Arts
22 Cork Street W1S 3NA
t: 020 7437 5799

www.beauxartslondon.co.uk

With galleries in London and Bath, Beaux Arts shows modern and contemporary British painting and sculpture, and exhibits emerging new artists.
MAP 7/33

Belgrave Gallery
53 England's Lane NW3 4YD
t: 020 7722 5150

www.belgravegallery.com

Another gallery with two locations; the other is in St Ives, Cornwall. Specializes in 20th-century British and contemporary art.
MAP 1/6

Ben Brown Fine Arts
Floor 1
21 Cork Street W1S 3LZ
t: 020 7734 8888

www.benbrownfinearts.com

Shows 20th-century international work, including British, Italian and American art and German photography.
MAP 7/34

Bernard Jacobson Gallery
6 Cork Street W1S 3EE
t: 020 7734 3431

www.jacobsongallery.com

Holds monthly solo or group exhibitions and specializes in high-calibre modern British and international art. Artists include Peter Blake, Patrick Caulfield, Anthony Caro, Howard Hodgkin, Donald Judd and Phillip King. Also keeps an interesting selection of works on paper in stock.
MAP 7/41

Beverley Knowles Fine Art
88 Bevington Road W10 5TW
t: 020 8969 0800

www.beverleyknowles.com

The only UK gallery specializing in contemporary and cutting-edge British female artists, ceramicists and filmmakers.
MAP 1/3

BISCHOFF/WEISS
95 Rivington Street EC2A 3AY
t: 020 7033 0309

www.bischoffweiss.com

Encourages primarily international emerging artists to use this large space for experimentation in all contemporary media, including site-specific works involving sculpture, film, video, large-scale installation and photography. Artists include Tatyana Murray, Ali Silverstein, Tatiana Trouvé.
MAP 13/5

Blow de la Barra
35 Heddon Street W1B 4BP
t: 020 7734 7477

www.blowdelabarra.com

An international contemporary art gallery. Artists include Stefan Brüggemann, Carolina Caycedo, Federico Herrero, Jo Robertson.
MAP 7/22

Boundary Gallery
98 Boundary Road NW8 0RH
t: 020 7624 1126

www.boundarygallery.com

Concentrates on modern British (1900-50) and contemporary. Artists include David Bomberg, Horace Brodzky, Jacob Epstein and contemporary artists David Breuer-Weil, Anita Klein, Sonia Lawson, Peter Prendergast. A leading expert on Jewish artists.
MAP 2/2

Brick Lane Gallery
196 Brick Lane E2 6SA
t: 020 7729 9721

www.bricklanegallery.com

Exhibits a variety of British and international artists, focusing mainly on emerging and mid-career artists. Exhibitions include innovative developments in painting, sculpture, photography, performance, video and works on paper.
MAP 13/47

Broadbent Gallery
25 Chepstow Corner
Chepstow Place W2 4XE
t: 020 7229 8811

www.broadbentgallery.com

Offers a range of abstract and non-figurative work with artists from the USA, France, Germany, Switzerland and Britain.
MAP 3/9

Browse and Darby Ltd
19 Cork Street W1S 3LP
t: 020 7734 7984

www.browseanddarby.co.uk

As well as contemporary English painting, the gallery deals in late 19th- and early 20th-century European art. Particularly strong on English figurative artists, including Craigie Aitchison, Lucian Freud, Augustus John, Gwen John, Henry Moore, Ben Nicholson, Euan Uglow.
MAP 7/37

Cabinet
20a Northburgh Street
EC1V 0EA
t: 020 7251 6114

Tucked behind no. 20, this gallery is famous for its informality and respected for showing new, often groundbreaking artists before

they are well known, including Marc Camille Chaimowicz.

MAP 9/35

Cadogan Contemporary
87 Old Brompton Road
SW7 3LD
t: 020 7581 5451

www.artcad.co.uk

A selection of modern and contemporary British paintings and sculpture. Artists include Caroline Doyle, Keith Grant, Andrew Hunt, Daniel Ludwig.

MAP 4/18

Campbell's Art Gallery
33 Thurloe Place SW7 2HE
t: 020 7225 3942

www.campbellsart.co.uk

Represents artists from Britain, Europe (including contemporary Russian artists), the Middle East and the Caribbean.

MAP 4/19

Carl Freedman Gallery
44a Charlotte Road EC2A 3PD
t: 020 7684 8890

www.carlfreedmangallery.com

Specializes in emerging international artists. Artists include Michael Fullerton, Simon Martin, Peter Peri.

MAPS 11/4, 13/2

Caroline Wiseman Modern Art
26 Lansdowne Gardens
SW8 2EG
t: 020 7622 2500
⇌ *Wandsworth Road*

www.carolinewiseman.com

Paintings, drawings, sculpture and original prints by important British and international artists are displayed throughout this beautiful period house.

carpenters workshop gallery
2 Michael Road SW6 2AD
t: 020 7384 2211
⊖ *Fulham Broadway*

www.carpentersworkshopgallery.com

A design-led gallery, it has exhibited artist-designers such as Ron Arad, Atelier van Lieshout, Maarten Baas. Takes part in art and design events in which the disciplines connect.

Carter Presents
29 Orsman Road N1 5RA
t: 020 7012 1203
m: 07906 732 308

www.carterpresents.com

Contemporary art gallery featuring solo shows of young artists, sound installations, film and live performances. Artists include Claire Carter, David Cunningham, Daniel Jackson, Colin Smith.

MAP 13/16

The Chambers Gallery
23 Long Lane EC1A 9HL
t: 020 7778 1600

www.thechambersgallery.co.uk

Housed in a renovated art deco building, the gallery's exhibitions include painting and sculpture, with the emphasis on 20th-century figurative painting.

MAP 9/37

Chinese Contemporary Art
t: 020 7352 9775
m: 07977 208 686

www.chinesecontemporary.com

Dedicated to the work of the Chinese avant-garde post-1989, the gallery specializes in artists living and working in mainland China. Its exhibition programme includes painting, photography, performance, ink on paper and video. By appointment only.

clapham art gallery
Unit 02
40-48 Bromell's Road SW4 0BG
t: 020 7720 0955
⊖ *Clapham Common*

www.claphamartgallery.com

Promotes emerging artists and its exhibitions include a wide range of media, including painting, video, installation, photography, sculpture, mixed media and performance.

Connaught Brown
2 Albemarle Street W1S 4HD
t: 020 7408 0362

www.connaughtbrown.co.uk

One of London's leading specialists in post-impressionist and modern master paintings and drawings. Artists include Frank Auerbach, Marc Chagall, Tony Cragg, Barbara Hepworth, Henri Matisse, Henry Moore, Pablo Picasso. Also specializes in Scandinavian paintings of the period.

MAP 7/62

Contemporary Art Projects
20 Rivington Street EC2A 3DU
t: 020 7739 1743

www.caprojects.com
www.commentart.com

Promotes contemporary art, especially young, unpresented artists. Organizes an annual exhibition called *Start Your Collection* in August/September designed to connect new collectors and emerging artists. Hosts a weekend programme of East London Art Walks.

MAP 11/6

Frieze Art Fair

Regent's Park NW1
t: 020 7833 7270
www.friezeartfair.com

If it's October, it must be Frieze. Inaugurated in 2003, Frieze Art Fair in Regent's Park quickly became firmly established on the international art-world calendar and now generates art events all over the capital in the same week. Taxi drivers and restauranteurs acknowledge the increase in demand, with over 68,000 visitors flocking to see work by over a thousand artists at 151 galleries from 28 countries, housed in mammoth marquees. One of the appealing elements of the enormous interior space is the inclusion of trees from the park. And part of the surrounding park is transformed into an exterior extension of the exhibition space, showing sculpture and specially commissioned work.

The fair showcases new and established artists but the focus is very much on the newest cut of art in all its media. The galleries and the artists they represent are keenly considered for selection by co-directors Amanda Sharp and Matthew Slotover - the duo behind *frieze* magazine, which they began in 1991 - ensuring a high standard. Performance art plays a part, integrated into the bustle. In the first year, a queue of people was bought and donated to the Tate; other performance art has included a sleeping exhibit, a yogic policeman, child rearing. Work from established artists such as Tony Cragg, Bernard Frize, Andreas Gursky, Anish Kapoor, Chris Ofili and Philippe Parreno give a grounding to the new avant-garde.

Alongside the galleries and work on show, there is an ambitious series of events, performances, films and talks, taking Frieze beyond an art fair and providing an international platform for education, exhibition and stimulating discussion. Each day brings different crowds, from the preview day of wealthy patrons, collectors, curators and celebrities to the eclectic mix of art lovers, cool art crowd, first-time buyers or people fascinated by the entertainment that contemporary art provides.

Sir Nicholas Serota says: 'Frieze has played a key role in helping to make London one of the leading centres of the art world.' And the Culture Secretary told *Art Newspaper*: 'Frieze raises public awareness of contemporary art, provides opportunities for artists, stimulates the UK's contemporary art market and makes a significant contribution to London's economy... Frieze Art Fair has reinforced London's position as a world-class destination for contemporary visual art.'

Corvi-Mora

1a Kempsford Road SE11 4NU
t: 020 7840 9111

www.corvi-mora.com

In a one-time factory space shared with greengrassi, this contemporary gallery shows new and emerging artists, including Richard Aldrich, Abel Auer, Anne Collier, Liam Gillick, Richard Hawkins, Tomoaki Suzuki.
MAP 10/2

Cosa

7 Ledbury Mews North
W11 2AF
t: 020 7727 0398

www.cosalondon.com

Represents modern artists and sculptors, including Christie Brown, Michael Cullimore.
MAP 3/11

Crane Kalman Gallery Ltd

178 Brompton Road SW3 1HQ
t: 020 7584 7566

www.cranekalman.com

Specializes in 20th-century British, European and American art. Artists include Frank Auerbach, L.S. Lowry, Winifred Nicholson, Graham Sutherland.
MAP 4/21

Cubitt Gallery

Angel Mews N1 9HH
t: 020 7278 8226

www.cubittartists.org.uk

An artist-run gallery offering a diverse studio, gallery and off-site activities.
MAP 11/19

Curwen & New Academy Gallery

34 Windmill Street W1T 2JR
t: 020 7323 4700

www.curwengallery.com

Regular exhibitions of contemporary British artists, including works by Nikki Cass. The gallery also offers artwork for business spaces through its Business Art Galleries.
MAP 8/34

Danielle Arnaud

123 Kennington Road
SE11 6SF
t: 020 7735 8292

www.daniellearnaud.com

Set in the Georgian house that is Danielle Arnaud's family home, her aim is to show contemporary art in a sympathetic setting. Artists include Nicky Coutts, Heather & Ivan Morison, Sarah Woodfine. A committed gallerist with a good eye and a stable of progressive artists.
MAP 10/3

Daniel Shand

Unit 3
210 Cambridge Heath Road
E2 9NQ
t: 020 8981 9470

www.danielshand.co.uk

A residency project with artists given a month to show their work. The aim - to give the public a chance to see artists at work, and to offer artists the opportunity to use the exposure to evolve their practice.
MAP 13/38

Danusha Fine Arts

30 Warrington Crescent
W9 1EL
t: 020 7286 4832

www.danusha-fine-arts.co.uk

Specializes in Ukrainian artists whose work dates from the early 1950s to late 1990s.
MAP 1/5

David Risley Gallery

Ground Floor
45 Vyner Street E2 9DQ
t: 020 8980 2202

www.davidrisleygallery.com

Presents exhibitions of gallery artists, alongside group exhibitions of established and emerging artists, including Boo Ritson.
MAP 13/32

Dicksmith Gallery

Unit 27b
1-13 Adler Street E1 1EG
t: 020 7426 2007

www.dicksmithgallery.co.uk

Trend-making contemporary gallery. Shows gallery artists: Joel Croxson, Alistair Frost, Benjamin Alexander Huseby, Edward Kay, Meiro Koizumi, George Henry Longly, Duncan Marquiss, Rupert Norfolk; project artists: Leonor Antunes, Joe Bradley, Sarah Braman, Kate Davis, Clare Stephenson. Look for the buzzer to 27b at the second entrance to the 1-13 Adler Street complex.
MAP 12/30

Dominic Guerrini

18 Redburn Street SW3 4BX
t: 020 7565 2333

www.dominicguerrini.co.uk

Specializing in modern British and contemporary painting and sculpture. Artists include Lynn Chadwick, Elisabeth Frink, Damien Hirst.
MAP 4/10

Domobaal

3 John Street WC1N 2ES
t: 020 7242 9604

www.domobaal.com

Contemporary art gallery in a handsome 18th-century Grade

The Hayward

Southbank Centre
Belvedere Road SE1 8XZ
t: 020 7921 0813
www.hayward.org.uk
MAP 9/2

It started with a celebration. Following the years of devastation and deprivation after World War Two, the Festival for Britain was planned to raise the morale of the nation. The Royal Festival Hall on the south bank of the Thames was its flagship building, with celebrations all over the country and over eight and a half million people visiting London's festival pavilions and spectacles. In later years, controversial buildings were added alongside the Festival Hall, and in 1968 the brutalist Hayward Gallery (named for Sir Isaac Hayward, a former leader of London County Council) was built, to provide the complex with a modern art epicentre.

The Hayward is more than the walls that contain it. In fact it manages a vast collection that has no walls at all, that of the Arts Council Collection of England. Formed in 1946, the collection includes works by major 20th-century British artists and continues to acquire significant work by emerging artists. With access to, but not limited by, this nucleus of 7,500 works, the Hayward mounts major exhibitions of contemporary art, art from other cultures, individual artists, historical themes and artistic movements. Past exhibitions include *Undercover Surrealism*, *Africa Remix*, *The Painting of Modern Life* and solo shows of Francis Bacon, Dan Flavin, Roy Lichtenstein, Douglas Gordon and Antony Gormley.

It also provides space for smaller exhibitions and installations by emerging artists in The Hayward Projects Space. And Waterloo Sunset Pavilion (designed by artist Dan Graham) shows artists' videos, including Tracey Emin's *Why I Never Became a Dancer* and Gilbert & George's *Gordons Makes Us Drunk*.

The Hayward also manages touring exhibitions from the Arts Council Collection as well as the *British Art Show* (every five years), giving significant new artists the opportunity to reach a nationwide audience.

The flag project, initiated in 2007, invites artists to create a 'flag' reflecting issues of national identity, celebration and pageantry. The 30m flagpole opposite the Houses of Parliament has flown work by Tracey Emin and Yinka Shonibare, MBE.

The Hayward is occasionally closed between major exhibitions (though the smaller exhibition spaces and bookshop remain open).

II-listed building, created by Domo Baal. Artists include Daniel Gustav Cramer, Haris Epaminonda, Ron Haselden, Sharon Kivland.
MAP 9/27

Duncan R. Miller Fine Art
4-6 Bury Street SW1Y 6AB
t: 020 7839 8806

www.duncanmiller.com

Promotes the Scottish Colourists - Francis Cadell, John Duncan Fergusson, George Leslie Hunter and Samuel Peploe - as well as exhibiting other contemporary artists.
MAPS 6/20, 7/73

Eagle Gallery
Emma Hill Fine Art
159 Farringdon Road EC1R 3AL
t: 020 7833 2674

www.emmahilleagle.com

Has shown the work of many of the foremost young British artists to have emerged over the last decade, including Jane Bustin, Peter Doig, Mark Francis, Nicky Hirst, Callum Innes, Terry Smith. Entrance in Butler's Row at the side of the Eagle Pub.
MAP 9/29

East West Gallery
8 Blenheim Crescent W11 1NN
t: 020 7229 7981

www.eastwestgallery.co.uk

Located just off the Portobello Road, the gallery specializes in contemporary art, showing mainly figurative work with an emphasis on drawing.
MAP 3/14

Eleven
11 Eccleston Street SW1W 9LX
t: 020 7823 5540

www.elevenfineart.com

Founded by Charlie Phillips, founding director of Haunch of Venison, the gallery exhibits international contemporary art by established and emerging artists, including Rick Giles, Olly & Suzi, Martha Parsey, Jonathan Yeo.
MAP 6/2

Elms Lesters
1-5 Flitcroft Street WC2H 8DH
t: 020 7836 6747

www.elmslesters.co.uk

Known for exhibitions featuring the works of counter-cultural and urban artists. Has staged contemporary art and multi-media exhibitions by artists from Britain, Europe and the USA.
MAP 9/19

emilyTsingou gallery
10 Charles II Street SW1Y 4AA
t: 020 7839 5320

www.emilytsingougallery.com

The focus is on international contemporary art. Artists include Peter Callesen, Won Ju Lim, Karen Kilimnik, Jim Shaw, Marnie Weber, Mathew Weir.
MAP 7/66

England & Co
216 Westbourne Grove W11 2RH
t: 020 7221 0417

www.englandgallery.com

Represents emerging and established contemporary artists. It also holds a changing stock of 20th-century art and has regular shows.
MAP 3/13

Enviedart
16 Victoria Grove W8 5RW
t: 020 7589 8200

www.enviedart.com

The London branch of three Parisian galleries with 150 artists and a gallery in Brussels. Promotes affordable, emerging or already established talents. New exhibition every six weeks.
MAP 4/23

Eyestorm
Unit 4 Bankside Estate 5-11 Sumner Street SE1 9JZ
t: 020 7928 8877

www.eyestorm.com

Close to Tate Modern's Turbine Hall entrance. The gallery offers contemporary limited-edition prints and photographs, as well as affordable original art by contemporary artists. Also has a well-established online presence.
MAP 9/9

Faggionato Fine Art
49 Albemarle Street W1S 4JR
t: 020 7409 7979

www.faggionato.com

Shows the work of well-known contemporary and modern artists as well as European artists not yet internationally recognized. Work includes Francis Bacon (represents the Francis Bacon estate), Gilbert & George, Richard Prince, Andy Warhol.
MAP 7/57

Fairfax Gallery
5 Park Walk SW10 0AJ
t: 020 7751 4477

www.fairfaxgallery.com

Two floors of space, displaying a broad range of art from contemporary figurative to abstract work, and a dedicated sculpture garden at the rear.
MAP 4/8

f a projects
1-2 Bear Gardens SE1 9ED
t: 020 7928 3228

www.faprojects.com

On an old bear-baiting site near the Globe Theatre, this gallery has an international focus with the emphasis on new artists. Eight exhibitions per year which include painting, photographs, sculpture and video art. Artists include James Ireland, Juneau/Projects/, Maria Marshall, Serban Savu.
MAP 12/2

Farmilo Fiumano Gallery
27 Connaught Street W2 2AY
t: 020 7402 6241

www.farmilofiumano.com

Specializes in contemporary art and in promoting young artists from the world's leading art schools. Also exhibits Italian art, specializing in the Neapolitan Scuola di Realismo Magico.
MAP 5/9

f-art
24 Cheshire Street E2 6EH
t: 020 7729 5411

www.f-art.uk.com

In the Brick Lane area, aiming to 'celebrate the ephemeral, the surprising and the popular'.
MAP 13/46

The Fine Art Society
148 New Bond Street W1S 2JT
t: 020 7629 5116

www.faslondon.com

One of the world's oldest art galleries, it specializes in British art and design from the 17th to the 21st century. Its New Gallery has been created to show work by contemporary artists.
MAP 7/45

Flowers Central
21 Cork Street W1S 3LZ
t: 020 7439 7766
MAP 7/34

Flowers East
82 Kingsland Road E2 8DP
t: 020 7920 7777

www.flowerseast.com

Both locations deal mainly in contemporary British art but include a few American photographers. Artists include Glenys Barton, John Bellamy, Steve Pyke, Renny Tait.
MAP 13/14

Flying Colours Gallery
6 Burnsall Street SW3 3ST
t: 020 7351 5558

www.flyingcoloursgallery.com

In a pretty courtyard off the King's Road, the gallery shows (especially) contemporary Scottish artists. Has presented the work of around 150 artists, ranging from important, established artists to young, unknown talent.
MAP 4/11

Forster Gallery
1 Chapel Place
Rivington Street EC2A 4DQ
t: 020 7739 7572

www.forstergallery.com

Holds solo shows and group exhibitions, mixing established and emerging artists. Artists include Andrew McAttee.
MAPS 11/7, 13/7

Fortescue Avenue
Jonathan Viner
32-33 Fortescue Avenue
E8 3QB
t: 020 8986 9203
m: 07968 548 764

www.fortescueavenue.com

Specializes in contemporary international art and sculpture.
MAP 13/20

Fred (London) Ltd
Ground Floor
45 Vyner Street E2 9DQ
t: 020 8981 2987

www.fred-london.com

Contemporary art gallery specializing in mainly British and American artists, including Nayland Blake, Kate Davis, David Lock, Zak Smith.
MAP 13/32

Frith Street Gallery
17-18 Golden Square W1F 9JJ
t: 020 7494 1550

www.frithstreetgallery.com

Began by showing drawings and works on paper, but now exhibits all media, including video, film, photography and sculpture. Artists include Polly Abfelbaum, Craigie Horsfield, Callum Innes, Cornelia Parker, Thomas Schütte.
MAP 7/19

Frost & Reed Contemporary
2-4 King Street SW1Y 6QP
t: 020 7839 4645

www.frostandreed.com

A change of direction for Frost & Reed (established nearly two hundred years ago). The refurbished gallery shows contemporary work, with artists including Nigel Ashcroft, Edwin Penny.
MAPS 6/17, 7/71

Gagliardi Gallery
509 King's Road SW10 0TX
t: 020 7352 3663

www.gagliardi.org

Exhibits both established and emerging artists with art ranging

from abstract through figurative to landscape paintings.
MAP 4/2

Gagosian Gallery
6-24 Britannia Street
WC1X 9JD
t: 020 7841 9960

17-19 Davies Street W1K 3DE
t: 020 7493 3020

www.gagosian.com

Larry Gagosian is consistently nominated one of the top three most powerful people in the international art world. The converted police garage in Britannia Street allows exhibition on the scale for which he is renowned, and the Mayfair presence is more accessible for central London viewing. British artists include Glen Brown, Michael Craig-Martin, Dexter Dalwood, Tracey Emin, Douglas Gordon, Damien Hirst, Howard Hodgkin, Tim Noble & Sue Webster, Jenny Saville, Rachel Whiteread.
MAPS 7/6, 8/26

Gallery Kaleidoscope
64-66 Willesden Lane NW6 7SX
t: 020 7328 5833

www.gallerykaleidoscope.com

With at least six exhibitions a year, the gallery looks for new talent to display alongside established names in its major showroom. Another gallery shows constantly changing stock. Sculpture and ceramics are also on display.
MAP 2/3

Gallery Primo Alonso
395-97 Hackney Road E2 8PP
t: 020 7033 3678

www.primoalonso.com

An emerging not-for-profit artist-run space situated in the heart of the East End. Exhibitions have included Yason Banal, Tessa Farmer, Rui Matsunaga, John Stark.
MAP 13/40

Gallery 286
286 Earl's Court Road SW5 9AS
t: 020 7370 2239

www.gallery286.com

Based in a Victorian townhouse, this gallery specializes in sculpture, holograms and contemporary art. Sculpture is displayed in a large garden at the back of the house.
MAP 1/1

Gallery Yujiro
Studio Unit A502 Tower Point
Tower Bridge Business Complex
100 Clement's Road SE16 4DG
t: 020 7394 8591

www.galleryyujiro.com

A large gallery with artist studios. It encourages young, emerging British and international artists, including Takefumi Ichikawa, Lia Perjovschi.
MAP 1/15

Gimpel Fils
30 Davies Street W1K 4NB
t: 020 7493 2488

www.gimpelfils.com

A long-established gallery that has always maintained links with the avant-garde, it continues to develop its contemporary art programme and includes artists Hannah Maybank, Callum Morton and Andres Serrano alongside the more established work of Reg Butler, Niki de Saint Phalle, Peter Lanyon.
MAP 7/7

Goedhuis Contemporary
Flat 3
61 Cadogan Square SW1X 0HZ
t: 020 7823 1395

www.goedhuiscontemporary.com

Promotes Chinese contemporary art and artists throughout the world, including Cai Jin, Gu Wenda, Ho Huai-Shuo, Li Jin.
MAP 4/14

greengrassi
1a Kempsford Road SE11 4NU
t: 020 7840 9101

www.greengrassi.com

An anonymous black door conceals the warehouse this gallery shares with Corvi-Mora. This is a contemporary gallery representing British, USA and European artists in all media, including video, digital and installation. Artists include Tomma Abts, Matthew Arnatt, Ellen Gronemeyer.
MAP 10/2

Grosvenor Gallery
21 Ryder Street SW1Y 6PX
t: 020 7484 7979

www.grosvenorgallery.com

The focus is on 20th-century paintings, sculpture and drawings with an emphasis on works from the 1950s and '60s. Also specializes in modern and contemporary Indian art and South African art.
MAPS 6/23, 7/75

Hales Gallery
Studio G.07 Tea Building
7 Bethnal Green Road E1 6LA
t: 020 7033 1938

www.halesgallery.com

Based in the Tea Building, designed by HawkinsBrown, Paul Hedge and Paul Maslin are

Lisson Gallery

52-54 Bell Street NW1 5DA
t: 020 7724 2739
www.lissongallery.com
MAP 5/2

29 Bell Street NW5 5BY
t: 020 7535 7350
www.lissongallery.com
MAP 5/2

A visit to Lisson Gallery is essential. This is one of the world's most influential galleries – a place to review modern masters and be certain of spotting the next big thing. For over four decades, Nicholas Logsdail has maintained his commitment to working with, and showing, the most exciting and stimulating artists in the world, as well as being one of the most knowledgeable of dealers.

He founded Lisson Gallery as an artists' exhibition space in 1967, while he was a student at the Slade School of Fine Art. It quickly came to prominence as the first London space to introduce the American minimalists to a European audience, in its first decade showing Carl Andre, Dan Flavin, Dan Graham, Sol LeWitt, Donald Judd and Robert Mangold. The playful intellect, beauty, austerity of form and conceptual rigour of that first generation set the template for what followed. The gallery has always been a platform for emerging talent, working with communities of young, like-minded artists. In the 1980s it brought to prominence the New British Sculpture Group, including Tony Cragg, Richard Deacon, Anish Kapoor, Richard Long, Julian Opie, Richard Wentworth and Bill Woodrow.

With the advent of the 1990s, expansion led to a new building at 52-54 Bell Street designed by architect Tony Fretton. The space has been lauded for its design – an ideal environment in which to present art – and has achieved iconic status. All through the '90s Lisson Gallery continued to map out its own distinctive path, introducing the work of Francis Alÿs, Pierre Bismuth, Ceal Floyer, Douglas Gordon, Jonathan Monk, Tony Ourlser and Jane and Louise Wilson to the public.

At the start of the 21st century, the gallery signalled its intention to remain at the forefront of the contemporary art world by opening a new space and sculpture courtyard at 29 Bell Street, featuring a controversial exhibition by Santiago Sierra in which entry to the gallery was blocked by a large, corrugated shutter. Still working with generations of formative artists, including Art & Language, Daniel Buren and Lawrence Weiner, the gallery has recently showcased younger talents, among them Allora & Caldazilla, Gerard Byrne, Christian Jankowski, Tim Lee and Sean Snyder. It also sells catalogues and publications relating to exhibitions.

known for launching the careers of emerging British artists, including Jake and Dinos Chapman, Sarah Jones, Mike Nelson, Bob & Roberta Smith. The gallery now also represents international artists, including Hew Locke, Tomoko Takahashi, Spencer Tunick.
MAP 13/51

Hanina Fine Arts Ltd
180 Westbourne Grove
W11 2RH
t: 020 7243 8877

www.haninafinearts.com

A leading specialist in the avant-garde post-war School of Paris. Artists include Silvano Bozzolini, Jean Deyrolle, Jean Leppien, Dora Maar, Edgard Pillet.
MAP 3/12

Hart Gallery
113 Upper Street N1 1QN
t: 020 7704 1131

www.hartgallery.co.uk

This gallery holds nine exhibitions a year and represents British and international artists, sculptors and studio ceramicists.
MAP 11/21

Haunch of Venison
6 Haunch of Venison Yard
W1K 5ES
t: 020 7495 5050

www.haunchofvenison.com

Works with many of today's key international artists, presenting a broad, critically acclaimed programme of exhibitions showing exciting new and historically significant work in Zurich and Berlin as well as London. Artists include Zarina Bhimji, Nathan Coley, Anton Henning, Richard Long, Jorge Pardo, Simon Patterson, Keith

Tyson, Bill Viola, Wim Wenders.
MAPS 7/9, 8/1

Hauser & Wirth London
196a Piccadilly W1J 9DY
t: 020 7287 2300

www.hauserwirth.com

Housed in a building designed in the early 1920s by Sir Edwin Lutyens. Represents new and established contemporary artists, including Louise Bourgeois, Christoph Büchel, Martin Creed, Richard Jackson, Rachel Khedoori, Michael Raedecker.
MAP 7/65

Hazlitt Holland-Hibbert
38 Bury Street SW1Y 6BB
t: 020 7839 7600

www.hh-h.com

Shares space with Hazlitt, Gooden & Fox. Holland-Hibbert shows modern British painting, drawing and sculpture from the early 20th century to post-1945 avant-garde.
MAPS 6/21, 7/72

Helly Nahmad Gallery
2 Cork Street W1S 3LB
t: 020 7494 3200

www.hellynahmad.com

Large exhibition space on two floors, showing 20th-century and contemporary art.
MAP 7/43

Herald St
2 Herald Street E2 6JT
t: 020 7168 2566

www.heraldst.com

A contemporary gallery specializing in art, sculpture and installation. Artists include Markus Amm, Alexandra Bircken, Pablo Bronstein, Spartacus Chetwynd, Cary Kwok.
MAP 13/42

Hiscox Art Projects
1 Great St Helen's EC3A 6HX
t: 020 7448 6000

www.hiscoxartprojects.com

Aims to make exciting contemporary collections and exhibitions readily accessible to those living and working in the City, as well as the wider art community. Collections include work by Susan Derges, Damien Hirst, Gavin Turk.
MAP 12/12

Home
t: 07957 565 336

www.homeliveart.com

A production company creating live events with contemporary artists and performers. Initially a exhibition space in a home; now focuses on performances in theatres, pubs, parks, galleries and major institutions.

The Hospital
24 Endell Street WC2H 9HQ
t: 020 7170 9100

www.thehospital.co.uk

Originally an actual hospital, the building was renovated by Paul G. Allen, co-founder of Microsoft, who turned it into a private club incorporating a restaurant, screening room, library and art gallery. Admission to the gallery is free. Check website for worthwhile exhibition details.
MAPS 8/44, 9/20

Hotel
53a Old Bethnal Green Road
E2 6QA
t: 020 7729 3122

www.generalhotel.org

Run by progressive gallerists Darren Flook and Christabel Stewart, the gallery began in their home, with exhibiting artists

not located in London being invited to stay for the duration of their expos. Gallery now located in ground-floor shop of the same building. Artists include Steven Claydon, David Noonan.
MAP 13/41

Houldsworth Gallery
50 Pall Mall Deposit
124-28 Barlby Road W10 6BL
t: 020 8969 6166
⊖ ⇌ *Kensal Green*

www.houldsworth.co.uk

A move to a project space from Cork Street for a galley that focuses on younger British artists in various media. Artists include Christopher Bucklow, Laura Ford, Matt Franks.

IAP Fine Art
65 Roman Road E2 0QN
t: 020 8980 8877

www.iapfineart.com

Agent, gallery and print publishers for British artists Chris Gollon and Maggi Hambling.
MAP 13/37

IBID Projects
21 Vyner Street E2 9DG
t: 020 8983 4355

www.ibidprojects.com

Contemporary art gallery showcasing paintings and photography. Artists include Jānis Avotins, Guillermo Caivano, Christopher Orr, Anj Smith.
MAP 13/28

I-MYU Projects
Floor 1
23 Charlotte Road EC2A 3PB
t: 020 7033 4480

www.i-myu.com

A gallery for emerging Korean artists, including Debbie Han,

Ji Yuen Hong, Dong Won Shin.
MAPS 11/5, 13/4

jaggedart
Elliott House
28a Devonshire Street
W1G 6PS
t: 020 7486 7374

www.jaggedart.com

A user-friendly gallery that encourages browsing, viewing, touching and learning about the art on display. Works include paintings, graphics, photography and three-dimensional pieces.
MAP 5/14

James Hyman Gallery
5 Savile Row W1S 3PD
t: 020 7494 3857

www.jameshymangallery.com

Writer, curator and art dealer James Hyman uses the larger gallery space of his new premises for an increased programme of international contemporary artists alongside representation of modern British artists and estates. Good source of publications and *catalogues raisonnés* of artists exhibited or represented.
MAP 7/25

Jill George Gallery
38 Lexington Street W1F 0LL
t: 020 7439 7319

www.jillgeorgegallery.co.uk

From recent graduates to established artists, the gallery stocks drawings, watercolours, monoprints and limited-edition prints by British contemporary artists. Exhibitions are held every five weeks and every 18 months for graduates.
MAPS 7/17, 8/40

John Martin Gallery
38 Albemarle Street W1S 4JG
t: 020 7499 1314

www.jmlondon.com

Shows work of contemporary, mainly British and Irish, artists.
MAP 7/52

Jonathan Clark Modern British Art
18 Park Walk SW10 0AQ
t: 020 7351 3555

www.jonathanclarkfineart.com

Located in a Georgian building, the gallery deals in modern British paintings, sculpture and works on paper. Also represents the estates of Roger Hilton and Ivon Hitchens.
MAP 4/6

Jonathan Cooper Park Walk Gallery
20 Park Walk SW10 0AQ
t: 020 7351 0410

www.jonathancooper.co.uk

Exhibits modern art - figurative, wildlife, sporting and botanical - and photography.
MAP 4/7

Josh Lilley Fine Art
30a Pembridge Villas W11 3EL
t: 07957 200 570

www.joshlilleyfineart.com

Specializes in Aboriginal contemporary art, representing John Mawurndjul, as well as contemporary international and European artists.
MAP 3/10

Karsten Schubert
Floor 1
5-8 Lower John Street
W1F 9DR
t: 020 7734 9002

www.karstenschubert.com

The first to represent the YBAs in his first gallery (on Dering Street), and now shows works by artists including Georg Baselitz, Michael Landy, Bridget Riley, Gary Webb, Alison Wilding. Also produces books and prints with the publisher Ridinghouse.
MAP 7/20

Kate MacGarry
7a Vyner Street E2 9DG
t: 020 8981 9100

www.katemacgarry.com

Showcases the work of emerging British and international artists, from Mexico, Los Angeles and Berlin, in a programme of solo exhibitions. Artists include Matt Bryans, Iain Forsyth & Jane Pollard, Peter McDonald.
MAP 13/27

Keith Talent Gallery
2-4 Tudor Road E9 7SN
t: 020 8986 2181

www.keithtalent.com

Programme of exhibitions which change about every five weeks. Artists include Sarah Bednarek, Paul Peden.
MAP 13/21

King's Road Gallery
436 King's Road SW10 0LJ
t: 020 7351 1367

www.kingsroadartgallery.com

Often interesting large-scale canvases and photographs with strong Asian influence.
MAP 4/4

Laura Bartlett Gallery
10 Northington Street WC1N 2JG
t: 020 7404 9251

www.laurabartlettgallery.com

International contemporary artists working in photography, video, drawing, sculpture and painting.
MAP 9/28

La Viande
3 Charlotte Road EC2 3DH
m: 07968 959 545

www.laviande.co.uk

A contemporary art space for young artists. Exhibitions have included painting, sculpture, printing, installation, drawing, photography, 3-D design, graffiti, performance and site-specific work.
MAPS 11/8, 13/8

Lazarides
8 Greek Street W1D 4DG
t: 020 3214 0055

www.lazinc.com

Shows artists outside the established art stream. Street supremo Banksy is represented here, along with others whose work is described as 'cult art' to resist the categories of graffiti, graphics or pop art. Artists include Kelsey Brookes, Stanley Donwood, Faile, Tony Gray, Conor Harrington, Jamie Hewlett, Paul Insect, Invader, Mark Jenkins, Antony Micallef, Mode 2, Polly Morgan, Ben Turnbull.
MAP 8/43

Lefevre Fine Art Ltd
31 Bruton Street W1J 6QS
t: 020 7493 2107

www.lefevrefineart.com

Specializing in impressionist, modern and contemporary international and European painting, drawing and sculpture. A family business with connections to the original Lefevre Gallery, associated with new developments in art from its inception in 1926.
MAP 7/48

Leonard Street Gallery
73a Leonard Street EC2A 4QS
t: 020 7033 9977

www.tlsg.co.uk

Designed as a multi-media contemporary art space, this gallery focuses on young artists, specializing in a variety of media from sonic and visual installations to more traditional modern art.
MAP 11/1

Lightcontemporary
5a Porchester Place W2 2BS
t: 020 8488 4782

www.lightcontemporary.com

Showcases Latin American contemporary art, photography, video and installations.
MAP 5/8

Lisson Gallery
52-54 Bell Street NW1 5DA
t: 020 7724 2739

29 Bell Street NW1 5BY
t: 020 7535 7350

www.lissongallery.com
SEE PAGE 133

Long & Ryle
4 John Islip Street SW1P 4PX
t: 020 7834 1434

www.longandryle.com

Sarah Long and Carolyn Ryle-Hodges advise clients on purchasing modern and contemporary art. Artists include Simon Casson, Daniel Chatto, Maro Gorky, Sunil Patel.
MAP 6/5

Lounge/Monika Bobinska
242 Cambridge Heath Road E2 8DA
m: 07866 063 663

www.lounge-gallery.com

The Photographers' Gallery

5 and 8 Great Newport Street
WC2H 7HY
t: 020 7831 1772
www.photonet.org.uk
MAP 9/18

The Photographers' Gallery ranks among the top international photographic institutions and is one of the UK's finest galleries, solely dedicated to promoting the best of national and international photography. Established in 1971, it was the first public photography gallery in the world, and has always promoted the best British and international photography.

Through an energetic programme of exhibitions, education and events in its public gallery, it has an unparalleled record of presenting established and emerging artists and photographers to a broad audience. A print-sales gallery and bookshop further extend the diversity of interest for visitor, browser or collector. Drawing on photographers and artists from all over the world, this is one of London's most popular public art galleries with half a million visits annually.

The gallery has played a key role in the promotion of photography to a wide public and in encouraging its inclusion in the programmes of other leading galleries and museums. Its many achievements include being the first to show Jacques-Henri Lartigue, Ansel Adams and Irving Penn in the UK and promoting the names of now established British photographers such as Martin Parr and Fay Godwin. It also regularly introduces international artists - more recently Rineke Dijkstra, Catherine Opie, Boris Mikhailov and Joel Sternfeld - to the UK. With the support of the Deutsche Börse Group, the gallery hosts an annual £30,000 European Photography Prize, one of the most prestigious international art awards.

The gallery's current facilities at 5 and 8 Great Newport Street, near Leicester Square, consist of two, separate-site exhibition spaces, the bookshop, a café and the print-sales gallery. It is fast outgrowing these premises and the organization has embarked on visionary plans for a new major centre for photography in London by 2010; this will be at new premises on a single site - at 16-18 Ramillies Street, Soho.

A very recent (unplotted) move to Bethnal Green for Lounge. Represents a range of emerging artists whose work is in the collections of Charles Saatchi and David Roberts, and participates in prestigious exhibitions and events such as ARTfutures, East International, John Moores and the Jerwood Drawing Prize. Artists include James Brooks, Andrew Hladky, Adam King, Jost Münster, Gaia Persico, D.J. Roberts, Greg Rook, Lalie Schewadron.

MacLean Fine Art
10 Neville Street SW7 3AR
t: 020 7589 4384

www.macleanfineart.com

Promotes the work of emerging and established artists. Artists include Jennifer Anderson, Arabella Johnsen.
MAP 4/16

Madder 139
137-39 Whitecross Street
EC1Y 8JL
t: 020 7490 3667

www.madder139.com

Showcases emerging artists, photographers and sculptors, including Justin Coombes, Poppy de Villeneuve, Jason Shulman, Nessie Stonebridge.
MAP 1/12

Manya Igel Fine Arts Ltd
21-22 Peters Court
Porchester Road W2 5DR
t: 020 7229 1669

www.manyaigelfinearts.com

Specializing in traditional modern British art. The work is shown in three flats in Bayswater.
MAP 3/8

Mark Jason Gallery
1 Bell Street NW1 5BY
t: 020 7258 5800

www.markjasongallery.com

Exhibits new and established talent in monthly solo and group shows throughout the year.
MAP 5/3

Marlborough Fine Art
6 Albemarle Street W1S 4BY
t: 020 7629 5161

www.marlboroughfineart.com

Known for its contemporary art, the gallery deals in paintings and sculpture by prominent international artists. Six to eight exhibitions each year. Also Marlborough Graphics, specializing in original prints.
MAP 7/60

Martin MacLeish
13 Dover Street W1S 4LN
t: 020 7493 0055

www.martin-macleish.com

Situated in a five-storey 18th-century building, it deals in traditional and modern paintings from the 17th to 20th century. Artists include Terry Frost, William Gear, Patrick Heron, Edward Seago, John Tunnard.
MAP 7/59

Martin Summers Fine Art Gallery
Studio 54 Glebe Place
SW3 5JB
t: 020 7351 7778

www.ms-fineart.com

After running the Lefevre Gallery for over 35 years, Martin Summers has his own gallery, specializing in 19th-century, 20th-century and contemporary painting, drawing and sculpture. Artists include William de Kooning, Beatrice Help, Stuart

Semple, Andy Warhol.
MAP 4/9

Matthew Bown Gallery
Floor 1
11 Savile Row W1S 3PG
t: 020 7734 4790

www.matthewbown.com

A modern and contemporary gallery. Artists have included Mark Dean, Tim Head, Keith Wilson.
MAP 7/24

Matt's Gallery
42-44 Copperfield Rd E3 4RR
t: 020 8983 1771
⇌ DLR Limehouse ⊖ Mile End

www.mattsgallery.org

Robin Klassnik's first gallery, founded almost 30 years ago, was based in his London Fields studio. The current gallery has two exhibition spaces with exhibitions in one and work in progress in the other. The intention is to give artists time to develop new ideas and the space in which to exhibit. Artists include Jo Bruton, Willie Doherty, Melanie Jackson, Mike Nelson.

Maureen Paley
21 Herald Street E2 6JT
t: 020 7729 4112

www.maureenpaley.com

One of the first to present work in the East End. Gallery artists include Turner Prize winners Wolfgang Tillmans and Gillian Wearing, as well as nominee Rebecca Warren. Other artists include Maaike Schoorel.
MAP 13/43

Max Wigram Gallery
99 New Bond Street W1S 1SW
t: 020 7495 4960

www.maxwigram.com

Royal Academy of Arts

Burlington House
Piccadilly W1J 0BD
t: 020 7300 8000
www.royalacademy.org.uk
MAP 7/64

The oldest fine-art institution in Britain, the Royal Academy of Arts was founded in 1768 by artists led by the painter Joshua Reynolds and took up its home in Burlington House in 1867. Despite its history, royal patronage and conservative approach, the RA continues to present contemporary art. Alongside blockbuster thematic shows of international importance, two curated exhibitions by Charles Saatchi made headlines: the infamous *Sensation* (1997) showcasing the YBAs and *USA Today* (2006). But perhaps most famous to the general public is the *Summer Exhibition*. Every year the RA puts on the largest open exhibition of contemporary art in the world. Work is submitted in all styles and media. The rotating committee selects about 1,200 works from up to 11,000 entries. Most of them are for sale.

Since 1998 sculpture has been displayed outside in the paved Annenberg Courtyard. Installations have included powerful work by Antony Gormley, Tony Cragg, Richard Long, David Mach, Eduardo Paolozzi, Damien Hirst, Anselm Kiefer, Jake and Dinos Chapman and Zhang Huan. The architect Norman Foster created the new Sackler Galleries upstairs, reached by an oval glass elevator from which the juxtaposition of Italianate and modern architecture can be best appreciated.

The RA's art school (known as 'The Schools' because each element in an artist's training had once to be mastered in a particular order in a different 'school') is the oldest in Britain. Students include William Blake, J.M.W. Turner, Edwin Landseer, J.E. Millais and, more recently, John Hoyland, Anthony Caro and Sandra Blow. Today, 60 students study drawing, painting and printmaking on a three-year postgraduate course.

The RA collection was amassed by the inclusion of work by each new royal academician and by donation. The restored John Madejski Fine Rooms display works from the collection. Recently elected academicians include Tracey Emin, Zaha Hadid, Gary Hume, Anish Kapoor, Lisa Milroy, Fiona Rae and Richard Wilson.

There is a bookshop, café, restaurant, members' room, and a programme of free lunchtime lectures, collection tours and exhibition guides. Art fairs, including Zoo (see page 160), and a contemporary season are held at 6 Burlington Gardens.

Max Wigram curated the controversial *Apocalypse* exhibition at the Royal Academy in 2000. He now represents new, often socio-political British and international artists in a range of media, including sculpture, painting, film, photography and installation. Artists include Marine Hugonnier, Alison Moffett, Richard Wathen.
MAPS 7/10, 8/2

The Mayor Gallery
22a Cork Street W1S 3NA
t: 020 7734 3558

www.mayorgallery.com

The first gallery to open in Cork Street (in 1925), it shows the work of leading US pop artists but also specializes in dada and surrealism. Artists include Allen Jones, Roy Lichtenstein, Tom Wesselmann.
MAP 7/32

Messum's
8 Cork Street W1S 3LJ
t: 020 7437 5545

www.messums.com

Specializes in modern British and contemporary figurative painting and sculpture.
MAP 7/40

Metal Gallery
London Silver Vaults
53-64 Chancery Lane
WC2A 1QS
t: 020 7242 7624

www.themetalgallery.com

Recent (unplotted) move for this showcase for the best of British talent in metal design.

Mumford Fine Art
Rooftop Gallery
12 D'Arblay Street W1F 8DU
t: 020 7748 2340

www.mumfordfineart.net

Represents artists from North America and Britain as well as work by late 20th-century sculptor Elisabeth Frink.
MAPS 7/16, 8/38

Mummery + Schnelle
83 Great Titchfield Street
W1W 6RH
t: 020 7636 7344

www.mummeryschnelle.com

International contemporary art. Developing a programme that presents the work of artists including Philip Akkerman, Marco Bohr, Merlin James, Carol Rhodes.
MAP 8/11

Museum 52
52 Redchurch Street E2 7DP
t: 020 7366 5571

www.museum52.com

Exhibitions include painting, photography, sculpture, prints, moving image and new media.
MAP 13/48

My Life in Art
4 Broadway Market E8 4QJ
t: 020 7275 9575

www.mylifeinart.com

Showcasing newly launched British artists, this gallery focuses mainly on painting and photography. Artists include Midori Harata, Kate Marshall.
MAP 13/24

Nettie Horn
25b Vyner Street E2 9DG
t: 020 8980 1568

www.nettiehorn.com

Eclectic variety of contemporary British and international artists with the emphasis on strong new artists exploring experimental techniques and materials.
MAP 13/30

New Grafton Gallery
49 Church Road SW13 9HH
t: 020 8748 8850
⇌ Barnes Bridge

www.newgrafton.com

A Mayfair gallery under David Wolfers (a promoter of modern British figurative art), now based in Barnes, run by his daughter Claudia and Janine Peake, known for identifying new talent.

New Realms Limited
33 Ability Plaza
Arbutus Street E8 4DT
t: 020 7812 9041

www.newrealms.org.uk

A contemporary art gallery showing paintings and modern artworks by new artists from eastern Europe, Russia, the Baltic states and Central Asia.
MAP 13/18

nomoregrey ART
23-25 Redchurch Street E2 7DJ
m: 07769 977 660

www.nomoregrey.co.uk

This project-led space holds regular shows of new and established contemporary artists.
MAP 13/50

Novas CUC Bankside
73-81 Southwark Bridge Road
SE1 0NQ
t: 020 7403 8495
MAPS 10/6, 12/1

Novas Gallery Camden
73 Parkway NW1 7PP
t: 020 7267 5641

www.novas.org/arts

Showcases established and developing artists as well as art students (especially excluded

minorities), including drawing, printmaking, illustration, painting, sculpture, video, animation, installation and photography.
MAP 1/10

October Gallery
24 Old Gloucester Street
WC1N 3A
t: 020 7242 7367

www.octobergallery.co.uk

Exhibits new artists from around the world and is a pioneer of the Transvangarde (transcultural avant-garde). Artists include El Anatsui, Aubrey Williams.
MAPS 8/29, 9/24

Offer Waterman & Co
11 Langton Street SW10 0JL
t: 020 7351 0068

www.waterman.co.uk

Specialists in modern British painting, drawing and sculpture. The gallery exhibits and deals in museum-quality work by artists including Frank Auerbach, Sandra Blow, David Bomberg, Anthony Caro, Lynn Chadwick, Naum Gabo, Barbara Hepworth, Patrick Heron, R.B. Kitaj, Eduardo Paolozzi, William Scott.
MAP 4/3

One in the Other
Lower Ground Floor
45 Vyner Street E2 9DQ
t: 020 8983 6240

www.oneintheother.com

A contemporary gallery working with young, emerging and established artists, including Paul Johnson, Simon Linke, Luke Caulfield.
MAP 13/32

Osborne Samuel
23a Bruton Street W1J 6QG
t: 020 7493 7939

www.osbornesamuel.com

Modern and contemporary work, including sculpture by Henry Moore and Lynn Chadwick, paintings by Frank Auerbach and Terry Frost and masterprints by Pablo Picasso and Joan Miró.
MAP 7/49

Panter & Hall
9 Shepherd Market W1J 7PF
t: 020 7399 9999

www.panterandhall.com

With a continuous programme of solo and mixed gallery shows, represents young talent alongside celebrated names in 20th-century art.
MAPS 6/27, 7/1

Paradise Row
St Matthew's Hall
17 Hereford Street E2 6EX
t: 020 7613 3311

www.paradiserow.com

Avant-garde gallery showing works by artists including Diann Bauer, Margarita Gluzberg, Kirk Palmer.
MAP 13/45

The Paragon Press
6 Wetherby Gardens
SW5 0JN
t: 020 7370 1200

www.paragonpress.co.uk

The press works mainly with artists resident in Great Britain to create a series or portfolio of prints, which are placed with museums and contemporary art collections worldwide. Exhibitions of its latest work are shown at the gallery. Signed limited-edition prints by Jake and Dinos Chapman, Peter Doig, Damien Hirst, Gary Hume, Anish Kapoor, Grayson Perry, Marc Quinn.
MAP 4/17

Paul Stolper
78 Luke Street EC2A 4PY
t: 020 7739 6504

www.paulstolper.com

Publishes portfolios and prints, and organizes exhibitions on new publications and solo or group shows with artists including Jeremy Deller, Damien Hirst, Peter Saville, Gavin Turk.
MAP 13/1

Peer
99 Hoxton Street N1 6QL
t: 020 7739 8080

www.peeruk.org

An independent arts organization that develops and presents projects in a range of media, allowing artists to experiment. Artists include Aaron Noble.
MAPS 11/13, 13/12

Plus One Gallery
91 Pimlico Road SW1W 8PH
t: 020 7730 7656

www.plusonegallery.com

A spacious gallery specializing in contemporary and classical realism and photorealism. It represents 40 leading painters and sculptors, mainly American and British with a few from Europe. There are at least eight solo shows a year and a changing display of work by gallery artists is always on view.
MAP 6/1

Pollock Fine Art
58a King Henry's Road
NW3 3RP
t: 020 7449 0714

www.pollockfineart.com

One of the largest private dealers of Andy Warhol in Britian, the gallery focuses on pop, modern and contemporary art with artists including Banksy, Jean-Michel

Basquiat, Damien Hirst. It has staged exhibitions of Hans Bellmer, Peter Blake, Bjarne Melgaard, Andy Warhol.
MAP 1/7

Portal Gallery
15 New Cavendish Street
W1G 9UB
t: 020 7935 5222

www.portal-gallery.com

Well known for its idiosyncratic paintings, Beryl Cook is the gallery's most celebrated artist.
MAP 5/13

Portland Gallery
8 Bennet Street SW1A 1RP
t: 020 7493 1888

www.portlandgallery.com

Showing modern British and contemporary paintings with a particular specialization in the Scottish Colourists. Monthly exhibitions of well-known and emerging contemporary artists.
MAPS 6/26, 7/56

Poussin Gallery
Block K 175 Bermondsey Street
SE1 3UW
t: 020 7403 4444

www.poussin-gallery.com

Specializes in recent and new abstract painting and sculpture by mainly British artists.
MAP 1/17

Purdy Hicks Gallery
65 Hopton Street SE1 9GZ
t: 020 7401 9229

www.purdyhicks.com

In a Victorian warehouse near Tate Modern, this gallery shows contemporary British and Irish paintings and photography alongside international artists. Up to ten solo exhibitions each year.
MAP 9/7

Quantum Contemporary Art
The Old Imperial Laundry
71-73 Warriner Gardens
SW11 4XW
t: 020 7498 6868
⇌ Battersea Park/Queenstown Road Battersea

www.quantumart.co.uk

Brings contemporary British art to a wider public by offering young and new talent at affordable prices. Described by *The Financial Times* as a 'fun, hip and friendly' gallery.

Rebecca Hossack Gallery
2a Conway Street W1T 6BA
t: 020 7436 4899

28 Charlotte Street W1T 2NA
t: 020 7255 2828

www.r-h-g.co.uk

The first gallery in Europe to show Aboriginal art as well as other non-Western art. Also known for groundbreaking and idiosyncratic contemporary art, across cultures, in all media.
MAPS 8/13, 8/35

Redfern Gallery
20 Cork Street W1S 3HL
t: 020 7734 1732

www.redfern-gallery.com

Large stock of modern and contemporary watercolours, drawings, paintings, sculptures and original prints. Artists include Brendan Neiland, Victor Pasmore, Patrick Procktor.
MAP 7/35

Richard Green
147 New Bond Street W1S 2TS
t: 020 7493 3939

39 Dover Street W1N 4NN
t: 020 7499 4738

www.richard-green.com

A wide range of fine-quality paintings from 17th-century masters to 20th-century British artists.
MAPS 7/46, 7/53

Richard Nagy Ltd
14 Hyde Park Gardens W2 2LU
t: 020 7262 6400

www.richardnagy.com

Specializes in Egon Schiele, Gustav Klimt, German expressionists (Max Beckmann, Otto Dix and Emil Nolde), and classic modernists such as Pablo Picasso and Henri Matisse.
MAP 5/7

RICH Fine Art
111 Mount Street W1K 2TT
t: 020 7499 4881

www.richonline.com

Exhibits a wide range of art from the 16th to the 20th century, as well as unusual objects and pieces of furniture.
MAP 7/3

Riflemaker
79 Beak Street W1F 9SU
t: 020 7439 0000

www.riflemaker.org

Housed in the West End's oldest public building, a riflemaker's workshop dated 1712, this lead-runner gallery, founded by Tot Taylor and Virginia Damtsa, shows work by up-coming artists with a new exhibition every eight weeks. Artists include Jaime Gili, Francesca Lowe, Jamie Shovlin, Gavin Turk. Second gallery has opened at 1 Greek Street, W1.
MAPS 7/18, 8/39

Ritter/Zamet
2 Bear Gardens SE1 9ED
t: 020 7261 9510

www.ritterzamet.com

Saatchi Gallery

Duke of York's Headquarters
King's Road SW3 4RY
t: 020 7823 2332
www.saatchi-gallery.co.uk
MAP 4/13

By championing the work of young and largely unseen artists and displaying rarely exhibited work by established international names, the Saatchi Gallery has built up one of the most stimulating and up-to-date art collections in the world. During the past two decades its pioneering exhibitions have showcased work by over 150 artists and provided a unique springboard for young unknowns.

When the Saatchi Gallery first opened its doors to the public at its Boundary Road address in 1985, access to contemporary art was regarded by many as the privilege of a specialist few. Founder Charles Saatchi believed contemporary art should be available to everyone, and that it should be an integral part of a nation's culture. By supporting and showing the work of YBAs, the gallery set a precedent in the art world, fuelling interest in and contributing to the growing popularity of contemporary art. It epitomizes passion and vision - a commitment that has helped establish London as one of the world's leading contemporary art capitals. It does not shy away from controversy, choosing to exhibit cutting-edge works by the latest artistic talent, however provocative. This uncompromising stance has made the gallery what it is today: a trendsetter inspiring both the current, and next, generation of artists and art lovers.

In May 2006 the Saatchi Gallery launched its website, Saatchi Online, which now receives 50 million hits a day on average, making it the world's largest interactive art gallery. Over 70,000 artists are free to show their work. As a result a wave of diverse new works has been made available to a far broader audience, and artists, collectors, dealers, students and all those interested in contemporary art can access visuals and information directly and chat live.

Opened in spring 2008 with the exhibition *The Revolution Continues: New Art from China*, the new Saatchi Gallery is one of the world's largest museums devoted to contemporary art. Due to a partnership with contemporary art auction house Phillips de Pury & Company, it is the first completely free major contemporary art museum in the world. Visitors are not charged admission to any exhibition, including its changing programme of curated shows.

On the site of the last bear-baiting ring on Bankside. The gallery displays work by young avant-garde artists, including Simon Bedwell, Krysten Cunningham, Paule Hammer, Kate Hawkins.
MAP 12/2

Robert Bowman Modern
34 Duke Street St James's SW1Y 6DF
t: 020 7930 8003

www.robertbowman.com

A gallery dedicated to sculpture in bronze, marble and terracotta from the 19th century to modern and contemporary.
MAP 7/68

Robert Sandelson
5 Cork Street W1S 3NY
t: 020 7439 1001

www.robertsandelson.com

Modern and contemporary British and international art.
MAP 7/29

Rocket
Studio G.04 Tea Building 56 Shoreditch High Street E1 6JJ
t: 020 7729 7594

www.rocketgallery.com

A contemporary gallery specializing in Danish paintings, photography and furniture. The entrance to the Tea Building is on Bethnal Green Road.
MAP 13/51

Rockwell Gallery
230 Dalston Lane E8 1LA
t: 07970 921 237
⇌ Hackney Downs/Hackney Central

www.therockwellproject.co.uk

An artists' collective. Solo and group shows. Artists include

Max Attenborough, Dan Coombs, Christian Jankowski, Olivia Plender.

Rokeby
37 Store Street WC1E 7QF
t: 020 7168 9942

www.rokebygallery.com

Specializes in contemporary art, exhibiting work by established and emerging artists from Britian and beyond. Artists include Tim Knowles, Raul Ortega Ayala.
MAP 8/33

ROLLO Contemporary Art
51 Cleveland Street W1T 4JH
t: 020 7580 0020

www.rolloart.com

Concentrates on painting and sculpture by artists ranging from the established to newcomers.
MAP 8/10

Rossi & Rossi Ltd
16 Clifford Street W1S 3RG
t: 020 7734 6487

www.asianart.com

Dealers in Asian art, photography and textiles.
MAP 7/30

Sadie Coles HQ
35 Heddon Street W1B 4BP
t: 020 7434 2227

69 South Audley Street W1K 2QZ
t: 020 7493 8611

www.sadiecoles.com

Features a programme of pioneering contemporary art exhibitions by artists including Carl Andre, Don Brown, Angus Fairhurst, Urs Fischer, Jonathan Horowitz, Jim Lambie, Sarah Lucas, Victoria Morton, Simon Periton, Wilhelm Sasnal, Nicola Tyson, Andrea Zittel. A good

indicator of art currency, trends and developments.
MAPS 7/2, 7/22

Sarah Myerscough Fine Art
15-16 Brook's Mews W1K 4DS
t: 020 7495 0069

www.sarahmyerscough.com

Shows work by some of the best young, up-and-coming artists in Britain. Artists include Michael Corkrey, Rebecca McLynn, Jenny Pockley, Andy Stewart.
MAP 7/8

Scream
34 Bruton Street W1J 6QX
t: 020 7493 7388

www.screamlondon.com

Inspired by Rolling Stones guitarist Ronnie Wood's career as an artist (and run by Tyrone Wood; son of Ronnie), exhibits contemporary art, sculpture, photography, installation, video and live art. Wall design to colour scheme changed for each show.
MAP 7/47

Sesame Art
354 Upper Street N1 0PD
t: 020 7226 3300

www.sesameart.com

Specializes in contemporary painting with a focus on work that is innovative, challenging but accessible. Solo and themed shows throughout the year.
MAP 11/20

Seven Seven
77 Broadway Market London Fields E8 4PH
t: 07808 166 215

www.sevenseven.org.uk

Exhibitions are held once a month, displaying new art from around the world. You can purchase from the website

through the Arts Council's Own Art scheme.
MAP 13/22

Shades and Wood Gallery
77 Kensington Church Street
W8 4BG
t: 020 7938 1852

www.shadesandwood.co.uk

This new gallery is dedicated to showing the best of Indian contemporary art with the focus on painting and sculpture.
MAP 3/4

The Showroom
44 Bonner Road E2 9JS
t: 020 8983 4115

www.theshowroom.org

Known for promoting young artists, its solo shows have been a starting point for many now well-known artists, including Jim Lambie, Eva Rothschild, Simon Starling, Sam Taylor-Wood.
MAP 13/35

Simon Lee Gallery
12 Berkeley Street W1J 8DT
t: 020 7491 0100

www.simonleegallery.com

Contemporary art from the 1960s to the present day. Artists include Larry Clark, George Condo, Gary Simmons, Robert Therrin, Toby Ziegler.
MAP 7/55

Sims Reed Gallery
The Economist Building
23a St James's Street
SW1A 1HA
t: 020 7930 5111

www.simsreed.com

Specializes in original modern master graphics by European, American and British artists, including Francis Bacon, David Hockney, Howard Hodgkin,

Roy Lichtenstein, Joan Miró.
MAPS 6/24, 7/76

Spectrum London
77 Great Titchfield Street
W1W 6RF
t: 020 7636 7778

www.spectrumlondon.co.uk

A wonderful 185-square-metre space, shows contemporary figurative painting and is noted for its promotion of the anti-establishment stuckist artists.
MAP 8/9

Sprovieri
27 Heddon Street W1B 4BJ
t: 020 7734 2066

www.sprovieri.com

Exhibits installation, painting, performance, photography, sculpture and audiovisual works. The gallery represents an international group of emerging, mid-career and established artists.
MAP 7/23

Sprüth Magers
7a Grafton Street W1S 4EJ
t: 020 7408 1613

www.spruethmagerslondon.com

Features contemporary American and European art.
MAP 7/50

Standpoint Gallery
45 Coronet Street N1 6HD
t: 020 7739 4921

www.standpointlondon.co.uk

Ten exhibitions a year, showing contemporary paintings, sculpture and printmaking.
MAP 11/10

StART Space
150 Columbia Road E3 7RG
t: 020 7729 0522

www.st-art.biz

Presents year-round exhibitions of contemporary art. A platform for established artists alongside exciting up-and-coming new talent, both international and home grown.
MAP 13/44

Stephen Friedman Gallery
25-28 Old Burlington Street
W1S 3AN
t: 020 7494 1434

www.stephenfriedman.com

Specializes in international contemporary art, with a new exhibition every six weeks. Artists include Dryden Goodwin, Mark Grotjahn, Yinka Shonibare, MBE.
MAP 7/26

Store
27 Hoxton Street N1 6NH
t: 020 7729 8171

www.storegallery.co.uk

A contemporary gallery. Artists include Ryan Gander, Claire Harvey, Dan Holdsworth, Rosalind Nashashibi, Bedwyr Williams.
MAPS 11/11, 13/10

Stuart Shave Modern Art
10 Vyner Street E2 9DG
t: 020 8980 7742

www.stuartshavemodernart.com

In a former warehouse, the gallery focuses mainly on young and new talent. Painting, sculpture and installation by artists including Philip Lai, Katy Moran, Eva Rothschild, Steven Shearer.
MAP 13/33

Studio 1.1
57a Redchurch Street E2 7DJ
t: 07952 986 696

www.studio1-1.co.uk

An artist-run space described as 'an arena for ideas in every contemporary form'.
MAP 13/49

The Subway Gallery
The Black Wall
Kiosk 1 Pedestrian Subway Edgware Road/Harrow Road W2 1DX
t: 07811 286 503

www.subwaygallery.com

Artist Robert Gordon McHarg III is based in a shoe-repair booth below the Marylebone flyover. Monthly exhibitions of his work and of artists who have never been shown before are on display in the booth and on a nearby subway wall. A must to see is McHarg's waxwork of Charles Saatchi - *Him*.
MAP 5/4

Sutton Lane
1 Sutton Lane EC1M 5PU
t: 020 7253 8580

www.suttonlane.com

A contemporary art gallery showcasing international artists with exhibitions changing every five weeks. Entrance sited in the passageway between 25 and 27 Great Sutton Street.
MAP 9/36

Terrace
4-17 Frederick Terrace E8 4EW
t: 07913 681 286

www.terracestudios.co.uk

This is an artist-run gallery and studios. Artists include Diane Bielik, Karl Bielik, Julia Hamilton.
MAP 13/19

Thackeray Gallery
18 Thackeray Street Kensington Square W8 5ET
t: 020 7937 5883

www.thackeraygallery.com

Dedicated to the promotion of contemporary British art, it represents 24 innovative artists with whom it has a long-term collaboration, committing to a solo exhibition for each artist every two years.
MAP 3/1

Thomas Dane Gallery
Floor 1
11 Duke Street St James's SW1Y 6BN
t: 020 7925 2505

www.thomasdane.com

A contemporary gallery with an exhibition programme of international artists and solo shows. Artists include Hurvin Anderson, Anya Gallaccio, Steve McQueen, Paul Pfeiffer.
MAPS 6/19, 7/69

Timothy Taylor Gallery
15 Carlos Place W1K 2EX
t: 020 7409 3344

21 Dering Street W1S 1AL
t: 020 7409 3344

www.timothytaylorgallery.com

Artists include Craigie Aitchison, Roni Horn, Alex Katz, Fiona Rae, Bridget Riley, Sean Scully, Lucy Williams. The gallery holds between seven and ten exhibitions annually.
MAPS 7/4, 7/12, 8/4

Transition Gallery
Unit 25a Regent Studios 8 Andrew's Road E8 4QN
t: 020 7254 4202

www.transitiongallery.co.uk

The gallery is run by artist Cathy Lomax and shows work by both trail-blazing and established contemporary artists.
MAP 13/25

The 24-7 ArtHouse
t: 07939 362 520

www.atari-artdesign.com

Hosted by on-line gallery Atari, this studio in Clapham shows exhibitions of its artists' work. Private viewings arranged.

Union
57 Ewer Street SE1 0NR
t: 020 7928 3388

www.union-gallery.com

There are two galleries: Union Ewer Street (near Tate Modern) and Union Teesdale Street in Bethnal Green, E2 (unplotted). Ewer Street headquarters, in space totalling 372 square metres, presents various media, including large installations and projections. Teesdale Street is based in a former warehouse and has five or six small-scale exhibitions by younger British and international artists.
MAP 10/8

Vertigo
62 Great Eastern Street EC2A 3QR
t: 020 7613 1386

www.vertigogallery.co.uk

This spacious gallery in a former Victorian rope and tarpaulin factory hosts monthly exhibitions of artists whose work ranges from contemporary to representational to abstract.
MAPS 11/3, 13/3

Victor Felix Gallery
Scena
240 Camberwell Road SE5 0DP
t: 07720 056 242
⇒ Loughborough Junction

Contemporary British figurative art by artists including Jackie Anderson, Chris May, Annabelle Nicoll, Philippa Robbins.

Serpentine Gallery

Kensington Gardens W2 3XA
t: 020 7402 6075
www.serpentinegallery.org
MAP 3/3

The Serpentine Gallery, perhaps London's prettiest gallery, is located on the south side of Kensington Gardens, near beside the Serpentine Lake. Originally built in 1934 as a royal tea pavilion, it has been an art gallery of international strength since 1970. With several sky-lit rooms connecting to create an exhibition flow, it shows work by keenly selected young artists, artists in mid-career or more established artists who have made waves on the British and international scene. With the focus on solo shows, exhibitions have included work by Matthew Barney, Louise Bourgeois, Glenn Brown, John Currin, Thomas Demand, Andreas Gursky, Damien Hirst, Ellsworth Kelly, Langlands & Bell, Mariko Mori, Chris Ofili, Gabriel Orozco, Cornelia Parker, Bridget Riley, Cindy Sherman and Cy Twombly. Broader themed exhibitions include *Michael Elmgreen & Ingar Dragset: The Welfare Show* (2006), *Hearing Voices, Seeing Things*, led by Bob & Roberta Smith (2006), *China Power Station I*, held at the Battersea Power Station (2006), *Uncertain States of America* (2006) and *Serpentine Gallery Experiment Marathon (2007),* presented by Olafur Eliasson and Hans Ulrich Obrist.

In 2000, gallery director Julia Peyton-Jones conceived the idea for a new annual commission. Each summer the gallery commissions an internationally acclaimed architect to design a temporary pavilion on the lawn in front of the gallery. Architects who have created experimental structures include Zaha Hadid (2000), Daniel Liebeskind (2001), Toyo Ito (2002), Oscar Niemeyer (2003), Alvaro Siza and Eduardo Souto de Moura with Cecil Balmond (2005), Rem Koolhaas and Cecil Balmond (2006), Olafur Eliasson and Kjetil Thorsen (2007). Also in the gallery grounds is a permanent work by artist-poet Ian Hamilton Finlay, dedicated to the Serpentine's former patron: Diana, Princess of Wales. It comprises eight benches, a tree plaque and a carved stone circle at the gallery entrance.

The bookshop is run by Walther Koenig Books and, as well as books, *catalogues raisonnés*, monographs, magazines and journals, it sells limited-edition prints. An events programme offers various ways to experience, discuss and get involved in contemporary art, regardless of knowledge or age, ranging from free gallery talks to 24-hour experimental marathons and family activities on summer Sundays.

Victoria Miro Gallery
16 Wharf Road N1 7RW
t: 020 7336 8109

www.victoria-miro.com

A major vanguard gallery in an impressive space. Represents established international artists while continuing to support the work of innovative younger and emerging new artists. Artists include Varda Caivano, Peter Doig, Chris Ofili, Grayson Perry, Conrad Shawcross. The newer Victoria Miro 14 (on the same site and conceived by architect Claudio Silvestrin) opens for special exhibitions and projects.
MAP 11/16

Vilma Gold
6 Minerva Street E2 9EH
t: 020 7729 9888

www.vilmagold.com

New exhibition every five weeks, showing painting, sculpture and video performance. Artists include Nicolas Byrne, William Daniels, Brian Griffiths, Thomas Hylander, Dani Jakob, Andrew Mania, Mark Titchner.
MAP 13/39

VINEspace
25a Vyner Street E2 9DG
t: 020 8981 1233

www.vinespace.net

Shows experimental, site-specific and temporary installations in its group and solo exhibitions.
MAP 13/29

Waddington Galleries
11 Cork Street W1S 3LT
t: 020 7851 2200

www.waddington-galleries.com

One of the most established art galleries and dealerships for contemporary art in London, exhibiting painting, sculpture, prints and works on paper by 20th-century artists from Britain, Europe and the USA. Artists include Peter Blake, Patrick Caulfield, Ian Davenport, Barry Flanagan, Patrick Heron, Henry Moore, Ben Nicholson, William Turnbull, Bill Woodrow.
MAP 7/38

Waterhouse & Dodd
26 Cork Street W1S 3MQ
t: 020 7734 7800

www.modbritart.com

Holds four exhibitions of contemporary art each year and maintains a permanent stock of contemporary paintings. Includes artists Trevor Bell, Graham Dean, Sarah Gillespie, Steven Lawler.
MAP 7/28

Whitecross Gallery
122 Whitecross Street
EC1Y 8PU
t: 020 7253 4252

www.whitecrossgallery.com

Promotes the work of both new and established contemporary artists and holds between six and nine annual exhibitions.
MAP 1/11

White Cube Hoxton Square
48 Hoxton Square N1 6PB
t: 020 7930 5373

www.whitecube.com
SEE PAGE 161

White Cube Mason's Yard
25-26 Mason's Yard SW1Y 6BU
t: 020 7930 5373

www.whitecube.com
SEE PAGE 161

Whitford Fine Art
6 Duke Street St James's
SW1Y 6BN
t: 020 7930 9332

www.whitfordfineart.com

Focuses on British post-war and abstract art, pop art, cubism and modernism. Also specializes in 1960s designer furniture.
MAPS 6/18, 7/70

Wilkinson Gallery
50-58 Vyner Street E2 9DQ
t: 020 8980 2662

www.wilkinsongallery.com

Amanda and Anthony Wilkinson specialize in contemporary international artists, sculptors, video and filmmakers. Artists include Kevin Appel, Kamrooz Aram, Tilo Baumgartel, Matthew Higgs, Phoebe Unwin.
MAP 13/31

Will's Art Warehouse
180 Lower Richmond Road
SW15 1LY
t: 020 8246 4840
⊖ *Putney Bridge* ⇌ *Putney*

www.wills-art.com

The concept of Will Ramsay, who masterminds the Affordable Art Fair. Gallery and fair specialize in selling contemporary art priced between £50 and £3,000.

Woolff Gallery
Unit 3 Lloyds Wharf
Mill Street SE1 2BD
t: 07961 417 334

www.woolffgallery.co.uk

A contemporary gallery exhibiting artists including Daisy Boman, Andrew Hood, Michael Maly, David Wheeler.
MAP 12/8

South London Gallery

65 Peckham Road SE5 8UH
t: 020 7703 6120
≷ Peckham Rye
www.southlondongallery.org

Taking a trip beyond the relative comfort zone of central London to the South London Gallery is well worthwhile. This is the place in south London to see exciting new contemporary art in a beautiful, distinctive venue. Applauded for its adventurous programme, the SLG consistently takes a lead in showing and collecting work by international major artists and validated emerging artists. Central to the gallery is a spacious sky-lit exhibition hall, with further spaces to enjoy browsing art books and magazines in a friendly environment. 2009 sees the gallery expand into a neighbouring property, with further exhibition spaces, a flat for artists' residencies, a café looking onto artist-designed gardens, an education studio and seminar room.

Since 2001 director Margot Heller has programmed solo exhibitions of emerging British talent and more established international figures within the contemporary art world as well as group exhibitions providing a platform for younger artists. Recent exhibitions include John Armleder, Chris Burden, Nigel Cooke, Mark Dion, Melik Ohanian, Eva Rothschild and Saskia Olde Wolbers.

The SLG is well known for its programme of live art and regularly showcases some of the UK's leading names, including Marcia Farquhar, Aaron Williamson and Franko B. Innovative, off-site projects, including Chris Burden's *The Flying Steamroller* presented at Chelsea College of Art and On Kawara's *Reading One Million Years* performed in Trafalgar Square, ensure the SLG's work is seen by thousands and position it as one of London's best-loved contemporary art venues.

With its roots in the mid-19th century, it was only in 1992 that the SLG's exhibition programme began to focus on the latest developments in contemporary art. In 2002 it began to collect contemporary works relating to south London with the help of the Contemporary Art Society. Purchases include works by Tracey Emin, Antony Gormley and Anish Kapoor. Today the collection can be seen on the gallery's website, and it is also a valuable resource for projects with schools. Over the past five years the gallery has developed its work with both schools and the local community, organizing regular artist-led projects, workshops and events for families and outreach work in the surrounding neighbourhoods.

PHOTOGRAPHY

Architectural Association
36 Bedford Square WC1B 3ES
t: 020 7887 4111

www.aaschool.ac.uk

Photographic shows are open to the public, admission free.
MAP 8/32

Association of Photographers (AOP) Gallery
81 Leonard Street EC2A 4QS
t: 020 7739 6669

www.the-aop.org

Stages photographic exhibitions and events, including solo exhibitions by accomplished and up-and-coming photographers, group shows by members, and exhibitions of the association's prestigious awards schemes.
MAP 11/2

Atlas Gallery
49 Dorset Street W1U 7NF
t: 020 7224 4192

www.atlasgallery.com

Promotes contemporary fine-art photographers; 20th-century masters include Edward Steichen, Alfred Stieglitz, Paul Strand, Edward Weston.
MAP 5/12

Brown's Hotel
Albemarle Street W1S 4BP
t: 020 7493 602

www.brownshotel.com

Inspired by the Helmut Newton bar in Berlin, the Donovan Bar pays homage to Terence Donovan (1936-96). Enjoy a drink surrounded by his iconic photographs.
MAP 7/51

The Camera Press Gallery
21 Queen Elizabeth Street
Butlers Wharf SE1 2PD
t: 020 7940 9171

www.tomblaugallery.com

Focuses on exhibitions of the work of artists represented by Camera Press.
MAP 12/7

Hackelbury Fine Art Ltd
4 Launceston Place W8 5RL
t: 020 7937 8688

www.hackelbury.co.uk

Exhibits both established 20th-century photographers and young photographers of the 21st century. Photographers include Berenice Abbott, Michael Kenna, William Klein, Irving Penn.
MAP 4/22

Hamiltons Gallery
13 Carlos Place W1K 2EU
t: 020 7499 9493

www.hamiltonsgallery.com

This gallery has consistently exhibited modern masters and up-and-coming photographers in its spectacular and well-lit space. Photographers represented include Richard Avedon, Richard Caldicott, Murray Fredericks, James Nars, Jedd Novatt, and the estates of Norman Parkinson and Horst P. Horst.
MAP 7/5

Hoopers Gallery
15 Clerkenwell Close
EC1R 0AA
t: 020 7490 3908

www.hoopersgallery.co.uk

Photographer Roger Hooper aims to provide a platform for new and talented photographers as well as established names.
MAP 9/32

Magnum Print Room
63 Gee Street EC1V 3RS
t: 020 7490 1771

www.magnumphotos.co.uk

The world-famous Magnum picture agency, based in Paris, was founded in 1947 as a photographers' collective. Its extraordinary picture library reflects every aspect of life throughout the world, 'chronicling and interpreting its peoples, events, issues and personalities'. The Print Room plans four themed group shows each year, working sometimes in association with Atlas Gallery. Ring Gee Street for details of events.
MAP 9/34

Michael Hoppen Gallery
3 Jubilee Place SW3 3TD
t: 020 7352 3649

www.michaelhoppengallery.com

The spacious building provides galleries for 19th- and 20th-century photography, and Michael Hoppen Contemporary occupies Floor 3. Has an exhibitions programme and a print room of artists' work, including Richard Avedon, Peter Beard, Valérie Belin, Henri Cartier-Bresson, Désirée Dolron, Annie Leibovitz, Daido Moriyama, Garry Winogrand.
MAP 4/12

off broadway
63-65 Broadway Market
E8 4PH
t: 020 7254 9771

www.offbroadway.org.uk

The gallery specializes in 'photo-canvases' (photography printed directly onto canvas).
MAP 13/23

Photofusion
17a Electric Lane SW9 8LA
t: 020 7738 5774
⊖ ⇌ *Brixton*

www.photofusion.org

London's largest independent photography resource centre, including galleries, darkrooms, a photo library, an agency, and seminars and workshops.

The Photographers' Gallery
5 and 8 Great Newport Street WC2H 7HY
t: 020 7831 1772

www.photonet.org.uk

SEE PAGE 137

Special Photographers Company (Reunion Images)
236 Westbourne Park Road W11 1EL
t: 020 7221 3489

www.specialphotographers.com

Holds collectors' prints, gallery editions and rights-managed contemporary photography.
MAP 3/15

GALLERY TOURS AND WALKS

Contemporary Art Society

Expert tours on the last Saturday of each month.
See page 123.

East London Art Walks

Guided Saturday and Sunday tours to six to eight exhibitions.
See page 126.

First Thursdays

East London's galleries and museums open till late on the first Thursday of each month.
See page 117.

PUBLIC ART

Alexander
Jubilee Oracle *(1980)*
South Bank SE1
Riverside, Jubilee Gardens
MAP 10/10

Ron Arad
Windwand *(1999)*
Westferry Circus
Canary Wharf E14
MAP 12/33

Ron Arad
The Big Blue *(2000)*
Canada Square Park
Canary Wharf E14
Illustrated on page 162
MAP 12/37

Art Lights London

www.artwisecurators.com/all.pdf

Starting in 2008, this event is to be held each winter. Buildings, streets, squares, parks, open spaces, bridges and waterways will be the backdrop. Artists, designers, architects, writers and poets will create ambitious lighting projects. Artists include Vito Acconci, Peter Blake, Hussein Chalayan, Shilpa Gupta, Mariko Mori, Julian Opie.

David Backhouse
The Animals in War Memorial *(2004)*
Brook Gate
Park Lane W1
MAP 5/10

Stephen Balkenhol
Couple *(2003)*
More London Place
Tooley Street SE1
MAP 12/4

Fiona Banner
Full Stops *(2003)*
More London Riverside SE1
Five of them, west of City Hall
MAP 12/6

David Batchelor
Evergreen *(2003)*
The Queen's Walk SE1
Set among birch trees
MAP 12/5

Zadok Ben-David
Restless Dream *(1933)*
Limehouse Link Tunnel E14
Western portal façade
⇌ *DLR Limehouse*

Fernando Botero
Broadgate Venus *(1990)*
Exchange Square
Broadgate EC2
MAP 12/19

Lynn Chadwick
Couple on Seat *(1984)*
Cabot Square
Canary Wharf E14
Illustrated on page 27
MAP 12/36

Xavier Corbero
The Broad Family *(1988)*
Exchange Place
Broadgate EC2
Off Appold Street
MAP 12/16

Stephen Cox
Ganapathi and Devi *(1988)*
Sun Street roundabout
Broadgate EC2
MAP 12/15

Stephen Cox
Water Feature *(1990)*
Exchange Square
Broadgate EC2
MAP 12/18

Michael Craig-Martin
Big Fan (2002)
Triton Square NW1
Illustrated on page 31
MAP 8/17

Salvador Dalí
Nobility of Time (1977-84)
South Bank SE1
MAP 10/11

Ian Davenport
Poured Lines
Southwark Street (2006)
Southwark Street SE1
Below Blackfriars railway bridge
Illustrated on page 34
MAP 9/6

Paul Day
Battle of Britain (2005)
Victoria Embankment SW1
MAP 6/14

Paul Day
The Meeting Place (2007)
St Pancras International NW1
Under the station clock
MAP 8/25

Jim Dine
Venus (1989)
155 Bishopsgate EC2
In the lobby
MAP 12/20

Tom Dixon
Ingot (2006)
77 Hatton Garden EC1
On the façade
MAP 9/30

Frank Dobson
London Pride (1951, cast 1987)
Royal National Theatre
South Bank SE1
MAP 9/5

152

The Economist Plaza
25 St James's Street SW1
t: 020 7831 1243
www.contempart.org.uk/economist
The only outdoor public exhibition space in central London committed to a continuous programme of sculptural works by contemporary artists. Commissioned and organized by the Contemporary Art Society (see page 123).
MAPS 6/25, 7/77

Jacob Epstein
Ages of Man (1907-08)
Zimbabwe House
429 Strand WC1
Remains of 18 figures on the façade
MAP 9/14

Jacob Epstein
Night and *Day* (1928)
London Transport HQ
55 Broadway SW1
On the façade of St James's Park underground station
MAP 6/10

Jacob Epstein
The Madonna and Child (1950)
Convent of the Holy Child Jesus Dean's Mews
Cavendish Square W1
On the façade
MAP 8/7

Jacob Epstein
Pan Sculpture (1959)
Central Reservation
Edinburgh Gate SW1
MAP 1/2

Alan Evans
Go Between (1989)
4-6 Broadgate EC2
Gateway/barrier between two buildings on Broadgate estate
MAP 12/21

Barry Flanagan
Camdonian (1980)
Newman's Row
Lincoln's Inn Fields WC2
MAPS 8/27, 9/25

Barry Flanagan
Leaping Hare on Crescent & Bell (1988)
10-12 Broadgate Circle EC2
Illustrated on page 38
MAP 12/24

Norman Foster, Anthony Caro and Arup
Millennium Bridge (2000)
Linking St Paul's Cathedral and Tate Modern
MAP 9/11

Fourth Plinth
Trafalgar Square WC2

The most central of London's squares contains Nelson's column and, at each corner, a monumental plinth. Three bear permanent bronze statues. The fourth (in the north-west corner) was originally intended for a statue of George IV but it was never invested, due to lack of funds and later lack of interest. Not until 1998, following a competition to find a subject for the plinth, was it inaugurated. Installations have included Mark Wallinger, *Ecce Homo*, 1999; Bill Woodrow, *Regardless of History*, 2000; Rachel Whiteread, *Monument*, 2001; Marc Quinn, *Alison Lapper Pregnant*, 2005; Thomas Schütte, *Model for a Hotel*, 2007 (page 13).
MAP 9/15

Elisabeth Frink
Shepherd and Sheep (1975)
Paternoster Square EC4
Illustrated on page 41
MAP 9/38

Tate

Tate Britain
Millbank SW1P 4RG
t: 020 7887 8888
www.tate.org.uk/britain
MAP 6/8

Tate Modern
Sumner Street SE1 9TG
t: 020 7887 8888
www.tate.org.uk/modern
MAP 9/10

The original Tate Gallery, at Millbank in London, opened in 1897. Its official name was the National Gallery of British Art, but it became known as the Tate Gallery, after founder Sir Henry Tate. It was designed to house the 19th-century British painting and sculpture he gave to the nation, together with British paintings transferred from the National Gallery. Its responsibilities were for modern British art, work by artists born after 1790. In 1917 it was also made responsible for the national collection of international modern art and for British art after 1500. It became wholly independent in 1955. Today, it is Tate, a family of four galleries: Tate Britain and Tate Modern in London, Tate Liverpool and Tate St Ives. Division of the London Tates came in 1992, when the trustees decided to divide displays of the collection between two sites: a gallery for international modern and contemporary art, later named Tate Modern, and a gallery for British art from 1500, occupying the whole of the building at Millbank, later named Tate Britain.

Tate Britain is now the national gallery of British art from 1500 to the present day, from the Tudors to the Turner Prize, holding the greatest collection of British art in the world. The exhibition spaces include the Duveen Galleries, where contemporary sculpture commissions are displayed. Contributing artists here have included Michael Landy, Richard Long, Richard Serra and Mark Wallinger. Tate Britain also focuses on contemporary art through its Art Now programme, reflecting a commitment to the support of emerging artists through mostly solo shows. Instigated in the 1990s, it has now been given a more prominent position.

Tate Modern opened in 2000 to display the national collection of international modern art (defined as art since 1900). The search for a building to convert for the purpose hit upon a power station that had closed in 1982. A very striking, distinguished building in its own right, designed by the architect Sir Giles Gilbert Scott, it offered all the space required. And it was in an amazing location on the south bank of the Thames opposite St Paul's Cathedral and the City. Plans were almost immediately made to build a footbridge to link the new gallery and the City via what was to be named the Millennium Bridge. Since the original Tate site is

also on the river, a satisfactory symmetry emerged, with the two linked by a riverboat service. An international architectural competition was held, attracting entries from practices all over the world. The final choice was Herzog & de Meuron, a Swiss firm. A key factor in their success was their proposal to retain much of the essential character of the building. The power station's huge turbine hall became a dramatic entrance area, with ramped access, as well as a display space for very large sculptural projects. Funded by Unilever, the turbine-hall projects are a significant part of the exhibition programme, and have included monumental work from Anish Kapoor, Louise Bourgeois, Olafur Eliasson, Bruce Nauman, Rachel Whiteread, Carsten Höller, Juan Muñoz and Doris Salcedo.

The Tate Collection

Tate is, ultimately, one big store/collection. Its aim is to make as much of its collection as possible available to visitors through its programme of changing exhibitions and displays. It is (loosely) divided between all the Tates (Britain, Modern, Liverpool and St Ives). Few pieces are guaranteed 'permanently on view'. Exhibitions move between the four galleries or go on tour and works are loaned to big exhibitions elsewhere entirely. Work can be viewed on-line and users can check if a work is on display; contact www.tate.org.uk. Phone-line staff are also trained to answer queries about the availability of particular pieces. In addition, works on paper not on display are available to view in the Prints & Drawings Room at Tate Britain. If the work you wish to view is not on display or loan, it may be possible to visit it in the Tate Store, though access is limited and by appointment.

The Turner Prize

Established in 1984 to draw public attention to contemporary art, the Turner Prize has reflected and informed the popular reception of new British art in this country and abroad. The name of artist J.M.W. Turner was chosen partly because he had wanted to establish a prize for young artists and partly because his own work was controversial in his day. Each year a specialist jury shortlists artists and selects a winner, causing debate and controversy. Malcolm Morley was the first to be awarded the prize. Subsequent winners have included Howard Hodgkin, Gilbert & George, Richard Deacon, Tony Cragg, Richard Long, Anish Kapoor, Grenville Davey, Rachel Whiteread, Damien Hirst, Douglas Gordon, Gillian Wearing, Chris Ofili, Wolfgang Tillmans, Martin Creed, Tomma Abts and Mark Wallinger.

Naum Gabo
Revolving Torsion,
Fountain (1972)
St Thomas's Hospital
Lambeth Palace Road SE1
In the riverside gardens
Illustrated on page 43
MAP 10/13

Eric Gill
Prospero and Ariel (1931)
Broadcasting House
2 Portland Place W1
On the façade
MAP 8/8

Antony Gormley
Quantum Cloud (1999)
SE10
On a platform in the Thames
beside a pier east of The O2
⊖ North Greenwich

Antony Gormley
Reflection (2001)
350 Euston Road NW1
Illustrated on page 46
MAP 8/15

Antony Gormley
Resolution (2007)
Shoe Lane EC4
At junction with St Bride Street
MAP 9/41

Diane Gorvin
Dr Salter's Daydream (1991)
Bermondsey Wall East SE16
Near Cherry Garden Pier and
opposite the Angel Pub
MAP 1/13

Thomas Heatherwick
Rolling Bridge (2004)
Paddington Basin W2
MAPS 3/7, 5/5

Thomas Heatherwick
Vents (2000)
Bishops Court
Paternoster Lane EC4
Off Ave Maria Lane
Illustrated on page 49
MAP 9/40

Barbara Hepworth
Single Form (1963)
Battersea Park SW11
On the south bank of the lake
⇌ Battersea Park/Queenstown
Road Battersea

Barbara Hepworth
Two Forms (Divided Circle)
(1969)
Dulwich Park SE21
Near the lake
⇌ West or North Dulwich

Barbara Hepworth
Winged Figure (1973)
Oxford Street/Holles Street W1
On the side wall of John Lewis
Illustrated on page 50
MAPS 7/14, 8/6

Patrick Heron
Big Painting Sculpture
(1996-98)
Stag Place SW1
Illustrated on page 162
MAP 6/9

Lawrence Holofcener
Allies (1995)
New Bond Street W1
At Clifford Street junction
MAP 7/42

Philip Jackson
Terence Cuneo (2004)
Waterloo railway station SE1
Near steps to Mepham Street
MAP 10/9

Charles Sargent Jagger
The Great Western Railway
Memorial (1921-22)
Paddington railway station W1
On platform 1
MAPS 3/6, 5/6

Martin Jennings
John Betjeman (2007)
St Pancras International NW1
On main concourse
MAP 8/24

Allen Jones
Acrobat (1993)
Chelsea & Westminster Hospital
369 Fulham Road SW10
In the atrium via main entrance
Illustrated on page 58
MAP 4/5

Allen Jones
Dancers (1987)
Cotton Centre
Tooley Street SE1
In the riverside atrium
MAP 12/3

Anish Kapoor
Holocaust Memorial (1996)
Liberal Jewish Synagogue
28 St John's Wood Road NW8
On the entrance hall wall
MAP 5/1

Phillip King
Clarion (1981)
Fulham Broadway SW6
Illustrated on page 61
⊖ Fulham Broadway

Langlands & Bell
Moving World (Night & Day)
(2008)
Terminal 5 Heathrow Airport
Either end of pedestrian plaza
See artwork on page 62

Langlands & Bell
Opening/Capture (2003)
Triton Square NW1
Portland stone benches
MAP 8/16

Jacques Lipchitz
*Bellerophon Taming
Pegasus* (1987)
Finsbury Avenue
Broadgate EC2
MAP 12/23

Bruce McLean
EYE-I (1993)
199 Bishopsgate EC2
Outside Bishopsgate Arcade
MAP 12/17

John Maine
Arena Sculpture (1983-88)
Royal National Theatre
South Bank SE1
Between the theatre and river
MAP 9/4

Igor Mitoraj
Centurione I (1983)
Columbus Courtyard
Canary Wharf E14
MAP 12/35

Henry Moore
Knife Edge Two Piece
(1962-65)
Abingdon Street Gardens SW1
Illustrated on page 67
MAP 6/11

Henry Moore
Three Standing Figures
(1947-48)
Battersea Park SW11
On the north bank of the lake
⇌ Battersea Park/Queenstown
Road Battersea

Henry Moore
Time Life Screen (1952)
151 New Bond Street W1
MAP 7/44

Henry Moore
*Two Piece Reclining Figure
No. 5* (1963-64)
Kenwood House
Hampstead Lane NW3
West of the house
⊖ East Finchley

Aaron Noble
Spire (2004)
27 Hoxton Square N1
On the corner of Mundy Street
Illustrated on page 72
MAPS 11/12, 13/11

Eduardo Paolozzi
The Artist as Hephaestus
(1987)
37-39 High Holborn WC1
MAP 9/26

Eduardo Paolozzi
Cooling Tower Panels
(1979-82)
Pimlico underground station
Bessborough Street SW1
MAP 6/4

Eduardo Paolozzi
Invention (1989)
Shad Thames SE1
Outside the Design Museum
MAP 12/10

Eduardo Paolozzi
Newton after William Blake
(1995)
British Library Piazza
96 Euston Road NW1
Illustrated on page 77
MAP 8/22

Eduardo Paolozzi
Piscator (1980)
Euston Square NW1
Outside Euston railway station
MAP 8/21

Eduardo Paolozzi
Underground Murals
(1980-86)
Tottenham Court Road
underground station W1
Mosaics throughout the station
MAP 8/41

Simon Patterson
Time and Tide (2005)
Plantation Place
Plantation Lane EC3
Illustrated on page 7
MAP 12/11

William Pye
Zemran (1972)
Queen Elizabeth Hall
South Bank SE1
Illustrated on page 83
MAP 9/1

Wendy Ramshaw
Columbus Screen (2000)
Columbus Courtyard
Canary Wharf E14
Between two buildings north
of the courtyard
MAP 12/34

Ivor Robert-Jones
Churchill (1975)
Parliament Square SW1
MAP 6/13

**Royal Academy of Arts
Courtyard**
Burlington House
Piccadilly W1
The Sculpture in the Courtyard
programme features large-scale
installations by internationally
renowned artists.
MAP 7/64

George Segal
Rush Hour (1983)
Finsbury Avenue Square
Broadgate EC2
Illustrated on page 92
MAP 12/22

Richard Serra
Fulcrum (1987)
Octagon Arcade Broadgate
EC2
Illustrated on page 93
MAP 12/25

Conrad Shawcross
Space Trumpet (2007)
Unilever House
100 Victoria Embankment EC4
Suspended in the foyer
Illustrated on page 96
MAP 9/12

**Philip Vaughan and
Roger Dainton**
Neon Tower (1972)
The Hayward
Belvedere Road SE1
On the roof of the gallery
MAP 9/3

Pierre Vivant
Traffic Light Tree (1995-98)
Heron Quays Roundabout
Canary Wharf E14
Illustrated on page 105
MAP 12/38

Ian Walters
Nelson Mandela (2007)
Parliament Square SW1
MAP 6/12

Whitfield Partners
Column (2003)
Paternoster Square EC4
MAP 9/39

Bill Woodrow
Sitting on History (1998)
British Library
96 Euston Road NW1
In the entrance hall
Earlier cast (555 King's Road
SW6) illustrated on page 111
MAP 8/23

ART COLLEGES

Camberwell College of Arts
45-65 Peckham Road SE5 8UF
t: 020 7514 6302
≥ Denmark Hill/Peckham Rye

www.camberwell.arts.ac.uk

Founded more than a hundred
years ago, Camberwell has a
distinguished fine-art tradition,
and has long been regarded as
one of the country's leading art
and design colleges. It launched
the careers of Gillian Ayres, Terry
Frost, Howard Hodgkin, Richard
Long, Tom Phillips and other
successful graduates working
throughout the world.

Central St Martin's College
of Art and Design
Southampton Row WC1B 4AP
t: 020 7514 7000

www.csm.arts.ac.uk

The iconic design of the
Routemaster bus, the chopper
bike, theatrical productions like
Phantom of the Opera and
exquisite fashion at Dior and
Chloé in Paris - all owe their
beginnings to St Martin's. Strong
on textile, fashion, design and
fine arts. Summer degree shows.
Entrance is in Theobald's Road.
MAPS 8/28, 9/23

Chelsea College of Art
and Design
16 John Islip Street SW1P 4JU
t: 020 7514 7751

www.chelsea.arts.ac.uk

Chelsea's international reputation
is built on a strong history. It is
rich in events, exhibitions and
summer degree shows. The
foundation and degree shows in
May and June are followed at
the end of July/early August by

the postgraduate fine-art show
and in mid-September by the
masters show. All opportunities
to buy work from new young
artists and designers.
MAP 6/7

Goldsmiths College, School
of Art and Design
Lewisham Way SE14 6NW
t: 020 7919 7171
≥ Brockley

www.goldsmiths.ac.uk

Famous alumni include artists
Lucian Freud, Antony Gormley,
Damien Hirst, Margaret Howell,
Gary Hume, Steve McQueen,
Bridget Riley, Sam Taylor-Wood,
Gillian Wearing.

London College of
Communication
Elephant and Castle SE1 6SB
t: 020 7514 6500

www.lcc.arts.ac.uk

Formerly the London College of
Printing, it hosts state-of-the-art
media facilities with courses
including interactive games
production, design management,
public relations and creative
advertising. The college houses
The Street, Community and Well
galleries, and exhibitions and
events take place throughout the
year, culminating in end-of-year
student shows.
MAP 10/5

Royal Academy Schools
Burlington House
Burlington Gardens W1S 3EX
t: 020 7300 8000

www.royalacademy.org.uk

Postgraduate fine-art courses
with an annual show of work in
the lower galleries at the Royal
Academy.
MAP 7/36

Royal College of Art
Kensington Gore SW7 2EU
t: 020 7590 4444

www.rca.ac.uk

The only university of art and design in the world specifically for postgraduates. Courses in painting, sculpture, graphics and other disciplines. Exciting rosta of external exhibitions and art fairs as well as a keenly watched annual exhibition of degree work in all media.
MAP 3/2

Slade School of Fine Art
University College
Gower Street WC1E 6BT
t: 020 7679 2313

www.ucl.ac.uk/slade

The result of a bequest by Felix Slade in 1871, who envisaged fine art being studied within a liberal arts university. Among the many acclaimed artists who studied here are Augustus and Gwen John, Eduardo Paolozzi, Paula Rego, Stanley Spencer, William Turnbull.
MAP 8/19

Wimbledon College of Art
52 Merton Hall Road
SW19 3QA
t: 020 7514 9641
⊖ ⇄ *Wimbledon*

www.wimbledon.arts.ac.uk

A lively art school. Established artists can exhibit at its Centre of Drawing. This commitment to drawing is evident in the post of Drawing Fellow attached to the fine-art school and the hosting and organization of the Jerwood Drawing Prize, the premier national contemporary drawing competition.

ART FAIRS

Affordable Art Fair
Battersea Park SW11
t: 020 7371 8787

www.affordableartfair.co.uk

Presents around 120 galleries, dealers and studio groups from Britain and abroad. Its aim is to make original work under £3,000 more accessible. A big fair with a mixed menu. Held in February and October.

ARTfutures
t: 020 7831 1243

www.contempart.org.uk

'The art of the future' is its byline. Organized by the Contemporary Art Society, ARTfutures promotes emerging and mid-career artists. Reliably high-calibre selection of work individually selected by the curators and for sale, with prices starting at £500. Described as a 'gallery without walls', venue and dates are changeable, but usually held in March.

Art London
Burton's Court
St Leonard's Terrace SW3 4SR
t: 020 7259 9399

www.artlondon.net

Over 85 leading British and international galleries show 20th-century and contemporary art, including paintings, sculpture, photography, works on paper and ceramics, ranging in price from £300 to over £100,000. Normally held in June.

The Bada Antiques and Fine Art Fair
Duke of York Square SW3
t: 020 7859 6108

www.bada-antiques-fair.co.uk

A hundred galleries showing pieces from the 17th century to the present day. The fair features a metal gallery of dealers in contemporary metalware, silverware and jewellery, and a selection of contemporary furniture. Held in March.

Ceramic Art London
Royal College of Art
Kensington Gore SW7 2EU
t: 020 7439 3377

www.ceramics.org.uk

A ceramic fair showing contemporary studio ceramics from leading makers in Britain and overseas. Held in March.

Chelsea Art Fair
Chelsea Old Town Hall
321 King's Road SW3 5EE
m: 01825 744 074

www.penman-fairs.com/
art_fairs_calendar.htm

An intimate fair featuring a selection of art from 1930 to the present. Over 40 British and international galleries exhibit work from a range of artists. Has an 'arts club' feel to it but can surprise. Held in early summer.

Collect
The international art fair for contemporary objects
Victoria & Albert Museum
Cromwell Road SW7 2RL
t: 020 7806 2549

www.craftscouncil.org.uk/collect

The only international art fair of its kind in Europe. Galleries from around the world show works of museum quality, giving the public the chance to cast an eye over a great variety of objects and the opportunity to buy. Held in February.

Whitechapel Art Gallery

80-82 Whitechapel High Street E1 7QX
t: 020 7522 7888
www.whitechapel.org
MAP 12/28

Visit the Whitechapel any time and you will find some aspect of international, national or local new art vital to the big picture of contemporary art in London. One of the oldest galleries promoting new art, and one of the first to receive public funding, the Whitechapel opened its doors to the public in 1901. It was originally named the East End Gallery, designed by Charles Harrison Townsend, an architect associated with the Arts and Crafts movement. The Whitechapel was conceived as a way of bringing contemporary art to the East End of London, a poor area with a cultural and ethnic mix, and was an instant success.

Pablo Picasso's *Guernica* was exhibited here in 1939, and the Whitechapel premiered exhibitions of international artists, including Mark Rothko and Jackson Pollock, Frida Kahlo and Nan Goldin. It has also provided showcases for emerging British artists, among them Gilbert & George, Lucian Freud, Richard Long and Mark Wallinger, and is recognized as one of the venues responsible for launching David Hockney and the pop art movement. Today it is still in the vanguard in an area now wholly associated with new galleries and artists' studios, and through exhibitions such as *East End Academy* it continues to promote artists who live and work in the East End of London as well as blockbuster international exhibitions.

It has never held a permanent collection, leaving the way clear for temporary exhibitions. But with every exhibition, catalogues are produced as well as limited editions by the artists, and the bookshop is a good source of art books and journals. With a £10.5 million expansion project underway to unite the existing gallery with the former library building next door, the gallery space is doubling in size and will continue to remain open as a free art gallery all year round.

The Whitechapel, under its energetic director Iwona Blazwick, has a substantial programme of exhibitions, events, local links with artist-led workshops, discussions, curated talks, late-night events, lectures and courses on collecting contemporary art, artist-in-residence schemes and an on-going commitment to encouraging young people to get involved. It also runs, in collaboration with the fashion label Max Mara, the art world's equivalent to the Orange Prize in fiction: a prize (and residency in Italy) for a British female artist.

FORM London

Olympia
Hammersmith Road W14 8UX
t: 020 7370 8921

www.form-london.com

Features 20th- and 21st-century modern and contemporary paintings, photography, sculpture, ceramics and jewellery, with an area dedicated to the work of 15 emerging designers and artists. Normally held in February/March.

Frieze Art Fair

Regent's Park NW1
t: 020 7833 7270

www.friezeartfair.com

SEE PAGE 127

Inspired Art Fair

Christ Church Spitalfields
Commercial Street E1 6LY
t: 020 8374 7318

www.inspiredartfair.com

This is a fair for independent contemporary photographers, painters, sculptors and digital artists who have not yet received critical recognition. Works range from £50 to £5,000. Normally held in November.

The Islington Contemporary Art and Design Fair

Candid Arts Trust
3 Torrens Street EC1V 1NQ
t: 020 7837 4237

www.candidarts.com

A showcase for selected artists and designers. Four exhibitions, each featuring different creative disciplines. Range of artists with some unusually good discoveries. Normally held in October/ November/December.

The London Art Fair

Business Design Centre
52 Upper Street N1 0QH
t: 020 7288 6736

www.londonartfair.co.uk

A good range of modern British and contemporary art. This is the largest and most established fair of its kind, featuring 100 leading galleries selected each year. Includes a section for new artists' work. Normally held in January.

London Original Print Fair

Royal Academy of Arts
Burlington House
Burlington Gardens W1S 3EX
t: 020 7439 2000

www.londonprintfair.com

The longest-running print fair in the world, exhibiting a broad selection of artists. Normally held in March/April.

Modern Works on Paper

Royal Academy of Arts
6 Burlington Gardens W1S 3EX
t: 01798 861 815

www.worksonpaperfair.co.uk

Shows contemporary and 20th-century prints, photographs, watercolours and drawings. Normally held in February.

photo-london

1 Old Billingsgate Walk
16 Lower Thames Street
EC3R 6DX
t: +33 (0) 1 47 56 64 77

www.photo-london.com

London's international photography fair is part of Paris Photo, managed by Reed Expositions France. Focuses on the 1970s onwards, showcasing the latest international trends. Normally held in May.

Photomonth

t: 020 7375 0441

www.photomonth.org

Over 50 exhibitions and events in 35 galleries and spaces in east London, demonstrating the strength of photojournalism and the depth of contemporary artistic expression. Co-ordinated by alternative arts. Held in October/November.

20/21 British Art Fair

Royal College of Art
Kensington Gore SW7 2EU
t: 020 8742 1611

www.britishartfair.co.uk

British artists represented by about 60 of the country's leading dealers. Held in September.

20/21 International Art Fair

Royal College of Art
Kensington Gore SW7 2EU
t: 020 8742 1611

www.20-21intartfair.com

Features art from Britain, Europe, Asia and Australia. Normally held in September.

Zoo Art Fair

Royal Academy of Arts
6 Burlington Gardens W1S 3EX
t: 020 7247 8597

www.zooartfair.com

Exhibitors are galleries under six years old, showing modern and edgy contemporary art. Call to book tickets to avoid queue. Crowded and with a buzz, Zoo Art Fair is held at the same time as Frieze Art Fair - in October.

White Cube

White Cube Hoxton Square
48 Hoxton Square N1 6PB
t: 020 7930 5373
www.whitecube.com
MAPS 11/9, 13/9

White Cube Mason's Yard
25-26 Mason's Yard SW1Y 6BU
t: 020 7930 5373
www.whitecube.com
MAP 7/67

If you want to experience the pulse of contemporary art in London, White Cube is the place. Jay Jopling is synonymous with the phenomenal success of the gallery he founded in 1993. Originating in the premises of Christie's auction house in the heart of establishment art in Duke Street St James's, Jopling rose meteorically, showing YBAs. In 2000 he opened White Cube² (now retitled White Cube Hoxton Square) in a converted 1920s industrial space in Shoreditch. The gallery building is an architectural 'white cube', and stands on the south-west corner of a small, grassed, tree-lined square within walking distance of Old Street and Liverpool Street stations. Two pre-fabricated storeys of cube components were added to the gallery's orginal building, transported from Manchester to Hoxton by lorry and craned into place. Such was the appetite for White Cube events that people watching thought they were witnessing an art installation.

It is a testament to Jopling's talent that Shoreditch was quickly confirmed as the new art centre of London, and he was followed by like-minded dealers and galleries. Exhibiting the international art world's most celebrated contemporary artists, including work by London-based Darren Almond, Jake and Dinos Chapman, Gilbert & George, Antony Gormley, Marcus Harvey, Mona Hatoum, Gary Hume, Runa Islam, Harland Miller, Neal Tait and Cerith Wyn Evans, Jay Jopling still represents many of his original artists, including Tracey Emin, Damien Hirst, Marc Quinn and Sam Taylor-Wood. But White Cube is not just about the YBAs, a phenomenon still making waves twenty-plus years on. Seventy per cent of all exhibitions at White Cube have been non-British artists and the validated work consistently crosses over generationally and nationally.

In October 2006, Jopling opened another architectural white cube: White Cube Mason's Yard, near his original gallery in St James's. The programme expands exponentially and includes major artists and photographers such as Andreas Gursky, Anselm Kiefer, Julie Mehretu, Gabriel Orozco, Damián Ortega, Fred Tomaselli and Jeff Wall. Developing the talents of emerging artists is also on the bill under the guidance of Tim Marlow, director of exhibitions.

Maps

1. LONDON OVERVIEW	inside front cover	
2. KILBURN/WEST HAMPSTEAD	164	
3. NOTTING HILL/KENSINGTON	166	
4. KNIGHTSBRIDGE/CHELSEA	168	
5. MARYLEBONE	170	
6. WESTMINSTER	172	
7. MAYFAIR/PICCADILLY	174	
8. BLOOMSBURY	176	
9. HOLBORN/SOUTH BANK	178	
10. LAMBETH	180	
11. ISLINGTON	182	
12. CITY/CANARY WHARF	184	
13. HOXTON/SHOREDITCH	186	

KEY TO MAPS

public galleries and art venues

private galleries

public art

art colleges

≋ National Rail

⊖ London Underground

⊖ DLR
Docklands Light Railway

1. LONDON OVERVIEW (inside front cover)

1 Gallery 286
2 Jacob Epstein *Pan Sculpture*
3 Beverley Knowles Fine Art
4 Allsopp Wedel/Allsopp Contemporary
5 Danusha Fine Arts
6 Belgrave Gallery
7 Pollock Fine Art
8 176

9 Beardsmore Gallery
10 Novas Gallery Camden
11 Whitecross Gallery
12 Madder 139
13 Diane Gorvin *Dr Salter's Daydream*
14 Café Gallery Projects
15 Gallery Yujiro
16 Coleman Projects Space
17 Poussin Gallery
18 Gasworks

Opposite (left to right from the top): Lisson Gallery; Tate Britain; Tate Modern; Frieze Art Fair; Patrick Heron, *Big Painting Sculpture* (1996-98); Bloomberg SPACE; Ron Arad, *The Big Blue* (2000); White Cube Hoxton Square; The Barbican.

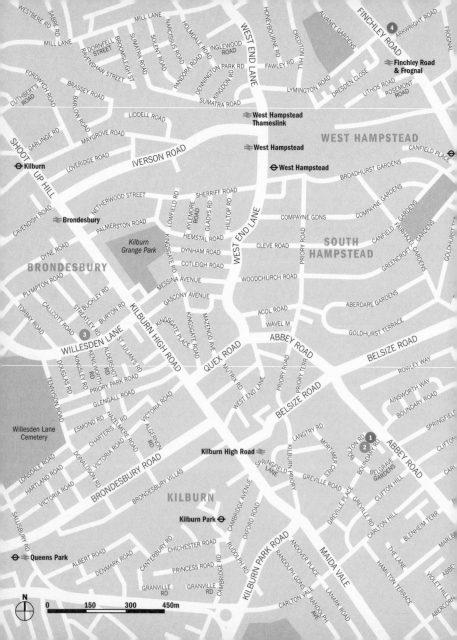

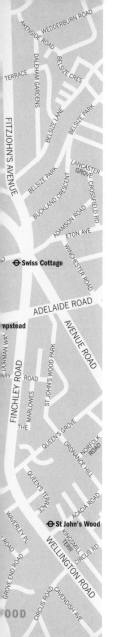

2. KILBURN/WEST HAMPSTEAD

1 Ben Uri Gallery/The London
 Jewish Museum of Art
2 Boundary Gallery
3 Gallery Kaleidescope
4 Camden Arts Centre
5 Freud Museum

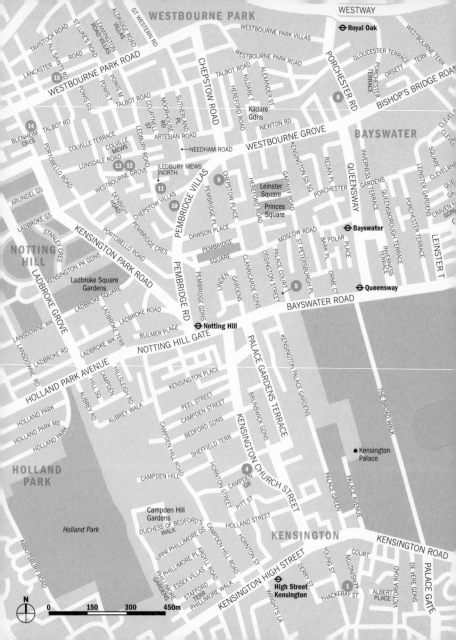

3. NOTTING HILL/KENSINGTON

Map labels (left):

NORTH WHARF ROAD
PADDINGTON BASIN
SOUTH WHARF ROAD
PADDINGTON
PRAED STREET
RNE TERR
Paddington
NORFOLK SQUARE
ILWORTH MEWS
SPRING ST
SUSSEX GDNS
AVEN ROAD
BATHURST MEWS
SUSSEX SQ
GLOUCESTER TER
WESTBOURNE STREET
LANCASTER TERRACE
K MS
TERRACE
Lancaster Gate
D
Hyde Park
Gardens
Serpentine 3 Gallery
THE RING
● Albert Memorial
NSINGTON GORE
● Royal Albert Hall
EXHIBITION ROAD
PRINCE CONSORT ROAD
● Royal College of Music

1 Thackeray Gallery
2 Royal College of Art
3 Serpentine Gallery
4 Shades and Wood Gallery
5 The Apartment
6 Charles Sargent Jagger
 The Great Western Railway Memorial
7 Thomas Heatherwick
 Rolling Bridge
8 Manya Igel Fine Arts Ltd
9 Broadbent Gallery
10 Josh Lilley Fine Art
11 Cosa
12 Hanina Fine Arts Ltd
13 England & Co
14 East West Gallery
15 Special Photographers Company (Reunion Images)

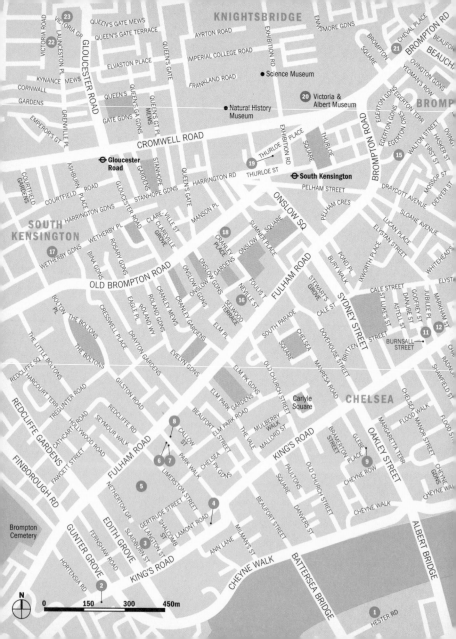

4. KNIGHTSBRIDGE/CHELSEA

1 Albion Gallery
2 Gagliardi Gallery
3 Offer Waterman & Co
4 King's Road Gallery
5 Allen Jones *Acrobat*
6 Jonathan Clark Modern
 British Art
7 Jonathan Cooper/Park Walk
 Gallery
8 Fairfax Gallery
9 Martin Summers Fine Art
 Gallery
10 Dominic Guerrini
11 Flying Colours Gallery
12 Michael Hoppen Gallery
13 Saatchi Gallery
14 Goedhuis Contemporary
15 Andipa Gallery
16 MacLean Fine Art
17 The Paragon Press
18 Cadogan Contemporary
19 Campbell's Art Gallery
20 Victoria & Albert Museum
21 Crane Kalman Gallery Ltd
22 Hackelbury Fine Art Ltd
23 Enviedart

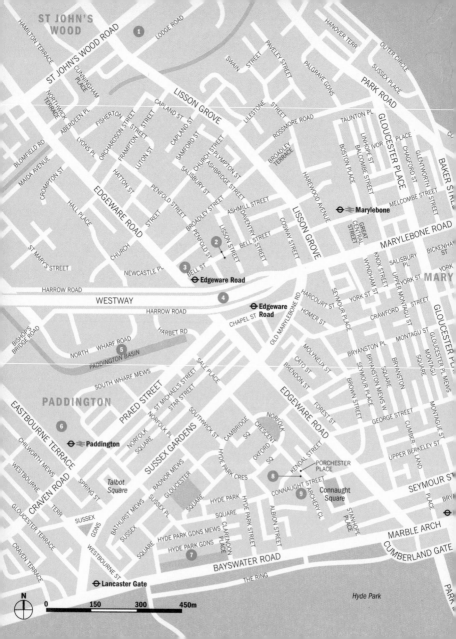

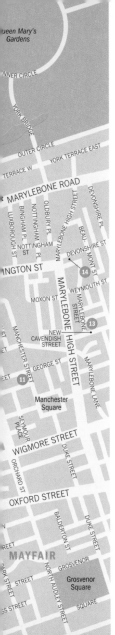

5. MARYLEBONE

1 Anish Kapoor
 Holocaust Memorial
2 Lisson Gallery
3 Mark Jason Gallery
4 The Subway Gallery and The
 Black Wall
5 Thomas Heatherwick
 Rolling Bridge
6 Charles Sargent Jagger
 *The Great Western Railway
 Memorial*
7 Richard Nagy Ltd
8 Lightcontemporary
9 Farmilo Fiumano Gallery
10 David Backhouse
 The Animals in War Memorial
11 Arte Vista
12 Atlas Gallery
13 Portal Gallery
14 jaggedart

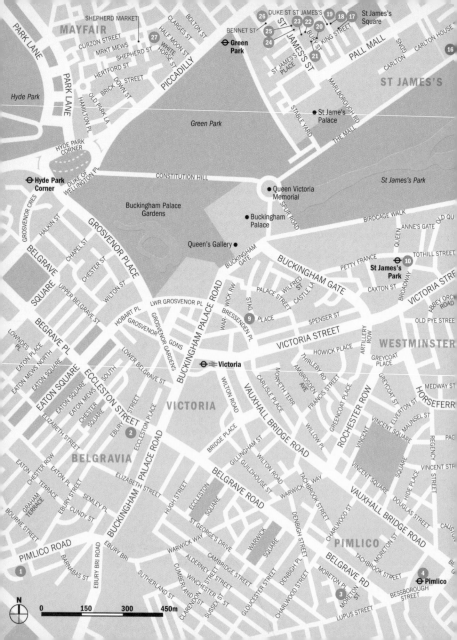

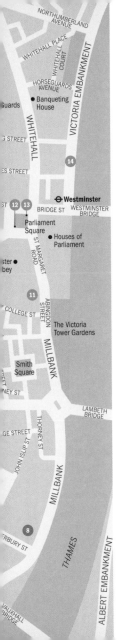

6. WESTMINSTER

1 Plus One Gallery
2 Eleven
3 Barbara Behan
4 Eduardo Paolozzi
 Cooling Tower Panels
5 Long & Ryle
6 CHELSEA Space
7 Chelsea College of Art and
 Design
8 Tate Britain
9 Patrick Heron
 Big Painting Sculpture
10 Jacob Epstein
 Night and Day
11 Henry Moore
 Knife Edge Two Piece
12 Ian Walters *Nelson Mandela*
13 Ivor Robert-Jones *Churchill*
14 Paul Day *Battle of Britain*
15 Mall Galleries
16 Institute of Contemporary Arts
17 Frost & Reed Contemporary
18 Whitford Fine Art
19 Thomas Dane Gallery
20 Duncan R. Miller Fine Art
21 Hazlitt Holland-Hibbert
22 Alla Bulyanskaya Gallery
23 Grosvenor Gallery
24 Sims Reed Gallery
25 The Economist Plaza
26 Portland Gallery
27 Panter & Hall

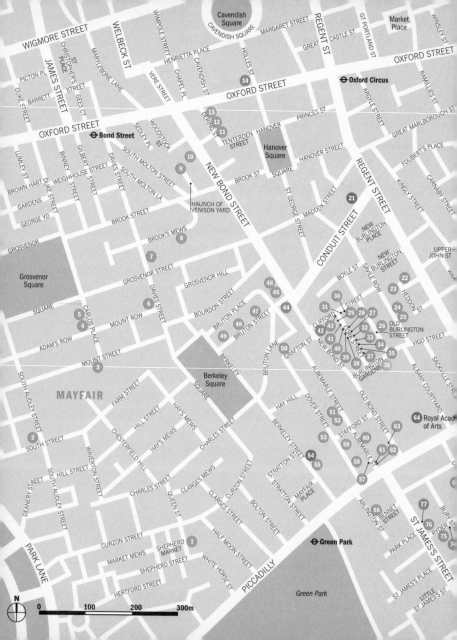

7. MAYFAIR/PICCADILLY

1 Panter & Hall
2 Sadie Coles HQ
3 RICH Fine Art
4 Timothy Taylor Gallery
5 Hamiltons Gallery
6 Gagosian Gallery
7 Gimpel Fils
8 Sarah Myerscough Fine Art
9 Haunch of Venison
10 Max Wigram Gallery
11 Anne Faggionato
12 Timothy Taylor Gallery
13 Annely Juda Fine Art
14 Barbara Hepworth
 Winged Figure
15 Anthony Reynolds Gallery
16 Mumford Fine Art
17 Jill George Gallery
18 Riflemaker
19 Frith Street Gallery
20 Karsten Schubert
21 Sketch
22 Sadie Coles HQ
 Blow de la Barra
23 Sprovieri
24 Matthew Bown Gallery
25 James Hyman Gallery
26 Stephen Friedman Gallery
27 Adam Gallery
28 Waterhouse & Dodd
29 Robert Sandelson
30 Rossi & Rossi Ltd
31 Alan Cristea Gallery
32 The Mayor Gallery
33 Beaux Arts
34 Ben Brown Fine Arts
 Flowers Central
35 Redfern Gallery
36 Royal Academy Schools
37 Browse and Darby Ltd
38 Waddington Galleries

39 Art First
40 Messum's
41 Bernard Jacobson Gallery
42 Lawrence Holofcener *Allies*
43 Helly Nahmad Gallery
44 Henry Moore *Time Life Screen*
45 The Fine Art Society
46 Richard Green
47 Scream
48 Lefevre Fine Art Ltd
49 Osborne Samuel
50 Sprüth Magers
51 Brown's Hotel
52 John Martin Gallery
53 Richard Green
54 Fleming Collection
55 Simon Lee Gallery
56 Portland Gallery
57 Faggionato Fine Art
 Albemarle Gallery
58 Alexia Goethe Gallery
59 Martin MacLeish
60 Marlborough Fine Art
61 Archeus
62 Connaught Brown
63 Agnew's
64 Royal Academy of Arts
65 Hauser & Wirth London
66 emilyTsingou gallery
67 White Cube Mason's Yard
68 Robert Bowman Modern
69 Thomas Dane Gallery
70 Whitford Fine Art
71 Frost & Reed Contemporary
72 Hazlitt Holland-Hibbert
73 Duncan R. Miller Fine Art
74 Alla Bulyanskaya Gallery
75 Grosvenor Gallery
76 Sims Reed Gallery
77 The Economist Plaza

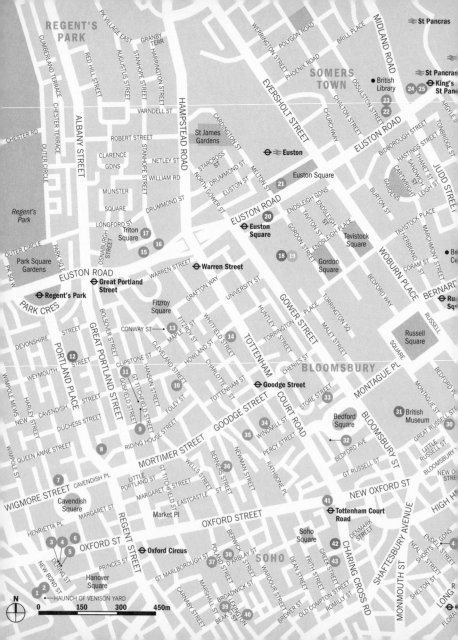

8. BLOOMSBURY

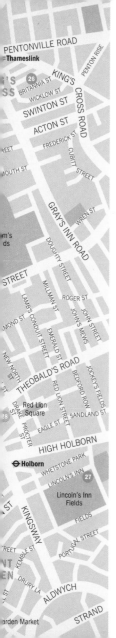

1 Haunch of Venison
2 Max Wigram Gallery
3 Annely Juda Fine Art
4 Timothy Taylor Gallery
5 Anne Faggionato
6 Barbara Hepworth
 Winged Figure
7 Jacob Epstein
 The Madonna and Child
8 Eric Gill *Prospero and Ariel*
9 Spectrum London
10 ROLLO Contemporary Art
11 Mummery + Schnelle
12 Royal Institute of British
 Architects
13 Rebecca Hossack Gallery
14 Alexandre Pollazzon Ltd
15 Antony Gormley *Reflection*
16 Langlands & Bell
 Opening/Capture
17 Michael Craig-Martin *Big Fan*
18 University College London
 Art Collections
19 Slade School of Fine Art
20 Wellcome Trust
21 Eduardo Paolozzi *Piscator*
22 Eduardo Paolozzi
 Newton after William Blake
23 Bill Woodrow
 Sitting on History
24 Martin Jennings
 John Betjeman
25 Paul Day *The Meeting Place*
26 Gagosian Gallery
27 Barry Flanagan *Camdonian*
28 Central St Martin's College of
 Art and Design

29 October Gallery
30 Austin/Desmond Fine Art
31 The British Museum
32 Architectural Association
33 Rokeby
34 Curwen & New Academy
 Gallery
35 Rebecca Hossack Gallery
36 Alison Jacques Gallery
37 Anthony Reynolds Gallery
38 Mumford Fine Art
39 Riflemaker
40 Jill George Gallery
41 Eduardo Paolozzi
 Underground Murals
42 The Gallery
43 Lazarides
44 The Hospital

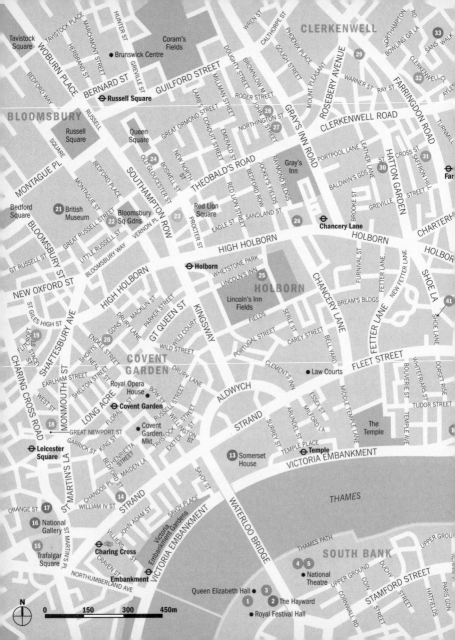

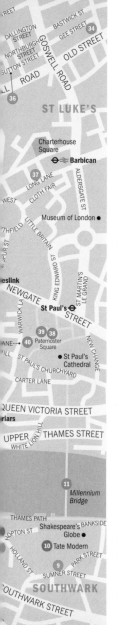

9. HOLBORN/SOUTH BANK

1 William Pye *Zemran*
2 The Hayward
3 Philip Vaughan and Roger Dainton *Neon Tower*
4 John Maine *Arena Sculpture*
5 Frank Dobson *London Pride*
6 Ian Davenport *Poured Lines Southwark Street*
7 Purdy Hicks Gallery
8 Bankside Gallery
9 Eyestorm
10 Tate Modern
11 Norman Foster, Anthony Caro and Arup *Millennium Bridge*
12 Conrad Shawcross *Space Trumpet*
13 Courtauld Institute of Art
14 Jacob Epstein *Ages of Man*
15 Fourth Plinth
16 The National Gallery
17 National Portrait Gallery
18 The Photographers' Gallery
19 Elms Lesters
20 The Hospital
21 The British Museum
22 Austin/Desmond Fine Art
23 Central St Martin's College of Art and Design
24 October Gallery
25 Barry Flanagan *Camdonian*
26 Eduardo Paolozzi *The Artist as Hephaestus*
27 Domobaal
28 Laura Bartlett Gallery
29 Eagle Gallery/Emma Hill Fine Art
30 Tom Dixon *Ingot*

31 The Aquarium L-13
32 Hoopers Gallery
33 Architecture Foundation
34 Magnum Print Room
35 Cabinet
36 Sutton Lane
37 The Chambers Gallery
38 Elisabeth Frink *Shepherd and Sheep*
39 Whitfield Partners *Column*
40 Thomas Heatherwick *Vents*
41 Antony Gormley *Resolution*

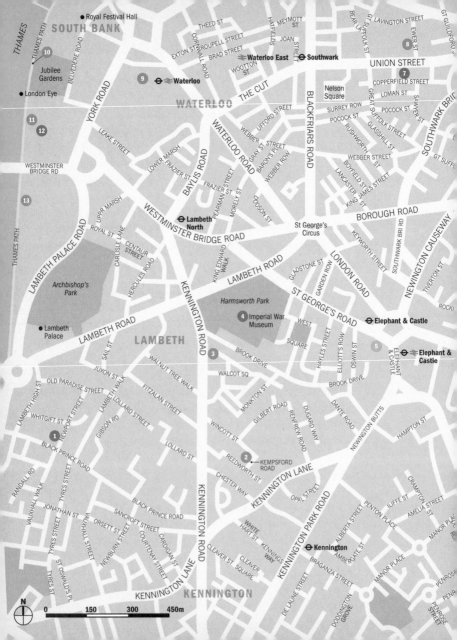

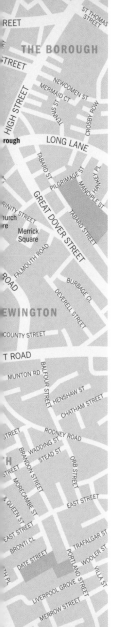

10. LAMBETH

1 Beaconsfield
2 Corvi-Mora
 greengrassi
3 Danielle Arnaud
4 Imperial War Museum
5 London College of
 Communication
6 Novas CUC Bankside
7 Jerwood Space
8 Union
9 Philip Jackson
 Terence Cuneo
10 Alexander *Jubilee Oracle*
11 Salvador Dalí
 Nobility of Time
12 Dalí Universe/County Hall
 Gallery
13 Naum Gabo
 Revolving Torsion, Fountain

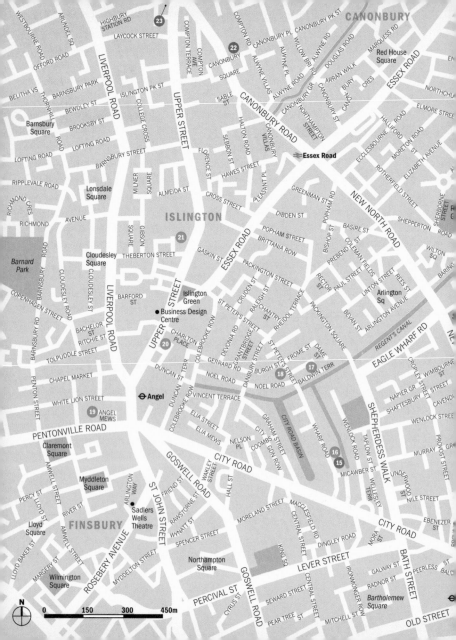

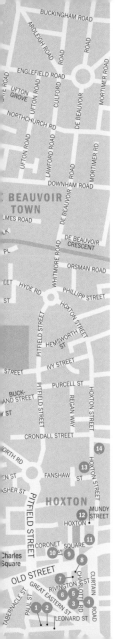

11. ISLINGTON

1 Leonard Street Gallery
2 Association of Photographers Gallery
3 Vertigo
4 Carl Freedman Gallery
5 I-MYU Projects
6 Contemporary Art Projects
7 Forster Gallery
8 La Viande
9 White Cube Hoxton Square
10 Standpoint Gallery
11 Store
12 Aaron Noble *Spire*
13 Peer
14 Associates
15 Parasol unit
16 Victoria Miro Gallery
17 August art
18 Art Space Gallery/Michael Richardson Contemporary Art
19 Cubitt Gallery
20 Sesame Art
21 Hart Gallery
22 Estorick Collection of Modern Italian Art
23 C4RD/Centre for Recent Drawing

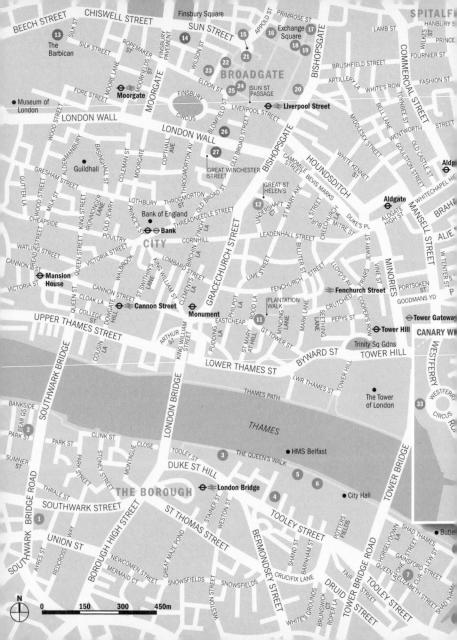

12. CITY/CANARY WHARF

1 Novas CUC Bankside
2 f a projects
 Ritter/Zamet
3 Allen Jones *Dancers*
4 Stephen Balkenhol *Couple*
5 David Batchelor *Evergreen*
6 Fiona Banner *Full Stops*
7 The Camera Press Gallery
8 Woolff Gallery
9 Design Museum
10 Eduardo Paolozzi *Invention*
11 Simon Patterson
 Time and Tide
12 Hiscox Art Projects
13 The Barbican
14 Bloomberg SPACE
15 Stephen Cox
 Ganapathi and Devi
16 Xavier Corbero
 The Broad Family
17 Bruce McLean *EYE-1*
18 Stephen Cox *Water Feature*
19 Fernando Botero
 Broadgate Venus
20 Jim Dine *Venus*
21 Alan Evans *Go Between*
22 George Segal *Rush Hour*
23 Jacques Lipchitz
 Bellerophon Taming Pegasus
24 Barry Flanagan
 *Leaping Hare on Crescent
 & Bell*
25 Richard Serra *Fulcrum*
26 Wallspace
27 Deutsche Bank
28 Whitechapel Art Gallery
29 Unit 2

30 Dicksmith Gallery
31 Fieldgate Gallery
32 Elastic Residence
33 Ron Arad *Windwand*
34 Wendy Ramshaw
 Columbus Screen
35 Igor Mitoraj *Centurione I*
36 Lynn Chadwick
 Couple on Seat
37 Ron Arad *The Big Blue*
38 Pierre Vivant
 Traffic Light Tree

185

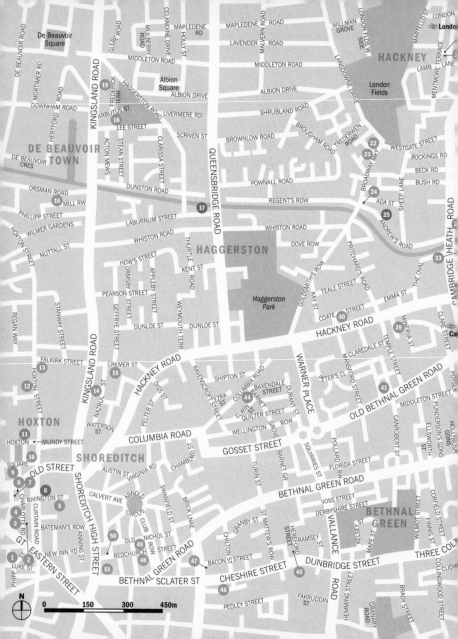

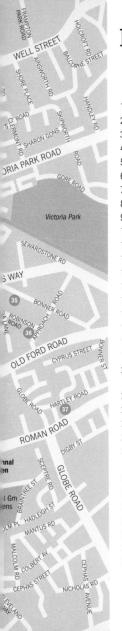

13. HOXTON/SHOREDITCH

1 Paul Stolper
2 Carl Freedman Gallery
3 Vertigo
4 I-MYU Projects
5 BISCHOFF/WEISS
6 Rivington Place
7 Forster Gallery
8 La Viande
9 White Cube Hoxton Square
10 Store
11 Aaron Noble *Spire*
12 Peer
13 Associates
14 Flowers East
15 The Agency
16 Carter Presents
17 The Drawing Room
18 New Realms Limited
19 Terrace
20 Fortescue Avenue/Jonathan Viner
21 Keith Talent Gallery
22 Seven Seven
23 off broadway
24 My Life in Art
25 MOT
 Transition Gallery
26 Alma Enterprises
27 Kate MacGarry
28 IBID Projects
29 VINEspace
30 Nettie Horn
31 Wilkinson Gallery
32 Fred (London) Ltd
 David Risley Gallery
 One in the Other

33 Stuart Shave Modern Art
34 Cell Project Space
35 The Showroom
36 The Approach
37 IAP Fine Art
38 Daniel Shand
39 Vilma Gold
40 Gallery Primo Alonso
41 Hotel
42 Herald St
43 Maureen Paley
44 StART Space
45 Paradise Row
46 f-art
47 Brick Lane Gallery
48 Museum 52
49 Studio 1.1
50 nomoregrey ART
51 Hales Gallery
 Rocket

Picture credits

Index of artists

Abbott, Berenice 150
Abfelbaum, Polly 116, 131
Abts, Tomma 15, 17, 101, 132, 154
Acconci, Vito 151
Adams, Ansel 137
Aitchison, Craigie 123, 146
Akakçe, Haluk 18
Akkerman, Philip 140
Aldrich, Richard 128
Alexander 151, 181
Allora & Caldazilla 133
Almond, Darren 161
Alÿs, Francis 133
Amm, Markus 134
Anderson, Hurvin 19, 146
Andre, Carl 20, 121, 133, 144
Appel, Kevin 148
Arad, Ron 126, 151, 163, 185
Araki, Nobuyoshi 117
Armleder, John 149
Arnatt, Matthew 132
Art & Language 133
Arup 152, 179
Attenborough, Max 144
Attia, Kader 120
Auer, Abel 128
Auerbach, Frank 21, 40, 126, 141
Avedon, Richard 150
Avery, Charles 116
Ayala, Raul Ortega 144
Ayres, Gillian 121, 157
Backhouse, David 151,171
Bacon, Francis 8, 21, 22, 40, 123, 129, 130, 145
Balkenhol, Stephen 151, 185
Balla, Giacomo 94
Balmond, Cecil 147
Banksy 23, 136, 141
Banner, Fiona 151, 185
Barney, Matthew 147
Barton, Glenys 131
Baselitz, Georg 136
Basquiat, Jean-Michel 141-2
Batchelor, David 151, 185
Bauer, Diann 141
Beard, Peter 150

Beecroft, Vanessa 118
Belin, Valérie 150
Bell, Nikki 62
Bell, Trevor 148
Bellamy, John 131
Ben-David, Zadok 151
Benton 124
Beuys, Joseph 121
Bhimji, Zarina 120, 134
Bircken, Alexandra 134
Bismuth, Pierre 133
Blake, Peter 24, 53, 118, 123, 142, 148, 151
Blow, Sandra 139, 141
Boccioni, Umberto 94, 116
Bohr, Marco 140
Bomberg, David 21, 121, 123, 141
Botero, Fernando 151, 185
Bourgeois, Louise 134, 147, 154
Boyce, Sonia 120
Breuer-Weil, David 123
Bronstein, Pablo 134
Brooks, James 138
Brown, Christie 128
Brown, Don 118, 144
Brown, Glenn 132, 147
Bruton, Jo 138
Bryans, Matt 136
Büchel, Christopher 134
Bucklow, Christopher 135
Bulloch, Angela 52
Burden, Chris 149
Buren, Daniel 133
Burrell, Heather 114
Bustin, Jane 130
Butler, Reg 132
Byrne, Gerard 133
Byrne, Nicolas 148
Caivano, Guillermo 135
Caivano, Varda 148
Caldicott, Richard 150
Calle, Sophie 119
Callesen, Peter 130
Camp, Sokari Douglas 121
Caro, Anthony 25, 39, 61, 123, 139, 141, 152, 179
Cartier-Bresson, Henri 150
Cass, Nikki 128
Caulfield, Luke 141
Caulfield, Patrick 26, 121-2, 123, 148
Chadwick, Lynn 27, 128, 141, 151, 185

Chagall, Marc 115, 126
Chaimowicz, Marc Camille 126
Chalayan, Hussein 151
Chapman, Jake and Dinos 28, 134, 139, 141, 161
Chatto, Daniel 136
Chetwynd, Spartacus 134
Childish, Billy 124
Chirico, Giorgio de 32, 116
Clark, Larry 145
Claydon, Steven 135
Coley, Nathan 15, 29, 134
Collier, Anne 128
Collishaw, Mat 52
Condo, George 145
Cooke, Nigel 149
Coombes, Justin 138
Coombs, Dan 144
Corbero, Xavier 151, 185
Corkrey, Michael 144
Coutts, Nicky 128
Cox, Stephen 151, 185
Cragg, Tony 30, 116, 123, 126, 127, 133, 139, 154
Craig-Martin, Michael 31, 132, 152, 177
Creed, Martin 70, 119, 134, 154
Croxson, Joel 128
Cullimore, Michael 128
Cunningham, Krysten 144
Currin, John 147
Dainton, Roger 157, 179
Dalí, Salvador 32, 115, 152, 181
Dalwood, Dexter 33, 132
Daniels, William 148
Davenport, Ian 34, 123, 148, 152, 179
Davey, Grenville 154
Day, Paul 152, 173, 177
Deacon, Richard 30, 35, 133, 154
Dean, Graham 148
Dean, Mark 138
Dean, Tacita 119
de Kooning, Willem 138
Deller, Jeremy 141
Dellsperger, Brice 120
Demand, Thomas 147
Derges, Susan 36, 134
Dijkstra, Rineke 137
Dine, Jim 63, 122, 152, 185

Dion, Mark 149
Dix, Otto 142
Dixon, Tom 152, 179
Dobson, Frank 152, 179
Doherty, Willie 138
Doig, Peter 130, 141, 148
Dolron, Désirée 150
Donovan, Terence 150
Eliasson, Olafur 9, 147, 154
Emin, Tracey 11, 37, 66, 118, 120, 129, 132, 139, 149, 161
English, Ron 124
Epstein, Jacob 123, 152, 163, 173, 177, 179
Evans, Alan 152, 185
Fairhurst, Angus 52, 144
Farquhar, Marcia 149
Farthing, Stephen 59
Fischer, Urs 144
Flanagan, Barry 38, 148, 152, 177, 179, 185
Flavin, Dan 124, 129, 133
Floyer, Ceal 133
Ford, Laura 135
Forsyth, Iain 136
Foster, Norman 25, 122, 139, 152, 179
Francis, Mark 130
Franko B 149
Franks, Matt 39, 135
Fraser, Robert 9, 47
Fredericks, Murray 150
Freud, Lucian 21, 40, 90, 123, 157, 159
Frink, Elisabeth 41, 128, 140, 152, 179
Frize, Bernard 127
Frost, Alistair 128
Frost, Terry 42, 138, 141, 157
Fujimura, Makato 121
Fullerton, Michael 126
Gabo, Naum 43, 50, 71, 141, 155, 181
Gallaccio, Anya 52, 146
Gander, Ryan 124, 145
Gauguin, Paul 123
Giacometti, Alberto 77, 103, 122
Gilbert & George 44, 129, 130, 154, 159
Giles, Rick 130
Gili, Jaime 142
Gill, Eric 155. 177

189

Gillespie, Sarah 148
Gillick, Liam 15, 45, 128
Gluzberg, Margarita 141
Godwin, Fay 137
Goldin, Nan 159
Goldsworthy, Andy 117
Gollon, Chris 135
Golub, Leon 124
Goodwin, Dryden 145
Gordon, Douglas 80, 123, 129, 132, 133, 154
Gormley, Antony 46, 129, 139, 149, 155, 157, 161, 177, 179
Gorvin, Diane 155, 163
Graham, Dan 129, 133
Griffiths, Brian 148
Gronemeyer, Ellen 132
Grotjahn, Mark 145
Gupta, Shilpa 151
Gursky, Andreas 127, 147, 161
Hadid, Zaha 114, 139, 147
Hale, Matt 116
Hambling, Maggi 135
Hamilton, Richard 47, 103
Hamilton Finlay, Ian 48, 147
Haring, Keith 124
Hartley, Alex 117
Harvey, Claire 145
Harvey, Lucy 124
Harvey, Marcus 161
Hatoum, Mona 120, 161
Hawarth, Jann 24
Hawkins, Richard 128
Head, Tim 138
Heatherwick, Thomas 49, 155, 167, 171, 179
Henning, Anton 134
Hepworth, Barbara 42, 43, 50, 71, 108, 126, 141, 155, 175, 177
Heron, Patrick 42, 51, 138, 141, 148, 155, 163, 173
Hewlett, Jamie 136
Hilton, Roger 42, 135
Hirst, Damien 8, 11, 34, 52, 66, 85, 106, 116, 121, 128, 132, 134, 139, 141, 142, 147, 154, 157, 161
Hirst, Nicky 130
Hitchens, Ivon 135
Hladky, Andrew 138
Hockney, David 53, 145, 159

Hodgkin, Howard 54, 123, 132, 145, 154, 157
Ho Huai-Shuo 132
Holden, Emma 124
Holdsworth, Dan 145
Höller, Carsten 9, 154
Holofcener, Lawrence 155, 175
Horn, Roni 146
Horowitz, Jonathan 144
Horsfield, Craigie 131
Horst, Horst P. 150
Howson, Peter 116
Hoyland, John 139
Hugonnier, Marine 140
Hume, Gary 52, 55, 85, 139, 141, 157, 161
Hunter, Tom 56, 118
Huseby, Benjamin Alexander 128
Hylander, Thomas 148
Innes, Callum 130, 131
Ireland, James 57, 118, 131
Islam, Runa 161
Ito, Toyo 147
Jackson, Melanie 138
Jackson, Philip 155, 181
Jackson, Richard 134
Jagger, Charles Sargent 155, 167, 171
Jakob, Dani 148
James, Merlin 140
Jankowski, Christian 133, 144
Jenkins, Mark 136
Jennings, Martin 155, 177
John, Augustus 121, 123, 158
John, Gwen 121, 123, 158
Johnson, Paul 141
Johnston, Daniel 124
Jones, Allen 58, 140, 155, 169, 185
Jones, Sarah 134
Judd, Donald 123, 124, 133
Julien, Isaac 120
Juneau/Projects/ 131
Kahlo, Frida 159
Kapoor, Anish 59, 111, 116, 127, 133, 139, 141, 149, 154, 155, 171
Kasmin, Aaron 116
Katz, Alex 146
Kawara, On 149

Kay, Edward 128
Keane, John 116
Kelly, Ellsworth 60, 124, 147
Kenna, Michael 150
Khedoori, Rachel 134
Kiefer, Anselm 139, 161
Kilimnik, Karen 130
King, Adam 138
King, Phillip 38, 39, 61, 123, 155
Kitaj, R.B. 21, 53, 141
Klein, Anita 123
Klein, William 150
Klimt, Gustav 142
Knowles, Tim 144
Koizumi, Meiro 128
Koolhaas, Rem 147
Kwok, Cary 134
Lai, Philip 145
Lambie, Jim 144, 145
Landy, Michael 69, 136, 153
Langlands & Bell 62, 116, 147, 155, 156, 177
Lanyon, Peter 42, 43, 132
Lartigue, Jacques-Henri 137
Lawson, Sonia 123
Lee, Tim 133
Leibovitz, Annie 150
LeWitt, Sol 121, 133
Lichtenstein, Roy 63, 122, 129, 140, 145
Liebeskind, Daniel 147
Li Jin 132
Lim, Won Ju 130
Linke, Simon 141
Lipchitz, Jacques 156, 185
Little, Graham 122
Lock, David 131
Locke, Hew 64, 123, 134
Long, Richard 65, 133, 134, 139, 153, 154, 157, 159
Longly, George Henry 128
Lowe, Francesca 142
Lowry, L.S. 128
Lucas, Sarah 11, 37, 52, 66, 120, 144
Maar, Dora 134
McAttee, Andrew 131
McDonald, Peter 136
Mach, David 139
McHarg, Robert Gordon III 146
McLean, Bruce 156, 185

McLynn, Rebecca 144
McQueen, Steve 37, 146, 157
Maine, John 156, 179
Mangold, Robert 133
Mania, Andrew 148
Mapplethorpe, Robert 122
Marclay, Christian 117
Marinetti, Filippo Tommaso 94
Marquiss, Duncan 128
Marshall, Maria 131
Martin, Simon 126
Matisse, Henri 51, 126, 142
Mehretu, Julie 161
Mikhailov, Boris 137
Miller, Harland 161
Milroy, Lisa 139
Miró, Joan 121, 141, 145
Mitoraj, Igor 156, 185
Modigliani, Amedeo 116
Moffett, Alison 140
Monk, Jonathan 133
Moore, Henry 8, 25, 50, 61, 67, 73, 103, 108, 122, 123, 126, 141, 148, 156, 173, 175
Moran, Katy 145
Morandi, Giorgio 116
Morgan, Polly 136
Mori, Mariko 147, 151
Morison, Heather & Ivan 68, 128
Moriyama, Daido 150
Morley, Malcolm 154
Morton, Callum 132
Morton, Victoria 144
Mueck, Ron 118
Muñoz, Juan 154
Münster, Jost 138
Murray, Tatyana 123
Nars, James 150
Nash, Paul 116
Nashashibi, Rosalind 69, 145
Nauman, Bruce 154
Neiland, Brendan 142
Nelson, Mike 70, 134, 138
Nicholson, Ben 42, 43, 50, 51, 71, 123, 148
Niemeyer, Oscar 147
Noble, Aaron 72, 141, 156, 183, 187
Noble, Paul 73, 123
Noble, Tim 74, 120, 132
Nolde, Emil 142

Noonan, David 135
Norfolk, Rupert 128
Novatt, Jedd 150
Obrist, Hans Ulrich 147
Ofili, Chris 11, 75, 120, 127, 147, 148, 154
Ohanian, Melik 149
Olly & Suzi 130
Opie, Catherine 137
Opie, Julian 30, 76, 122, 133, 151
Ormond, Tom 122
Orozco, Gabriel 147, 161
Orta, Lucy 117
Ortega, Damian 161
Ourlser, Tony 133
Palmer, Kirk 141
Paolozzi, Eduardo 77, 103, 139, 141, 156, 158, 173, 177, 179, 185
Pardo, Jorge 134
Parker, Cornelia 78, 131, 147
Parkinson, Norman 150
Parr, Martin 79, 137
Parreno, Philippe 127
Parsey, Martha 130
Parsons, Andy 114
Pasmore, Victor 142
Paterson, Toby 117
Patterson, Simon 6, 80, 123, 134, 156, 185
Penn, Irving 137, 150
Peploe, Samuel 130
Peri, Peter 126
Periton, Simon 144
Perry, Grayson 81, 117, 141, 148
Persico, Gaia 138
Pevsner, Antoine 43
Pfeiffer, Paul 146
Phillips, Tom 157
Picasso, Pablo 22, 32, 60, 71, 82, 94, 115, 121, 122, 126, 141, 142, 159
Piper, John 116
Plender, Olivia 144
Plusminus Produkties 124
Pockley, Jenny 144
Pollard, Jane 136
Pollock, Jackson 17, 87, 159
Prendergast, Peter 123
Prince, Richard 130
Procktor, Patrick 142
Pye, William 83, 156, 179

Pyke, Steve 131
Quinn, Marc 14, 84, 141, 152, 161
Rae, Fiona 85, 139, 146
Raedecker, Michael 124, 134
Ramshaw, Wendy 156, 185
Rego, Paula 86, 118, 121, 158
Reid, Jamie 124
Rhodes, Carol 140
Riley, Bridget 12, 87, 136, 146, 147, 157
Rist, Pipilotti 88
Ritson, Boo 128
Robert-Jones, Ivor 156, 173
Roberts, D.J. 138
Rogers, Brett Cody 124
Rook, Greg 138
Rosenquist, James 116
Rothko, Mark 89, 103, 159
Rothschild, Eva 145, 149
Saint Phalle, Niki de 132
Salcedo, Doris 154
Sasnal, Wilhelm 144
Saville, Jenny 90, 132
Saville, Peter 141
Savu, Serban 131
Schewadron, Lalie 138
Schiele, Egon 142
Schoorel, Maaike 138
Schoultz, Andrew 72
Schütte, Thomas 12, 14, 131, 152
Schwitters, Kurt 77
Scott, William 141
Scully, Sean 91, 146
Segal, George 63, 92, 156, 185
Serra, Richard 93, 153, 157, 185
Severini, Gino 94, 116
Sharp, Amanda 127
Shaw, Jim 130
Shaw, Raqib 95
Shawcross, Conrad 96, 148, 157, 179
Shearer, Steven 145
Sherman, Cindy 147
Shonibare, Yinka, MBE 97, 120, 123, 129, 145
Shovlin, Jamie 142
Shulman, Jason 138
Sierra, Santiago 133
Silverstein, Ali 123

Silvestrin, Claudio 120, 148
Simmons, Gary 145
Siza, Alvaro 147
Slotover, Matthew 127
Smit, Guy Richards 120
Smith, Bob & Roberta 134, 147
Smith, Terry 130
Smith, Zak 131
Snyder, Sean 133
Souto de Moura, Eduardo 147
Spencer, Stanley 116, 121, 158
Starling, Simon 145
Steichen, Edward 150
Sternfeld, Joel 137
Stewart, Andy 144
Stezacker, John 124
Stieglitz, Edward 150
Stonebridge, Nessie 138
Stoner, Tim 122
Strand, Paul 150
Sunna, Mari 124
Sutherland, Graham 116, 128
Suzuki, Tomoaki 128
Tait, Neal 161
Tait, Renny 131
Takahashi, Tomoko 134
Taylor-Wood, Sam 98, 121, 145, 157, 161
Therrin, Robert 145
Thorsen, Kjetil 147
Tillmans, Wolfgang 99, 138, 154
Tilson, Joe 24, 100
Titchner, Mark 101, 148
Tomaselli, Fred 161
Trouvé, Tatiana 123
Tunick, Spencer 134
Turk, Gavin 102, 134, 141, 142
Turnbull, William 103, 148, 158
Twombly, Cy 147
Tyson, Keith 45, 120, 134
Tyson, Nicola 144
Uglow, Euan 123
Unwin, Phoebe 148
Vaughan, Philip 157, 179
Villeneuve, Poppy de 138
Viola, Bill 104, 134
Virtue, John 118
Vivant, Pierre 105, 157, 185

Wall, Jeff 161
Wallinger, Mark 106, 124, 152, 153, 154, 159
Walters, Ian 157, 173
Warhol, Andy 11, 102, 124, 130, 138, 141, 142
Warren, Rebecca 138
Wathen, Richard 140
Wearing, Gillian 11, 78, 107, 138, 154, 157
Webb, David 114
Webb, Gary 15, 108, 124, 136
Weber, Marnie 130
Webster, Sue 74, 120, 132
Weiner, Lawrence 133
Weir, Mathew 130
Wenders, Wim 134
Wentworth, Richard 30, 119, 123, 133
Wesselmann, Tom 140
Weston, Edward 150
Westwood, Martin 124
Wheeler, David 148
Whiteread, Rachel 11, 14, 109, 114, 121, 132, 152, 154
Whitfield Partners 157, 179
Wilding, Alison 136
Williams, Bedwyr 145
Williams, Lucy 146
Williamson, Aaron 149
Wilson, Jane and Louise 123, 133
Wilson, Keith 138
Wilson, Richard 110, 117, 139
Winogrand, Garry 150
Wolbers, Saskia Olde 149
Woodfine, Sarah 128
Woodrow, Bill 14, 30, 59, 111, 133, 148, 152, 157, 177
Wool, Christopher 119
Wright, Ben 122
Wyn Evans, Cerith 119, 161
Yass, Catherine 122
Yeo, Jonathan 130
Zhang Huan 139
Ziegler, Toby 112, 145
Zittel, Andrea 144

Author's acknowledgments

Huge thanks to Chris Stephens at Tate Britain, to everyone at Quadrille and to the team who worked so hard helping me to produce these guides. Thanks to the artists, galleries, curators and colleagues for helpful advice and suggestions and to friends and family for their support and encouragement.

The information in this guide was correct at the time of going to press.
Art, artists and galleries move frequently and the publisher can take no
responsibility for information that may have subsequently changed.

First published in 2008 by
Quadrille Publishing Limited
Alhambra House
27-31 Charing Cross Road
London WC2H 0LS
www.quadrille.co.uk

Project Director: Anne Furniss
Creative Director: Helen Lewis
Design: Gabriella Le Grazie
Editor: Mary Davies
Picture Research: Nadine Bazar, Sarah Airey
Map Design: Russell Bell
Picture Co-ordinators: Samantha Rolfe, Peter Stone
Listings Compiler: Sue Wood
Editorial Assistance: Hillary Allanbrook, Helen Cleary, Lise Connellan, Sarah Jones
Production Director: Vincent Smith
Senior Production Controller: Ruth Deary

Cataloguing-in-Publication Data: a catalogue record for this book is available from the British Library.

ISBN 978 184400 594 9
Printed in Germany